LAND OF THE FRAGILE GIANTS

D0851085

A Bur Oak Original

BUR OAK

LAND OF THE
FRAGILE GIANTS

LANDSCAPES, ENVIRONMENTS,

AND PEOPLES OF THE LOESS HILLS

Edited by CORNELIA F. MUTEL and MARY SWANDER

With additional material by LYNETTE L. POHLMAN

PUBLISHED FOR THE BRUNNIER ART MUSEUM AT IOWA STATE UNIVERSITY BY THE UNIVERSITY OF IOWA PRESS

This publication is issued in conjunction with the traveling exhibition *Land of the Fragile Giants: Landscapes, Environments, and Peoples of the Loess Hills* held at the Moorhead Cultural Center, September 15 to November 1, 1994; Sioux City Art Center, December 11, 1994, to February 5, 1995; Arts on Grand, Spencer, February 15 to March 15, 1995; MacNider Museum of Art, Mason City, March 23 to May 14, 1995; Cedar Rapids Museum of Art, June 6 to July 16, 1995; Brunnier Art Museum, Ames, August 1, 1995, to January 5, 1996; De Soto National Wildlife Refuge, Missouri Valley, January 13 to March 3, 1996; and Iowa State Historical Museum, Des Moines, March 15 to June 2, 1996. *Land of the Fragile Giants* is an educational and cultural project composed of a touring exhibition, this publication, and accompanying educational programs. Created and organized by Iowa State University's Brunnier Art Museum, the project reflects the university's and museum's mission of scholarship and service to the students of the university and the citizens of Iowa.

All dimensions of artwork in the book are listed in inches, with height preceding width.

University of Iowa Press, Iowa City 52242

Design by Karen Copp

The editors wish to thank the *Des Moines Register* in which an excerpt of Mary Swander's "Aerial View" first appeared.

Library of Congress Cataloging-in-Publication Data

Land of the fragile giants: landscapes, environments, and peoples of the Loess Hills / edited by Cornelia F. Mutel and Mary Swander; with additional material by Lynette L. Pohlman.

 p. cm.—(A Bur oak original)

 Includes bibliographical references.

 ISBN 0-87745-477-9 (paper: acid-free paper)

 1. Loess Hills (Iowa and Mo.)—Description and travel—Exhibitions.
2. Loess Hills (Iowa and Mo.) in art—Exhibitions. 3. Natural history—Loess Hills (Iowa and Mo.)—Exhibitions. 4. Landscape—Loess Hills (Iowa and Mo.)—Exhibitions. 5. Ecology—Loess Hills (Iowa and Mo.)—Exhibitions. I. Mutel, Cornelia Fleischer.
II. Swander, Mary. III. Pohlman, Lynette. IV. Series.

F627.L76L36 1994

977.7—dc20 94-14909

 CIP

01 00 99 98 97 96 95 94 P 5 4 3 2 1

Wind-borne

Loose,

the windblown silt

of glacial melt,

and loose these hills,

as if they might wander

over the broken prairie.

Conjured out of air,

they herded here

to browse along the river

or drowse away forever

in undulant slumber.

Their dreams are switchgrass

and prairie goldenrod;

coralroot orchid and buffalo berry;

the spires and bells

of a flower unknown, unnamed,

scenting the air with mystery.

We smell it sometimes,

a sweetness in the city

or at the edge of a harrowed field,

something half-remembered

like a lost part of ourselves,

loose on the wind

blown back from the hills,

an offering.

— NEAL BOWERS

Contents

Acknowledgments

LYNETTE L. POHLMAN

The book and exhibition *Land of the Fragile Giants: Landscapes, Environments, and Peoples of the Loess Hills* focus on an important geological and aesthetic place in Iowa and illustrate the environmental impact of human activities on a unique natural landscape. *Land of the Fragile Giants*, an exhibition of paintings, prints, photographs, and sculptures created by Iowa and midwestern artists and reproduced here, offers a powerful contemporary overview of the Loess Hills landscape. These creations range from detailed botanical etchings to abstractions of wind and soil, from painterly impressionistic landscapes to stoic and humorous portraits to contemporary photographs of landscapes.

Many people have contributed to *Land of the Fragile Giants* in all aspects of the project—the exhibition, publication, and educational programming. The Brunnier Art Museum and Iowa State University are grateful to them all and sincerely appreciate and acknowledge their contributions of knowledge, time, energy, and commitment. This project is indeed about trusting partnerships between many people and organizations.

Contemporary consciousness of Iowa's Loess Hills has been increasing for nearly two decades. In 1989 public awareness of this area became even more focused by the publication of Cornelia F. Mutel's *Fragile Giants: A Natural History of the Loess Hills*. Before proceeding with the exhibition I contacted Cornelia, who heartily offered her support. She loaned the name and concept of "fragile giants" to the project, has been the bridge

with many of the scientists involved in the project, and shared her enthusiasm and expertise. By editing this book Cornelia Mutel and Mary Swander provided wonderful literary counsel and thoughtful transitions among the arts and sciences presented herein.

The driving force behind the exhibition is the visual arts, and to all the artists who participated and made this project a reality, my sincere appreciation. Their exuberance at exploring the Loess Hills and creating their art was exhilarating. The artists are Keith Achepohl, William Barnes, Randy Becker, Gary Bowling, Anne Burkholder, James Butler, Richard Colburn, Gina Crandell, Ben Darling, Dennis Dykema, Douglas Eckheart, Steven Herrnstadt, Drake Hokanson, Dan Howard, Keith Jacobshagen, Richard Leet, Robert McKibbin, Elizabeth Miller, Concetta Morales, Jo Myers-Walker, John Page, Genie`Hudson Patrick, John Preston, John Spence, Tom Stancliffe, David West, and Donald Wishart.

With equal enthusiasm and introspection, a group of humanists and scientists wrote with their hearts as well as their heads and contributed their essays to this book. The writers are E. Arthur Bettis III, Dianne Blankenship, Margaret Bonney, Michael Carey, Donald Farrar, David Gradwohl, Jean Prior, Cornelia Mutel, Don Reese, Tom Rosburg, Mary Swander, and Lois Tiffany.

In our dream to wholly unite the arts and sciences through this project, music was needed, as well as poetry. Neal Bowers

has had a long involvement with the Brunnier Art Museum, and we were delighted that he was able to write the poem "Wind-borne." "Wind-borne" also became the lyrics for a vocal composition of the same name. Iowa State University professors Jeffrey Prater and Roger Cichy were commissioned to compose vocal and band music, respectively. Iowa high schools received copies of each for use in future performances in association with this project.

Partnerships with organizations, as well as with the individuals in those organizations, were equally important to the implementation and success of this project. The following individuals and organizations eagerly cooperated with us to help pool and distribute knowledge to the citizens of Iowa: Tom Moore and Iowa Public Television; the Iowa Department of Education and Area Education Offices; the Iowa Department of Natural Resource's Geological Survey Bureau, Ron Williams, and Preparation Canyon State Park; Tom Bruegger and the Monona County Conservation Board; Brent Olsen and the Loess Hills State Forest; the community of Moorhead and the Moorhead Cultural Center, including Nola Eskelsen, Don Lamb, Sheila Lindsey, Ruth Pickle, Robert Shol, and Lorna and Darrell Wessell; and Iowa State University's departments of English, music, art and design, botany, anthropology, and education.

Charles Greiner, Front Porch Studio, photographed most of the works of art in this book. The first person to photograph the Brunnier Art Collection twenty years ago, Chuck has been a long-time museum supporter and has often donated his professional services. Don Poggensee, a seasoned photographer of the Loess Hills, generously allowed us to reproduce a selection of his images to illustrate the essays; other photographers are Tom Rosburg, Don Farrar, Art Bettis, and George Knaphus.

A principal goal of the Brunnier Art Museum when procuring works for its collections is to obtain art by significant Iowa artists. *Land of the Fragile Giants* allowed the museum to purchase works of art to join the permanent collection following the exhibition's tour. Iowa State University's Class of 1976 and W. Allen Perry contributed funds for art purchases, and the Ruth Smith Memorial Fund, consisting of donations from the family and friends of the late Ruth Smith, a long-time museum docent and supporter, provided additional funding.

I would also like to extend credit to museum staff members who tirelessly worked on this project. Deborah-Eve Lombard and Jacqueline Drewes developed youth and adult educational programming. Stacy Brothers provided administrative support and edited my many project and publication drafts. Mary Atherly and Eleanor Ostendorf managed the collection, transportation, and insurance associated with the traveling exhibition. Ray Benter coordinated public relations efforts, and Peggy Fay coordinated fund-raising for the project. Sharon Matt, a student museum employee and future museum professional, worked for two years on this project, tending to all sorts of tasks and details from conducting research to data input, to coordinating schedules with artists, to organizing museum activities.

Projects of this magnitude require the cooperation of many people. They also require financial support to transform the vision of the project into reality. We received major support from Iowa State University and additional grant support from the Iowa Arts Council and the National Endowment for the Arts. Lois Irvine of Ames supported the commissioning of the musical compositions and the poetry. The J. W. Fisher Endowed Art Outreach Fund at the Iowa State University Foundation provided major support for the educational outreach programs for the youth and adults of Iowa. Education kits for distribution to

elementary schools were partially supported by a Historical Resource Development Program Grant from the Department of Cultural Affairs, State Historical Society of Iowa.

Finally, I lovingly and gratefully acknowledge my parents, Lorna and Darrell Wessell, who instilled in me a deep appreciation for my cultural roots and nurtured a spirit of appreciation for the beauty found in nature's landscapes and peoples. They inspired the idea for the exhibition and tirelessly worked in their community to give *Land of the Fragile Giants* its premiere exhibition site in the Loess Hills.

The Fabric of the Hills

MARY SWANDER and CORNELIA F. MUTEL

As interest and awareness of the Loess Hills in Iowa have burgeoned in the last decade, so, too, did this project grow and develop. In 1992 Lynette Pohlman, originally from Monona County and now the director of Iowa State's University Museums, conceived the idea for an art exhibition about the Hills. She originally intended to keep the exhibit limited, strictly an outreach, Iowa show for small exhibition sites to depict an impressive, important part of the state. To develop and host the exhibition, she required the assistance of a partnership community. In April 1992 a town meeting notice was posted on Main Street in Moorhead, a tiny town of 264 people in the heart of the Loess Hills, to solicit interest in sponsoring the opening of an art exhibition. A week later 30 people turned out for a meeting, and two years later the town had renovated its old library and former drugstore into the Moorhead Cultural Center, which would serve as a permanent gallery space and would also premier *Land of the Fragile Giants* in the fall of 1994. The surrounding towns of Pisgah, Onawa, Turin, Soldier, and Dunlap joined in the efforts to raise money to sponsor the exhibition locally and sparked off a series of grassroots fund-raisers. In traditional Iowa fashion, pancake breakfasts and a raffle for a quilt made in the colors of the Hills followed.

As curator, Lynette invited professional artists to participate in the exhibition. The artists were required to visit the Loess Hills and create contemporary works inspired by their experiences there. Some artists hooked up with families in the Hills, and a new collaboration began, the artists becoming acquainted with a unique group of people as well as with the landscape. Then, as if one patch were sewn onto another, the project pieced together a fabric of its own. "I sat down at my desk and began making phone calls to various individuals and groups to join the celebration," Lynette said, "to musicians and writers, to scientists and organizations as varied as the Iowa Arts Council, the Department of Natural Resources, and Iowa Public Television. Everyone I contacted said, 'Yes!' and I found myself in a position where Iowa State University, the Brunnier Art Museum, and I could really make a difference. Grant Wood brought eastern Iowa to the world's attention through art, and I thought the same might be done for western Iowa. And the Brunnier staff is always attempting to link the sciences, arts, and humanities. The Loess Hills project became the perfect vehicle for making the connection between the sciences and the arts." Thus what began as a small project blossomed into a much broader educational and cultural experience.

This book extends Lynette's vision of a multidimensional view of the Hills. Here, personal essays by Iowa scientists and humanists blend with photographs and with photo reproductions of the commissioned works of art to create a panorama or a "big picture" of the Loess Hills. This book, however, does not attempt to be a thorough or comprehensive natural history of the region. Each author, whether geologist, botanist, poet, or farmer, has spent part of his or her life in the area, and in the

process the landscape has taken on a special meaning. Each has, through a significant recounting of his or her own particular "patch" of knowledge, provided a glimpse of a larger concept. But the whole is left to the reader to stitch together, to come away from this reading as one comes away from climbing one of the Hills themselves, with a sense of wonder and awe, with a sense that no matter how much we unravel their mysteries, there will always be something more to hold our attention.

In this book twenty-seven artists, six scientists, six humanists, a poet, and a curator share their personal explorations, interpretations, and perspectives of the Loess Hills. Painters, sculptors, printmakers, and photographers—the artists present their personal, visual interpretations of the Loess Hills and its ever-changing landscape, a landscape affected by both nature and humanity. Geologists, botanists, and ecologists—the scientists discuss their research within the framework of their own personal experiences, and lay out the threads that led to their interest in their topics, some discovering the majesty of the Hills rather late in their careers, others as early as childhood. Anthropologists, historians, conservationists, poets, and farmers—the humanists provide a background and context for the scientists, dramatizing stories of the past and the present and speculating on the future of the Hills. Artists, scientists, humanists, many voices come together in this book to illustrate the many people who appreciate and utilize this land—from those who do academic research to those who do agricultural fieldwork in the region.

The visual artists invited to participate in the exhibition all were from Iowa or the Midwest. A few had previously traveled to or lived in the Hills and were acquainted with their artistic presence. The others were introduced to the Hills through this project. Through their life's work and dedication to the arts, these artists were delighted to expand their horizons and either revisit a familiar place or explore a new landscape and peoples.

The scientific and humanistic authors were chosen for their own particular expertise on the Hills. Many are frequent lecturers at the annual Loess Hills Prairie Seminar near Turin. Others have spent their lives exploring this terrain, whether behind a plow or the lens of a microscope. In real life, the authors are scattered across the state from the halls of Iowa State University and the Iowa Geological Survey Bureau to the stalls of a forty-cow barn. In this book, the twelve authors are paired together under six headings, or themes, that serve to focus their writings. Sometimes the paired essays answer one another. Sometimes they echo and enlarge upon one another. Sometimes one provides the macro and the other the micro view. Always they complement the works of art included in these pages, enlarging our understanding of a landscape unique to Iowa, unique to the world.

Explorations and Interpretations: Artistic Views of the Hills

LYNETTE L. POHLMAN

At no other time in world history have the consequences of human intervention in nature been more closely scrutinized or more relentlessly made part of public awareness. Romantic conceptions of nature as immense, eternal, restorative, and unchangeable are evaporating in the face of global concern for the environment and the resulting actions taken to improve our local ecology. It has become increasingly crucial to evaluate realistically our natural resources and acknowledge our interdependence with the natural world. We must also examine the long history of our attitudes, both local and global, toward nature as we attempt to evolve new ways of seeing and caring for the world in which we live.

The Loess Hills in western Iowa are an unusual type of land formation. They are formed entirely of windblown deposits of loose soil. Centuries of wind, erosion, and human use created the landscape we see today. Loess soil is common and is found throughout the world. Large hill formations of loess soil, however, occur in only a few places, nestled abreast some of the world's grandest rivers, such as the Rhine, Yellow, and Missouri. The dramatic ridges, valleys, and peaks of the landscape are visually spectacular. Punctuated by natural and human environments, the Loess Hills offer an intriguing juxtaposition of nature and humanity.

For over seven millennia prior to European exploration, Native Americans called the Loess Hills home. They interacted with the natural world around them to sustain their families and culture. They practiced agriculture, hunted on the land, and traded with neighboring tribes. Their heritage and stories are preserved in cultural artifacts that are being studied and better understood in the contemporary world.

Early Spanish and French expeditions did not fully reveal the land and peoples of the American West to the world. It was left to the new government of the United States to launch the scientific exploration of the West. From 1803 to 1806, following the Louisiana Purchase, Captains Meriwether Lewis and William Clark led a successful expedition across the Great Plains to the Pacific Northwest. They kept extensive written records, but no artist accompanied this best-remembered expedition to visually record the landscape and peoples of the new territory. Other expeditions followed, each adding a new dimension. To document the vast lands, artists often joined the early expeditions. Their drawings and paintings of the landscapes, flora, fauna, and peoples of these territories were useful for scientific record and review. Their illustrations were also shown to audiences in the East and introduced the Great Plains and the West to an inquiring public.

One of the first artists to popularize the landscapes and native peoples of the Great Plains and West was George Catlin. On one of his several excursions, Catlin left St. Louis in the summer of 1832 and journeyed 2,000 miles north up the Missouri River, sketching and painting landscapes and portraits. The first to illustrate the high bluffs and strangely eroded banks along the winding Missouri River, Catlin was fascinated by the mystery of the geological variations visible at every bend in the river. In his

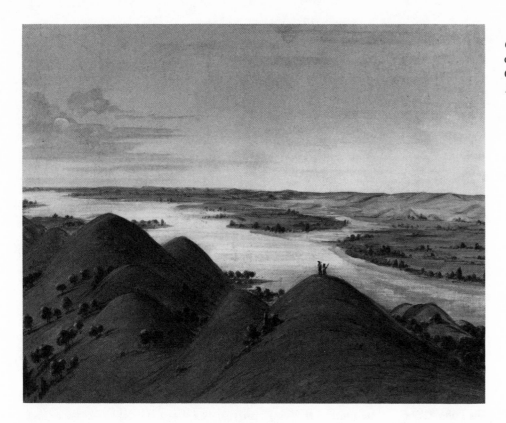

George Catlin, Grassy Bluffs on the Upper Missouri. *Collection of the Gilcrease Museum, Tulsa.*

1841 *Letters and Notes*, in nineteenth-century aesthetic, picturesque language, Catlin compared the fantastic shapes of the riverbanks and rising bluffs to "ramparts, terraces, domes, towers, citadels and castles." Catlin was captivated by the immense vistas, the green hills lush with prairie grasses, and the awe-inspiring aspect of raging prairie fires. He described the prairie fires as "hells of fire! Where the grass is seven to eight feet high . . . and the flames are driven forward by the hurricanes, which often sweep over the vast prairies of this denuded country. There are many of these meadows on the Missouri, and the Platte . . . so high, that we are obliged to stand erect in our stirrups, in order to look over its waving tops, as we are riding through it. The fire in these, before such a wind, travels at an immense and frightful rate."

Other artists followed Catlin. They joined scientific explorations and continued to document the land, flora, fauna, and human settlements. In 1833 a Swiss-born artist, Karl Bodmer, joined the German naturalist Maximilian, Prince of Wied, who was traveling through the Great Plains. Bodmer's drawings and watercolors provided a thorough record of the Missouri River valley. By the early 1880s, in addition to illustrative documentation, the new media of photography emerged, allowing Henry Farny to record the land and peoples of the Missouri River.

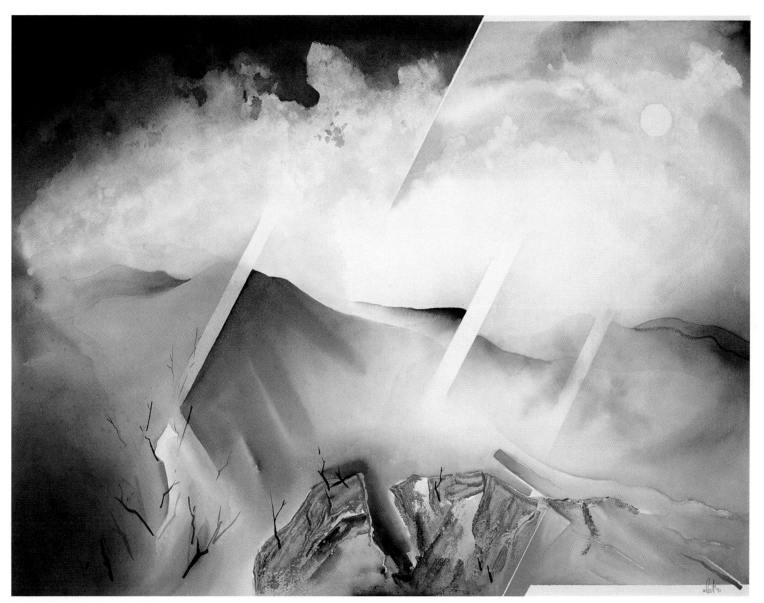

Loess Hills: The Genesis, 1993
Richard E. Leet
Watercolor
29 × 39
On loan from the artist

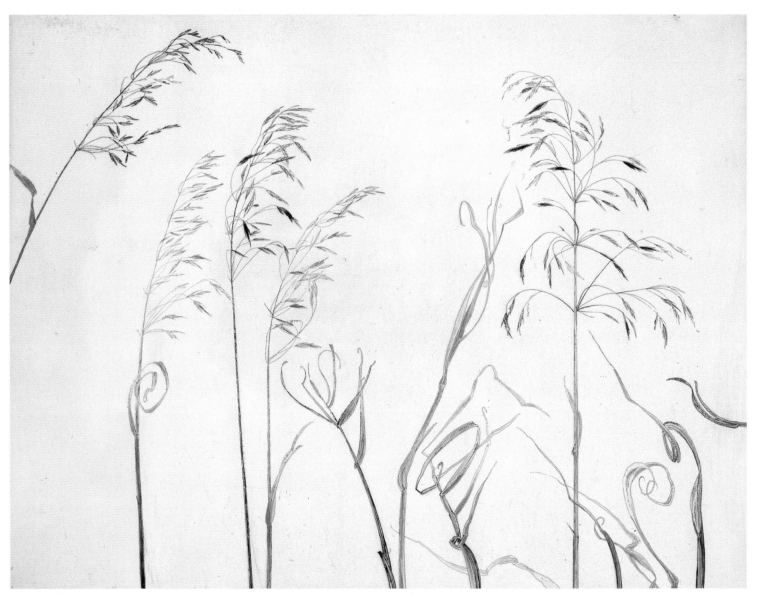

Iowa Song, 1994
Keith Achepohl
Etching, roulette, dry point
23½ × 31
On loan from the artist

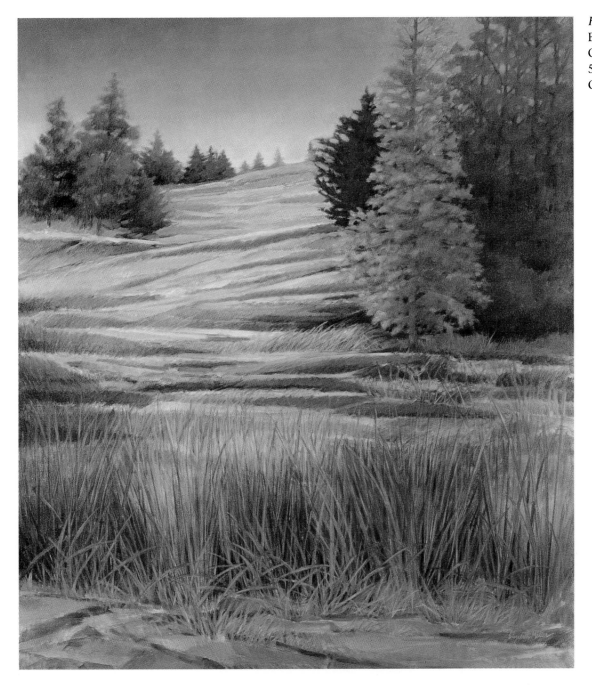

Hill Prairie, 1993
Elizabeth S. Miller
Oil on canvas
54 × 44
On loan from the artist

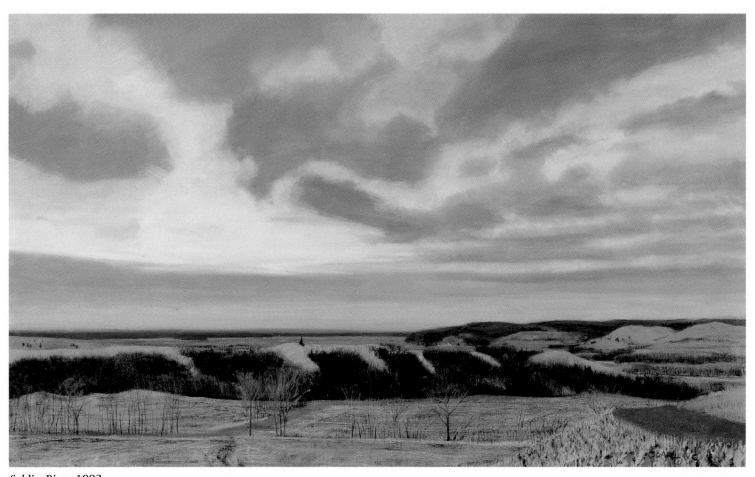

Soldier River, 1993
Ben Darling
Oil on canvas
36 × 60
On loan from Olson-Larsen Galleries,
 West Des Moines, Iowa

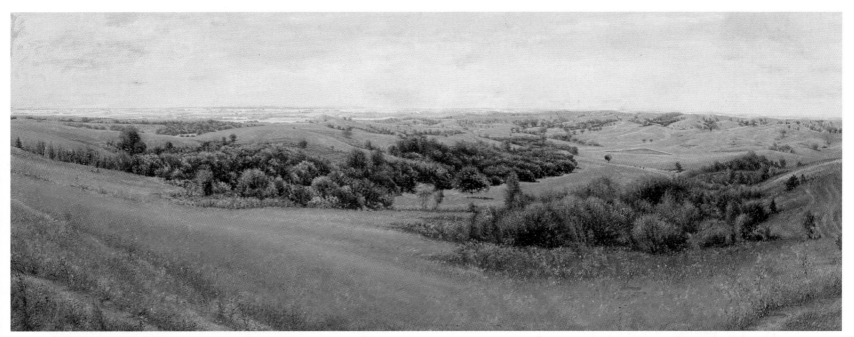

Dakota View from the Loess Hills, 1993–1994
James D. Butler
Oil on panel
25 × 66
On loan from the artist

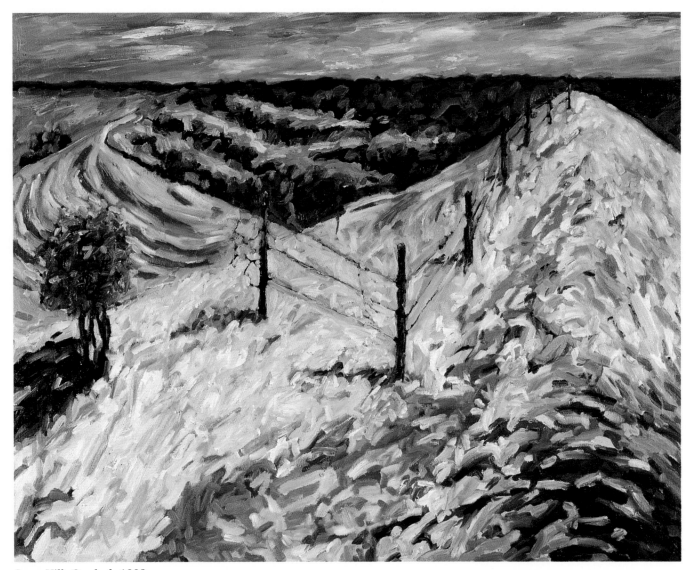

Loess Hills Overlook, 1993
Dennis Dykema
Oil on canvas
45 × 57
On loan from the artist

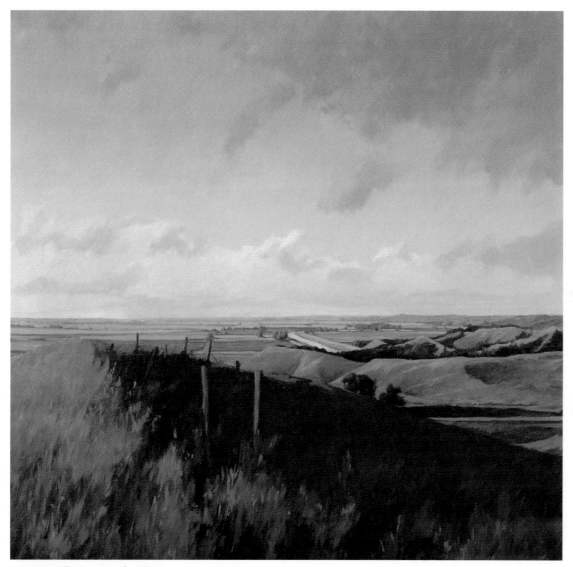

Murray Hill View North, 1993
John Preston
Oil on canvas
27 × 28
Brunnier Art Museum, Purchase Award
 for *Land of the Fragile Giants*, 1994
Gift of family and friends in memory of Ruth Smith

Interloper, 1994
Tom Stancliffe
Patinated steel
39 × 49 × 21
On loan from the artist

Bean Fields near Thurman, 1993
Robert H. McKibbin
Pastel on paper/arches cover
20 × 30
Brunnier Art Museum, Purchase Award
 for *Land of the Fragile Giants*, 1994
Gift of Iowa State University's Class of 1976

Ides of March (cut brush fires near Missouri Valley), 1994
Keith Jacobshagen
Oil on canvas
18 × 46
On loan from the artist

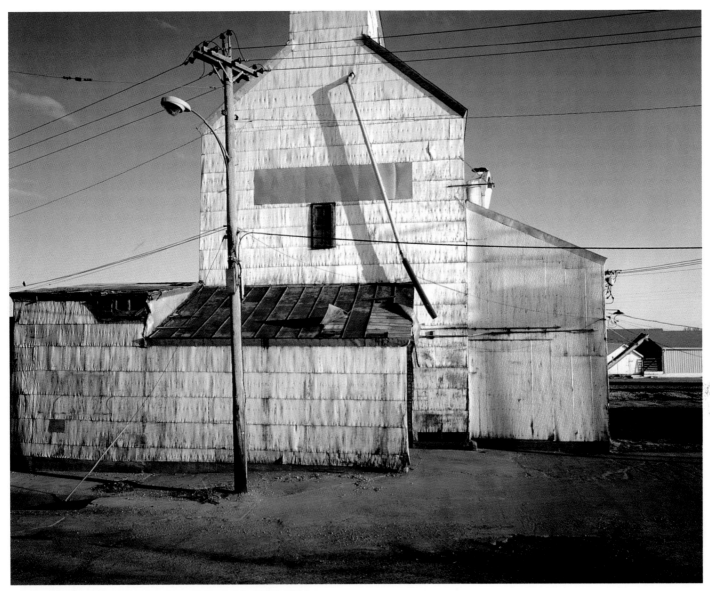

Neola, Pottawattamie County, Iowa, March 14, 1992, 1994
John Spence
Color photograph
20 × 24
On loan from the artist

kissitgoodbye, 1993–1994
Steven Herrnstadt
Digital image/iris watercolor print on Japanese paper
14¾ × 41
On loan from the artist

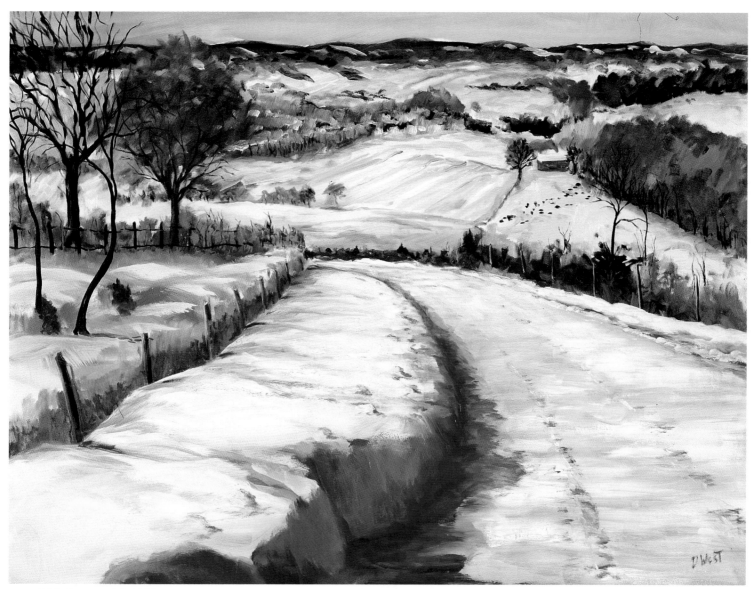

Loess Hills Snow, #435, 1993
David West
Oil on canvas
36 × 48
On loan from the artist

High Road, 1994
Genie Hudson Patrick
Oil on canvas
36 × 60
On loan from the artist

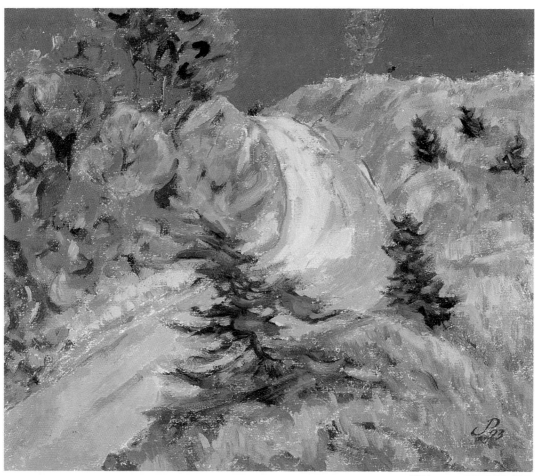

Cedars by the Road, #2057, 1993
John Page
Oil on canvas
11 × 13
On loan from the artist

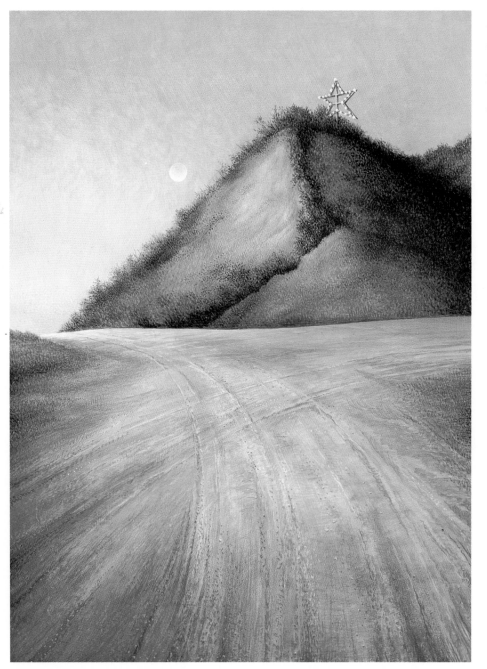

Cut, 1994
William C. Barnes
Casein on panel
15½ × 11¾
Brunnier Art Museum, Purchase Award
 for *Land of the Fragile Giants*, 1994
Gift of W. Allen Perry

Horizon 736—Loess Hills #2—Fall, 1993
Anne Burkholder
Watercolor
11 × 29½
On loan from the artist

Enchanted Hills, 1993
Douglas A. Eckheart
Mixed media: watercolor and ink drawing
13 × 36
On loan from the artist

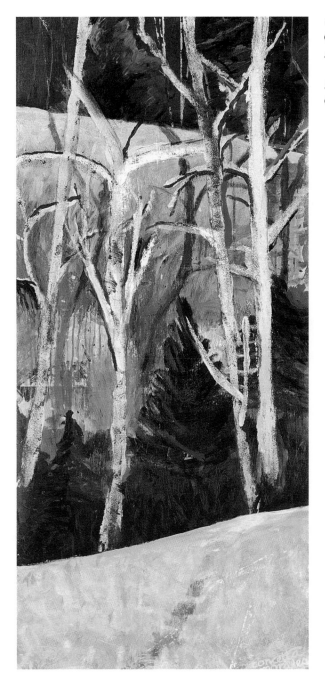

Cedars and Long Trees, 1994
Concetta Morales
Acrylic, monotype collage, and crayon
 on Stonehenge paper
50 × 24
On loan from the artist

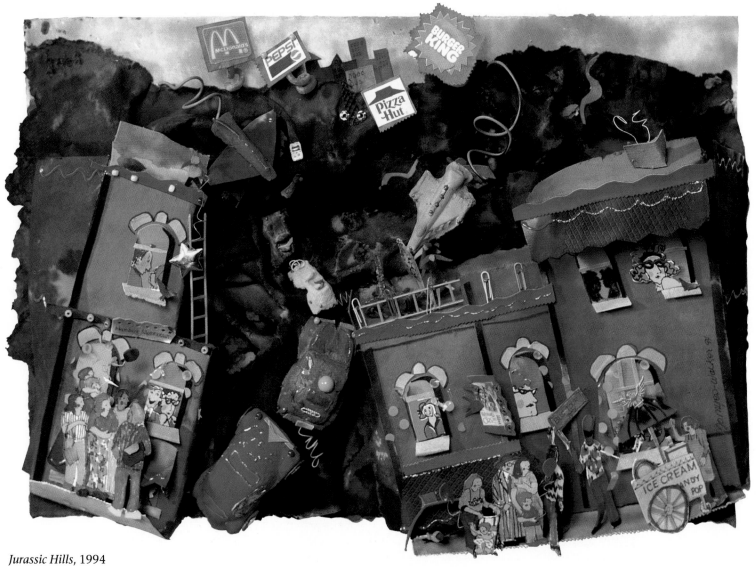

Jurassic Hills, 1994
Jo Myers-Walker
Handmade paper with dyed cotton fiber
26 × 39
On loan from the artist

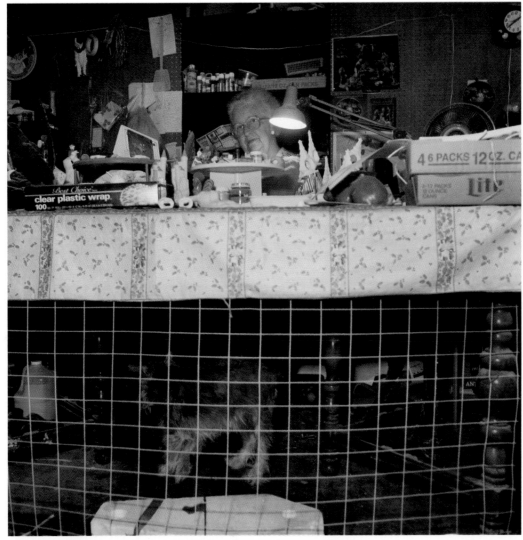

Helen Brownmiller at Jan's Creative Delights in Magnolia, Iowa, 1993
Richard Colburn
Color photograph
18¼ × 18¼
On loan from the artist

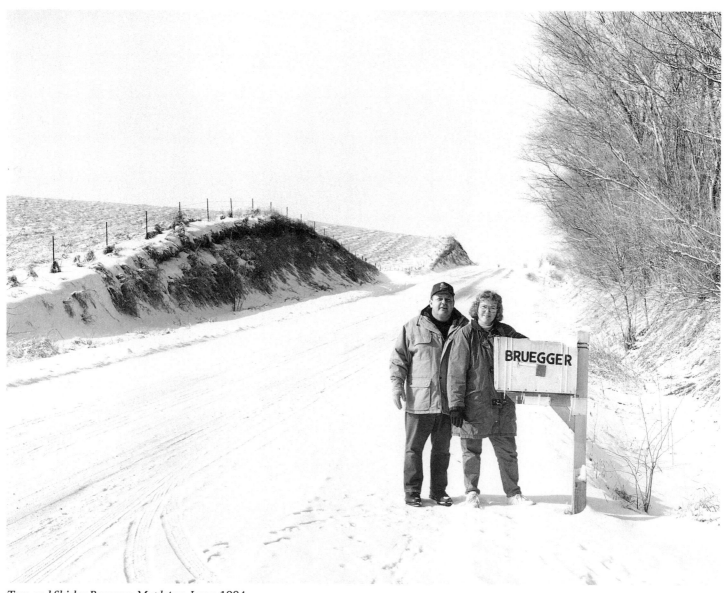

Tom and Shirley Bruegger, Mapleton, Iowa, 1994
Drake Hokanson
Black-and-white photograph
11 × 14
On loan from the artist

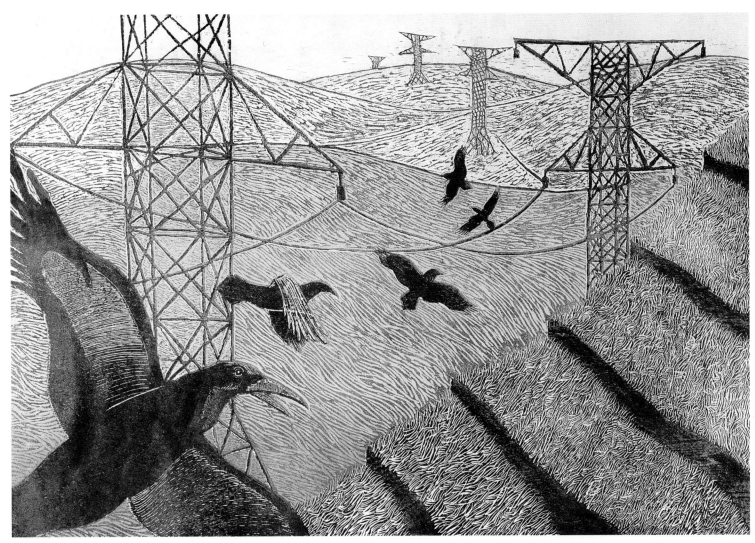

Crows over the Catsteps, 1994
Randy Becker
Woodcut
20 × 29
On loan from the artist

Detail from *A Place Apart: Loess Hills,* 1994
Donald J. Wishart
Video
9 minutes
On loan from the artist

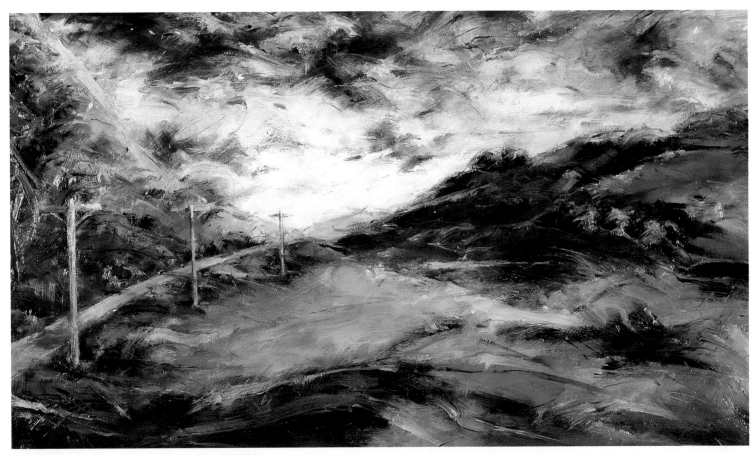

Loess Hills Testament (Eleven for the Road), 1993
Dan F. Howard
Oil on canvas
41 × 71
On loan from Vorpal Gallery, New York, New York

Screens and Draws Diptych, 1994
Gary Bowling
Oil on canvas
Two panels—44 × 52 each
On loan from Olson-Larsen Galleries,
 West Des Moines, Iowa

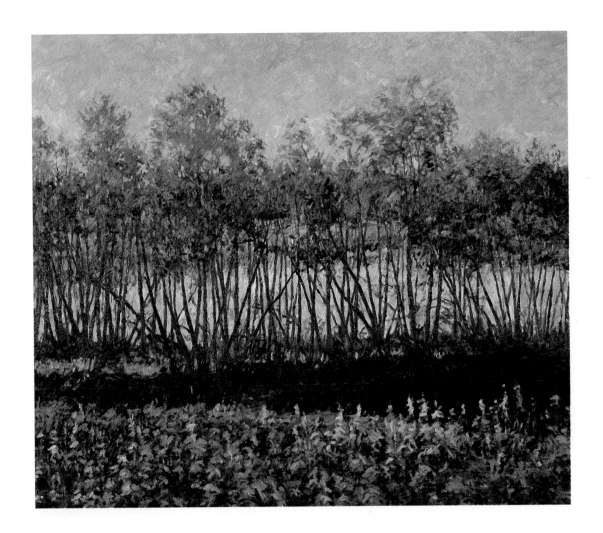

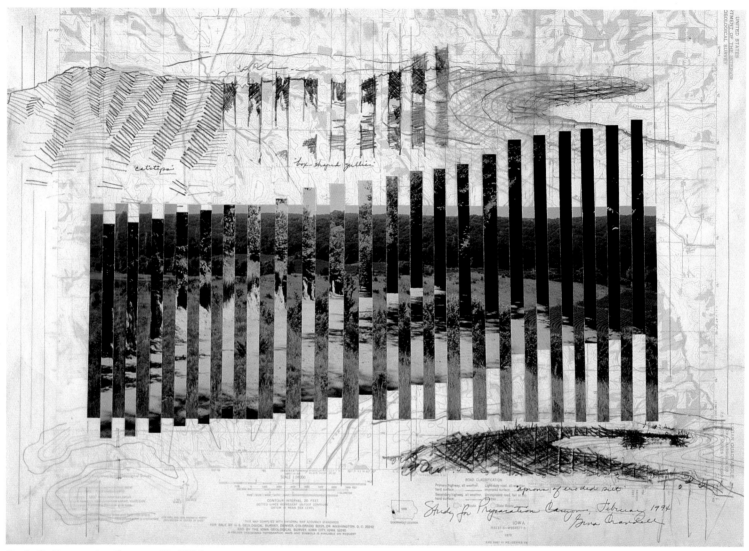

Study for Preparation Canyon, #1, 1994
Gina Crandell
Mixed media: photograph, U.S.G.S. map, and drawing
21 × 27
On loan from the artist

Toward the end of the century, many now-famous artists began traveling from the East to explore and artistically interpret the American Great Plains and West. Alfred Jacob Miller documented the Rocky Mountains, and William Jacob Hayes captured the hordes of buffalo on the plains. Illustrator, painter, and sculptor Frederic Remington captured enduring images of the cowboy's wild west and the individual freedom that characterized the frontier. Thomas Cole, Albert Bierstadt, Thomas Moran, and other gifted artists painted the romantic grandeur of the West, but none, following Bodmer, stopped to fully document and paint the majesty of the Great Plains. The Missouri River valley was passed by for nearly a century as a landscape worthy of popular aesthetic exploration and articulation.

Although they did not identify the Loess Hills by that name, Catlin and Bodmer sketched and painted this unique area. These illustrations serve to assist us, the contemporary audience, in knowing the landscape as it appeared in an earlier time. Through the visual arts language, the artists in the exhibition and represented in this book state the beauty of this special place and provide us with glimpses of some of the ecological, social, and political issues that confront the Loess Hills today. Not unlike Catlin and Bodmer, the *Land of the Fragile Giants* artists explored the land, flora, fauna, and settlements in the Loess Hills of our time. They explored and experienced some vistas and feelings reminiscent of earlier artists. Their works of art also express new visions and vistas of the continually evolving Loess Hills.

Formed millennia ago and never static, the Loess Hills are in a constant state of geological and ecological evolution. In Richard Leet's *Loess Hills: The Genesis* the viewer can feel the gale winds blowing the gritty soil over the glacial landscape. The Hills loom upward, witnesses to endless sunrises and sunsets. Rains create and erode ditches in the fragile soil. On this golden soil, vegetation grows and an infant prairie is born. The grasses in *Iowa Song* by Keith Achepohl evoke the beauty, grace, and simplicity of single plants, often overlooked for the sake of seeing the entire landscape vista. The grasses remind us that ecological networks are combinations of one plant and one animal that multiply to create one environment.

Current ecological, social, and political issues confront the Loess Hills. These issues derive from many relationships—relationships between prairies and forests, public and private lands, agriculture and virgin lands, profit and nonprofit enterprise, dwellers and tourists, hunters and nonhunters, and preservationists and economic developers. These issues are not merely related to one another but overlap, creating a multilayered web of perspectives. Just as these issues interrelate, the works of art in this book contain multifaceted images, expressing layers of meaning and interpretations. You the viewer must bring your own experiences and interpretations to these works of art. As each individual artist did, you, too, will make your own discoveries.

One of the most dramatic and quickly changing aspects of the Loess Hills in the last century has been the expansion of the forests. Historically predominantly a rolling prairie of waving grasses, the contemporary Hills are by comparison heavily treed. In the 1840s and 1850s the Loess Hills were settled by Euro-American farmers who cultivated fields, built farmsteads, and pastured livestock. They did not tolerate well the raging and destructive fires that create and sustain a prairie. Today forests are expanding alongside the agricultural fields, leaving less and less of the virgin prairie. The prairie grasses and deciduous trees are interwoven with cedar trees, which have become a nuisance to many people, rapidly taking over pastures and prairies.

Elizabeth Miller's *Hill Prairie* places the viewer firmly in the loose loess soil, looking up at the Hills. Covered with long-

stemmed grasses that camouflage the horizontal catsteps, the prairie meets the woods. The changing and companion landscapes of fields, trees, and hilltop prairies are one of the images most often depicted by *Land of the Fragile Giants* artists. Ben Darling painted *Soldier River* in the fall, showing the brown grasses matted on the hills, field stubble, and fingerlike tree branch tips. In comparison, James Butler's *Dakota View from the Loess Hills* presents the lush summer prairies and emerging forests as nearly void of human intervention, a peaceful and tranquil place. While people have been preoccupied with precisely defining their individual and community boundaries with roads, fields, and fences, Butler's painting reminds the viewer that hills, rivers, and forests also exist as boundaries. A landscape free of boundaries removes the artificial barriers that divide and separate people.

Equally prominent in the landscape imagery of this exhibition is the dramatic juxtaposition of the Hills and the river floodplain. A higher viewpoint is often presented, above and somehow distanced from the scene. Located in Harrison County, Murray Hill is one of the highest vantage points in the Hills. Hikers who venture to the top can almost see Omaha and Sioux City; on a clear night the skylines glimmer as if within grasp. Although it is difficult to pin down any real consistency except place, Dennis Dykema and John Preston both climbed this hill and took their inspiration from the experience. Dykema's *Loess Hills Overlook* involves a complex act of memory and synthesis to evoke a fresh atmospheric effect, while emphasizing the decorative, tapestry-like qualities of the painting and the place. Preston's *Murray Hill View North* is unified by the atmospheric effect that cloaks the hills and valley. This painting not only dramatizes the Hills' perpendicular rendezvous with the river bottom, it also presents the encroaching forests, the straightening and taming of the river by the Army

Corps of Engineers in the 1950s, and the presence of agriculture. On the uppermost point of the Loess Hills the fence serves as a guardian to the livestock, symbolizing human effort to tame even the pinnacles of the landscape. Tom Stancliffe's sculpture *Interloper* brings the looming, sensual Hills into three-dimensional reality while juxtaposing the flat, sleek surface of the field plain and diminutive prairie home. *Interloper* suggests that the land is dominant, with human intervention less grand and powerful.

In most of these works of art human presence is reflected in the landscape. Agriculture is the main industry of the Loess Hills, its traces carved into the land. With hills peeking out of the distance, *Bean Fields near Thurman* by Robert McKibbin depicts the lush fall colors of the river-bottom fields, splattered with colorful weeds and flowers mixed into the crops. While Catlin craved the sight of prairie fires rushing over the hills, Keith Jacobshagen's *Ides of March (cut brush fires near Missouri Valley)* dramatizes the flat, fertile river plain on which six generations of farmers have cultivated and celebrated bountiful harvests. No longer do the flames race across the grasslands. The land is now prepared for spring planting. John Spence's *Neola, Pottawattamie County, Iowa, March 14, 1992* reminds us of past harvests. The grain elevator of an earlier decade is no longer large enough to hold today's increased agricultural production. While the elevator's original stature and dominance on the landscape fade, its patinated richness reminds us of the small family farm and a life-style that is gradually fading as well.

Although at first glance humorous, Steven Herrnstadt's *kissit-goodbye* is a compelling and serious image portraying the effects of intense agriculture virtually raping the natural landscape. Through overuse of the land, be it by transforming livestock into a livelihood or by overplanting, human efforts can sabotage an ecosystem. As the Loess Hills and its dwellers enter the

next century, deciding how to balance nature with the land's ability to support increased agricultural development will be a difficult issue. Balancing profit, both agricultural and recreational, and preservation of the Hills' ecology is a serious responsibility for this and future generations.

After a century of intensive agriculture in which midwesterners have created a contemporary agricultural Eden on their way to feeding their families and the world, their efforts have banished many native animals from the natural paradise. The works of art in this exhibition do not contain many depictions of wildlife. Perhaps the artists did not see any, perhaps they chose not to depict any, perhaps animals were not part of the ecological story they wished to present. In reality, the Loess Hills host a diversity of wildlife. Just as nature and ecology see all species as connected, so, too, many people have encouraged the cohabitation of wildlife and domesticated animals to help restore the ecology of the Hills. At dusk, flocks of turkeys, herds of deer, roaming foxes, clever coyotes, elusive lynx, and soaring eagles and hawks dot the Loess Hills landscape.

As seen in winter's mantel of white, David West's *Loess Hills Snow* captures the real and romantic visions of the Loess Hills. While families live and farm in the hollows and make landscape changes, the distanced forest and prairie hilltops are relatively untouched by direct human intervention. Reflecting the modern facets of this place and its peoples, here the Hills also appear timeless, presided over by snow and sunlit trees.

Molded of soil and by water and wind, the Hills often afford twisty vistas. Genie Hudson Patrick's *High Road* weaves its way along the ridge-back of the gently sloping northern Loess Hills in Woodbury and Plymouth counties that are reminiscent of a high plateau. The visitor is struck not by steep slopes but instead by gently rolling, contour planted, raked land. In contrast, *Cedars by the Road* by John Page offers a glimpse of a wind-

in-your-face view of the twisty ridge-back road near Preparation Canyon State Park. The pesky cedars beside the road, their backs bent by the north wind, grow amid the prairie grasses. The road roars off into the blue horizon and the valley beyond.

In recent years the Loess Hills Scenic By-Ways map has made accessibility to the Loess Hills easier. The road systems follow the lay of the land and do not necessarily conform to the Jeffersonian grid system of intersecting roads every square mile. Consequently, people unfamiliar with the different areas of the Hills can become lost or confused. The advent of the Scenic By-Ways map and road markings has encouraged more and more motoring visitors and tour buses, resulting in the Hills fast becoming a destination for recreational exploration. Landscapes familiar to Loess Hills dwellers are now seen through new eyes and with renewed appreciation. Monona County residents all know the Turin star. William Barnes's *Cut* places the star on top of a well-known hill, nestled by the small village of Turin, and invites the viewer to become acquainted with the star, too. With a sense of calm, as if a person just passed through, the artist sculpts with his paintbrush a hilly landscape with the lonely, intersecting roadways often traversed by local inhabitants and seldom by visitors. Locals see the familiar landscape and roadway as a means to the next farm or field. Visitors see the same as a scenic overlook opportunity. Anne Burkholder's *Horizon 736—Loess Hills #2—Fall* also depicts the autumn landscape through the eyes of the motorist winding alongside a bending river, the road piercing recently picked cornfields. This landscape is not only perceived by humanity but inhabited—indeed completely domesticated—by us. The riverside trees and roadside grasses are seemingly misplaced in the ordered and cultivated landscape.

In the United States federal and state parks preserve our natural and cultural heritage. There are federal parks for mountains,

seashores, forests, and canyons, but there is not one national park devoted to preserving any of the Midwest's Great Plains prairies. It is therefore significant that in 1986 the federal government declared 10,000 acres of the Loess Hills in Harrison and Monona counties a National Natural Landmark. Some of these lands are held in the public trust within the state of Iowa's domain, while other lands remain privately owned. In addition, over fifty parks and recreational areas exist in the Loess Hills. These state and county public lands preserve forests and prairie lands for the future and include the Loess Hills Pioneer State Forest, Preparation Canyon State Park, Wabash Trace Nature Trail, Waubonsie State Park, Stone State Park, and the Sioux City Prairie. *Enchanted Hills* by Douglas Eckheart is a panoramic vista over the Loess Hills Pioneer State Forest. This overlook is popular with locals and has become known as "the spot." Leading into the distant forests, a worn footpath guides people through the ridge-top prairie, farther away from civilization and deeper into our nature-bound past. Once we step into the forests, Concetta Morales's *Cedars and Long Trees* presents a spinelike treed landscape structured with a rib cage, encompassed by round, fleshy shapes of land. This winter landscape lures the viewer into the forest for discovery and pleasure amidst the vibrant, prismatic colors reflected off the snow.

Thousands of acres of public and private Loess Hills parks and recreational areas serve local residents and visitors. Public trust land is not taxed; thus a dilemma exists. The public lands bring related economic development opportunities to local communities and, more important, preserve the land for future generations. These lands do not, however, generate tax revenues that could assist local communities in providing public services such as schools, roads, or libraries.

Economic development opportunities, tourists, and encroaching industrialization are transforming some small town agricultural centers in the Loess Hills. To meet the need for lodging, food, fun, products, and services, new businesses are emerging and established businesses are often finding new financial growth. Jo Myers-Walker's *Jurassic Hills* offers viewers many layers of social, cultural, and environmental change in the Hills. The title itself speaks to the ancient past as well as to the current rediscovery of the Loess Hills and alludes to the popular revival of dinosaurs as reflected in the contemporary movie industry. The lively main street and its theater throngs echo established community theater groups in Missouri Valley, Woodbine, and other towns. Quiet towns are awakened by the ever-increasing line of tourists' cars winding their way into the Hills, along with the playful and booming air force jets from the Strategic Air Command military base in Omaha. Commercialization and franchises loom like dinosaurs at the edge of the Hills, ready to feed and fulfill the needs of the contemporary tourist and dweller. While this work of art celebrates the Loess Hills culture and its current economic expansion, it also inspires reflection upon the growing human usage and potential depletion of this natural resource.

Many contemporary Loess Hills families can trace their ancestry to the settlement era of the 1840s and 1850s. Others have arrived more recently. With the exception of Council Bluffs and Sioux City, which ballooned with the commercialization of the Missouri River, the towns in the Loess Hills are small, with populations in the hundreds, not thousands. Community pride runs high, and people usually pull together to care for and nurture one another and better their lot in life. Through portraiture, artists Richard Colburn and Drake Hokanson glimpse the lives of Loess Hills inhabitants. Colburn's *Helen Brownmiller at Jan's Creative Delights in Magnolia, Iowa* captures the shyly elfin expression of Helen as she makes crafts. Enclosed within her world, the things around her reflect her life. As the Hills evolve

and change, here, too, customs have evolved and accumulated as the viewer sees expressions of past holiday seasons. The pet and its fence, however, give warning that not all things are to be trusted and greeted with as much warmth as Helen gives to her guests. *Tom and Shirley Bruegger, Mapleton, Iowa* by Hokanson epitomizes rural life. This image has currency. Here the home place retains its ideal as a repository of traditional beliefs and life-styles—a holding on to rural values put under threat of the dominant city culture found outside the Loess Hills. As county conservation agent, Tom Bruegger is also one of the many residents who has helped raise public awareness and promoted preservation of the Loess Hills.

Randy Becker's *Crows over the Catsteps* also speaks of humanity's attempted dominance over the land. While birds dance in the sky over the stepped hills, high-power lines dissect heaven and earth. Throughout the Hills, formations known as catsteps are created by soil slipping repeatedly and slumping downslope, resulting in small shelves covered by vegetation. Donald Wishart created a nine-minute video titled *A Place Apart: Loess Hills* in which he photographed hundreds of images of the flora and fauna of the area. The image presented in this book captures the steep slopes with gently folded catsteps leading up and down the hillside as if for use by humans and animals as they traverse the topography. The line of spring green trees growing between the hills forecasts the new ecology and landscape created by forestation of the prairie.

Not unlike Catlin's romantic view of the picturesque and sublime landscape, contemporary participants may still look at the Loess Hills through rose-colored glasses. Dan Howard's *Loess Hills Testament (Eleven for the Road)* offers us a moving picture of the Hills and sky. A sloping hill intersecting the valley, a road with telephone poles, and a clouded blue-white sky all dynamically pull the viewer deep into the picture. The right panel of Gary Bowling's *Screens and Draws Diptych*, however, avoids a focused perspective lead into the pictorial space in favor of an open front view across the field and tree hedge, with each layer of grass giving way to land rolling into the shadows and trees, which in turn give way to golden meadows and then rise to the sky plain. In this fashion the viewer is seduced to contemplate the landscape rather than enter into the space via an imaginary walk. In the left panel the viewer is swept into the landscape by the brook, to linger within the valley. Both Howard's and Bowling's paintings capture an intensity of light and color, each evoking the effect of light in part by heightening the colors and coordinating color relationships into clear sequences of contrasts throughout the painting. The sense of atmospheric vapors and the visual richness of these places evoke beauty and rural simplicity. These places represent the antithesis of the complexities and uncertainties of this country's dominant urban culture, merely glimpsed in Iowa's cities but experienced daily in the print and broadcast media. These works of art are pictures as representations—images which themselves generate beliefs and opinions and orchestrate discussions about the Loess Hills of today and tomorrow.

Our own images of the Loess Hills landscape and peoples do not necessarily reflect reality but rather are visions created firmly within our traditional notions and fantasies about the rural and romantic. These visions are often idealized, unspecified perceptions of rural life as we might hope to live it or as we think it now exists. What can be a tough place to make a living can also be a wonderful place to live and raise a family, avoiding the paradigms of larger city life.

Today's idealized, romanticized visions of humanity place it within nature rather than separating it from nature as was done in the past. When people serve predominantly human needs, they try to dominate nature and forcefully tame it into submis-

sion. As we collectively revisit and reevaluate our multiple relationships with the natural world, these relationships will be constantly redefined to reflect our particular time and place. Artist Gina Crandell's *Study for Preparation Canyon* will be transformed into a public work of art sited to be installed so that it is located in both the Loess Hills State Forest and Preparation Canyon State Park. Fabricated with the help of Loess Hills residents, this work will provide insight into and build expectations of the diverse Loess Hills landscapes of the future. Incorporating both the aboriginal landscape and the altered countryside of today, the completed project will allow visitors to experience visually and experientially the contemporary Loess Hills.

When we see and think of the works of art in *Land of the Fragile Giants*, we each form a personal philosophy of the vast panoramic views of the Loess Hills as they change today with the seasons, weather, land preservation efforts, farming, wildlife renewal projects, and impacts of residents and visitors. The works of art in *Land of the Fragile Giants* have emerged from the tension between the needs of the landscape and those of people. Those needs in turn funnel into the environmental issues gripping the area. These evocative works of art ask us what legacies we are leaving to be nurtured and uncovered by those who follow. As humans, where do we fit in nature's continuum in the Loess Hills? In this century the songs of the poet and the grandeur of the artist have often been overshadowed by the precision of the scientist. In the next century, scientific discovery and artistic exploration may unite to feed both the human soul and intellect, forming in the process a balanced environment for our living planet.

MARKINGS ON THE LAND

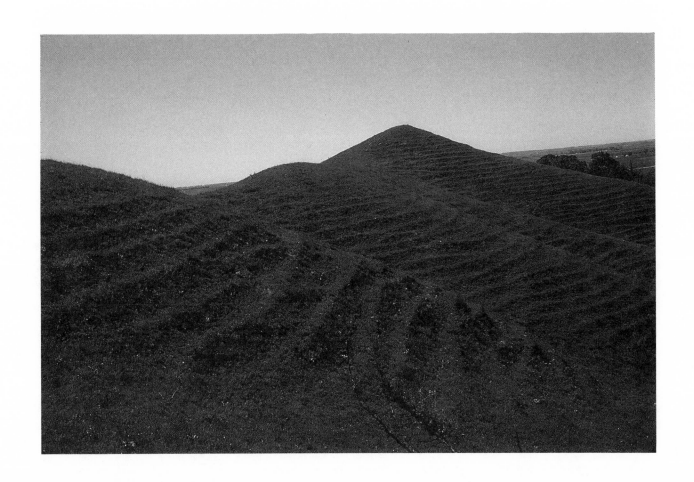

Start with their shape: that uniquely jagged flow of steep-sided, interconnected ridge lines and bluffs, snaking torturously from Sioux City 200 miles southward into Missouri along Iowa's western border, yet extending eastward only 10 miles or less. This stark landform, mysteriously comprised of some of the smallest of the earth's building blocks—wind-lifted grains of quartz silt piled in places over a hundred feet high—juts abruptly upward from the edge of the Missouri River floodplain, a rough-textured wildland cast across Iowa's neatly trimmed agricultural fields. On the steepest bluffs, the eye meets prickly yuccas, dry-scaled lizards, and other drought-resistant plants and animals much more typical of drier lands to the west than of Iowa. Too rugged for cultivation, the Loess Hills and their unusual organisms have survived to imprint both body and spirit, to become landmark, to bond us to place. The first two essays give us a guided tour of the Loess Hills as landmark and landform, of their formation and geological features, of the forces that constantly reshape the Hills, of the way the Hills in turn may reshape us.

Mary Swander spent her early childhood in Manning, Iowa, where the landscape of the state became part of her psyche. Frequent trips through the Loess Hills attuned her to the pleasures of changing topography, and in adulthood she became aware of the complexities of Iowa's natural history and the effect it has had on the character of the state's citizens. This sense of place, of both the land and its people, has served as a foundation for her many poems and essays published in national magazines, her three books of poetry, including *Driving the Body Back*, a book of interviews with midwestern gardeners, and her plays. An associate professor of English at Iowa State University, Mary divides her time between Ames, where she lives during the academic year, and an acreage near Kalona, Iowa, where she raises sheep, goats, and a large organic garden during the summer.

Jean Cutler Prior is known throughout Iowa as a research geologist who takes pleasure and pride in explaining her geological perceptions to the general public. Perhaps this is most evident in her book *Landforms of Iowa*. She was initiated to the Hills in 1970 when compiling information for the first edition of that book and has been a regular visitor since then, returning frequently to present interpretive programs and renew acquaintances with Loess Hills places and people that hold a special place in her heart. Since coming to Iowa from studies at Purdue and the University of Illinois, Jean's geological interpretations have been sought by Iowa Public Television, the State Preserves Board, the Iowa Humanities Board, the Nature Conservancy, county conservation boards, and other groups, as well as by her employer, the Iowa Department of Natural Resource's Geological Survey Bureau in Iowa City.

Aerial View

MARY SWANDER

I sat in the backseat of my father's Cessna 180, my eight-year-old body squished between those of my mother and brother. The roar of the engine filled the small plane, the blades of the propeller whirling and blurring, my father in the front seat at the controls, a headset on his ears. My brother, always motion sick, was purple and pale, his face the shade of a turnip. My mother, always afraid of flying, measured off the distance by the decades of the rosary that passed through her fingers. Her lips moving silently, the tiny beads pressed against her thumb, we glided through the glorious mysteries, flying toward our home in Manning, Iowa, over the Missouri River valley and the majestic Loess Hills.

"There's the river just ahead," my father shouted over the engine's din, pointing toward the ground where the Missouri formed the Nebraska-Iowa border, winding and snaking, cutting its dividing line between the two states. It was spring, the river distended, pushing at its banks, coming dangerously close to spilling out onto the alluvial plain that stretched—flat, wide, and greening—on either side of the water. We were coming back from a family vacation during the post–World War II days when fuel was cheap and many returning veterans like my father tried to put their newly acquired flying interests and skills to use in civilian life.

"And there are the Hills." My father tipped the plane's wing so we could get an even better view of the topography below.

"The Hills," my mother chanted, kissing the crucifix dangling from her beads.

"The Hills," my brother repeated, fishing in the seat pocket for an air bag.

"The Hills," I thought to myself and realized we were almost home. For once we hit the Loess Hills, those swellings that rose up out of the land like crinkled pieces of pie crust, I knew we had only fifteen minutes more before our wheels hit Manning's grassy airstrip.

On land, when we drove away from Manning, we looked for the water tower on our return trip. We played the who-can-spot-the-water-tower-first game, our old Studebaker dipping down Highway 141 through the undulating valleys near Denison, then churning eastward where the road begins to flatten, the last remnants of Loess Hills silt smoothing into the more typically rounded landscape. But in the air where water towers become mere flecks, the Hills themselves became our landmark, a sign that gave us our bearings. A geological formation that in itself is rare, the Loess Hills became our signal of normalcy. Once we'd flown over them, we returned to safety and familiarity. Flaps down, our adventure and vacation ended, we landed on a bittersweet runway.

Of course, in the 1950s, neither I nor any member of my family had any real consciousness of the specialness of our landmark. We had lived at their eastern edge most of our lives. We flew over them, we drove through them when we went to Omaha or Sioux City, our two closest cities. We thought they were "pretty" but knew it got harder to carve out a farm-living the deeper in them one settled. Instead, we stayed on their bor-

der and used them as our beacon. They marked not only a return to our native landscape but a return to ourselves, to the dailiness of mowing the lawn, of filling the dog's bowl with water.

"There are the Hills," I remember my father saying on so many flights home.

And there will be my own bed, I thought, my old pair of jeans, my best friend to play with across the street.

Now, more than thirty years later, I've learned that the Hills are a unique treasure, that this landscape contains features seldom duplicated in other parts of the planet. Loess, a fine-grained quartz silt, is a common windblown deposit along river valleys throughout the world. Major deposits grace the Rhine valley in Germany and the Yellow River in China. But it is only in Iowa that the loess is deep and extensive enough to create new landforms—landforms supporting an ecosystem vastly different from any other in the state. Undisturbed prairies in the Hills remain home to some endangered species and other populations more typical of the hot, dry areas farther west in the United States. A hike through the Hills might find you stepping around the tough, cactuslike stems of the yucca plant or sensing the stirrings of a plains pocket mouse, a relative of the kangaroo rat of the southwestern deserts, deep down within its burrow.

From above, the Hills are gentle mounds rising up off the plains. They are not mountains poking up out of the earth, coming to sharp, rocky summits towering above. Nor do the Hills grab your attention with their sudden boldness, dwarfing you in comparison. Instead, the Loess Hills are more subtle, seemingly an extension of your own psyche. Slowly, before you are even cognizant of being in a different space, the Hills are upon you, persuading you to attune your eye to a different roll of the land, a different sense of the horizon. Some of the Hills come to sharp crests and ridges barren of much woody vegeta-

tion. Others that have been populated by invading forests appear smooth and cushy.

Far below the landscape, hidden fossils hold secrets of past landscapes, climates, and animal populations deep within their beds. Invertebrate brachiopods, crinoids, cephalopods, corals, and bryozoans, plus larger vertebrates, including sharks and joint-necked armored fish, paint a Devonian seascape. Remnants of the plains pocket gopher, the meadow vole, the prairie vole, and the ground squirrel indicate that about 23,000 years ago, during the cold of the Wisconsinan glaciation, the Loess Hills were grasslands, probably moist meadows with some trees.

But the fossils of the megafauna that roamed the Hills for hundreds of thousands of years are perhaps the most spectacular ancient artifacts. Our imaginations take a real leap when we visualize herds of woolly elephants grazing Great Plains grasslands or an ox-sized ground sloth reaching up to strip leaves from a tree for a meal. Bones of three-toed horses, mammoths and mastodons, dire wolves, musk-oxen, and beavers as large as bears all create a picture of a land of splendor.

Most Iowans grow up brainwashed to accept the regional bias that we live on flat, boring land, without natural landmarks. Our eyes are trained to scan the horizon for the "big" shifts in our environment, the major topographical changes. In the absence of mountains, oceans, or many large lakes, we look to human-made structures like water towers for our bearings. Our more subtle landscape and people are devalued by others, so we devalue ourselves. We live in a wasteland, we're told, so we must be "hollow men." Then we, as hollow men or women, hang our heads in shame, no longer looking up from our straw piles to notice the symmetry of the shocks themselves, the magnificence of the sky opening above them, the slant of the August light breaking through the cloud cover.

We no longer understand that a gentle roll of the land, a quiet

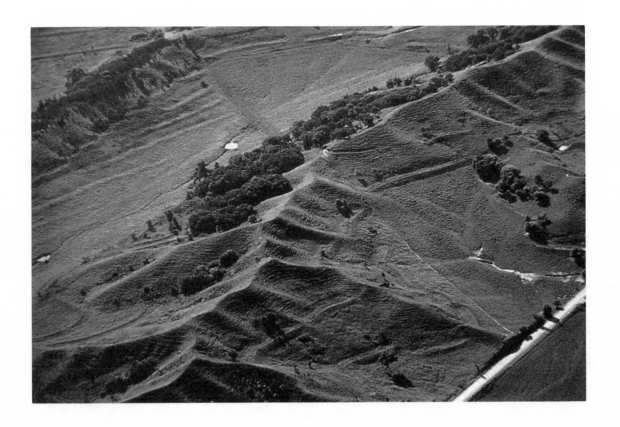

rising and falling of the soil under our feet could become our landmark. We lose touch with the thought that the earth underneath those piles of straw is just as valuable as the shocks themselves and that we are intricately connected to this good earth and must preserve that harmony. Only within the last few decades have we begun to develop, as a popular mass, an awareness of the beauty, wonder, and fragility of our state's geology. Now is an opportune time to nurture that awareness, allowing it to take on an importance that binds us together.

Leslie Silko, a Native American writer who grew up in the Laguna Pueblo Reservation in New Mexico, tells of the respect that her people place upon the landscape. Every rock, every bend in the road evokes a story, myth, or legend that may go back as many as a thousand years. Through the physicality of the land, her people are brought closer into community. They remember and retell tales of the trickster, an ancient mythological figure from their oral history tradition, who changed himself into this rock or that canyon. And because the dry climate of the desert preserves things, any change in the landscape—a rock chipped by a car falling into that canyon—has the potential of lasting for hundreds of years. That chip, that wrecked car, then, necessarily becomes part of the Laguna folklore. Their landmarks have a permanence that cements their culture in the mutable world surrounding them.

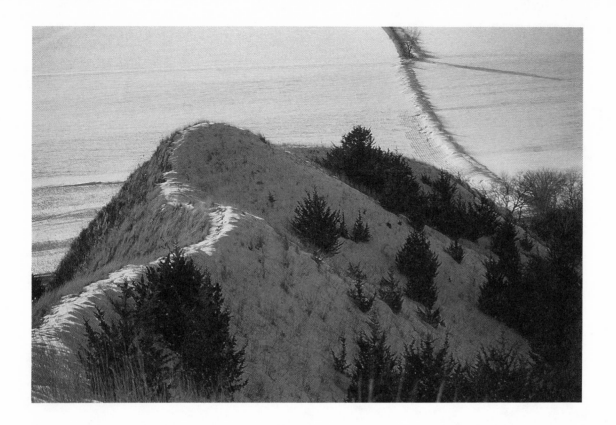

"How did that chip in the rock come to be?" the Laguna children ask.

A parent might answer, "I remember the time that a man from the east parked his car next to the gas station and went in to buy a bottle of beer. He left the engine running, and when he came out, the car was down in the bottom of the canyon."

"Did the trickster do it?" the children say.

"I don't know. Did the trickster do it?" the storyteller replies.

Even if we don't live in the desert, most Americans look toward natural landmarks as places of long-term permanence. We expect one more modern water tower to replace another but count on mountains and hills to remain stable. In contrast to New Mexico, the Iowa landscape is always changing, and at a relatively fast rate in geological terms. Again, we are told by those who drive down Interstate 80 that everything is static and "looks the same." But because ours is a moist climate, we are constantly in flux, constantly experiencing not preservation but deterioration. Things break down into the soil, and the wind blows the soil up and back down. We, perhaps more than those of most other regions, have a chance to grasp the real impermanence of natural landmarks and so, at once, the transiencies and preciousness of the whole of nature.

Again this summer I was up in the air in a small plane above Iowa, this time to survey the Great Flood of 1993. Iowa's riv-

ers—the Missouri and Mississippi on the west and east ends, the Nishnabotna, Des Moines, and Iowa, for example, in the interior—had pushed so far out of their banks that it was hard to remember where their banks were supposed to be. Cornfields that had been drained by tiles for years returned to sloughs. Quarries that had once been tempting but off-limits teenage swimming holes became lapping, lulling lakes.

But in the Loess Hills, where the powdery soil is highly erodible, the change was most obvious. Creeks and streams that had been straightened in the early part of the century to make way for more farmland became raging rivers trying to fight their way back to their original paths, taking chunks of land with them as they carved new channels. Major new gorges opened, collapsing bridges. Suddenly, new gullies emerged in pastures and fields.

How do we digest these changes? How do we integrate our quickly evolving landscape into our lives? Once we've acknowledged our landmarks, how do we incorporate their impermanence into our culture? Unlike the Laguna, most of us do not have thousands of years of history attached to the land. At most, we might have a 150-to-200-year past involvement. We, too, have a storytelling tradition, so a site near Sioux City might remind us of the Lewis and Clark Expedition, or a widening Loess Hills gully might call up a childhood exploration or the tale of an outlaw "hiding out" on that very spot during the 1920s. But, for the most part in our agrarian society, if we take note of change at all, we immediately connect it not with further mythmaking but with economics. Eroding soil means eroding income. The value of our geological landforms is deposited in our change purses rather than in the larger bag of our collective consciousness.

Let's take the aerial view for a moment, pull back the camera, and consider the Loess Hills as a landmark—not simply a place to make a living but a living place. First, we must remind ourselves of the notability of the Hills and become more surefooted in our efforts to preserve their ecology. Our pioneer ancestors plowed and grazed the prairies, straightened the rivers, built homesteads and roads in the Hills according to the preordained Jeffersonian grid, all without much thought of the fragility of the land. We can no longer be so casual. The 1993 summer rains brought that point "to the surface." In our ecological system, once one bead is lost, the whole string will unravel. A tiny creek overflows, a bank erodes, and a natural habitat for small mammals and birds is lost.

Next, when we better understand and respect the evolving nature of the Hills, we must better understand and respect ourselves. By coming to grips with the Hills, we are forced to think of ourselves in a changing landscape, in a changing planet and universe. Our vision widens. We have a rare opportunity to grasp the big picture. Our own lives may seem flat and small, but we can sense that they are part of a larger dynamic pattern that bonds us all. We sense a bigger structure, a higher power.

At eight, I looked down at the Loess Hills. They became part of my own personal mythmaking, symbolizing the end of a journey home. Now they symbolize a beginning. What I've come to appreciate about their uniqueness has made me, too, feel special, proud to have grown up where I did, proud to still be living in the same region. Their fragility has made me more aware of the tenuous balance of life and death on our planet. The troubles of my own life, the fears of inevitably facing my own death seem to diminish when I think of the Loess Hills as a string of beads that is an intricate part of the larger cosmos. Our true spiritual awakening will occur when we gather up the whole rosary and keep all the glorious mysteries in our minds at once.

Ice, Wind, and Water: A Geological Portrait of the Hills

JEAN C. PRIOR

My first encounter with loess, as least as a geologic deposit, was along the Wabash River valley when I was a college student in west-central Indiana. My geology professors explained that loess, a German word meaning "loose," refers to windblown silt and is a common geologic deposit across much of the Midwest and in many other parts of the world. Loess thickened geographically as a deposit and personally as part of my career and life when I later moved to Iowa and took a job with the Iowa Geological Survey. I found that in western Iowa, loess had accumulated in uncommon thicknesses. The result was a landscape dominated by unique shapes which were sculpted by erosion from the unusually thick, wind-deposited silt.

Now this deposit dominates a weekend of my life each year in late May or early June, during the Loess Hills Prairie Seminar held annually in the heart of the deep loess country of Monona County. This remarkable gathering of young and old, farmers, families, teachers, homemakers, naturalists, and physicians is a continuing tribute to the vision of Carolyn Benne of the Western Hills Area Education Agency in Sioux City. Her too-short life was tuned to the natural symphony of these Hills. My public interpretations of the Loess Hills began at her invitation. During one memorable weekend in 1978, I worked to keep up with the cloud of dust behind her Volkswagen Beetle as she sped through Cherokee, Plymouth, Woodbury, Monona, and Harrison counties, presenting programs she had arranged and visiting people and places I would come to know well in the years ahead. Today I lead others through the Loess Hills.

A caravan of cars is parked in the sun outside the small, white town hall at Turin. Inside, dark green shades are pulled over the windows, and visitors from the seminar, clad in casual field clothes, are arranged on rows of metal folding chairs or have folded themselves into a space on the wooden floor. In the darkened interior, with a quietly whirring ceiling fan to stir the warm air, a Kodak carousel and I work together to illuminate images of the Loess Hills for those crowded inside, to help them better understand the geological origins of the striking landscapes just beyond the door. One by one the slides drop into the beam of light, and the images on the screen begin to focus my geological perspective on the land.

The first slide. A colorful map of Iowa shows the state divided into different landform regions and emphasizes what many Iowans and visitors to our state fail to realize—that Iowa is a wonderful collection of remarkably diverse landscapes. The Loess Hills, one of seven major topographic provinces, string along the western Iowa border in a narrow band from north of Sioux City southward into Missouri. When approached from the west, their steeply ridged bluffs rise as abruptly as a range of mountains. From the east, however, there is a gradual sharpening of the rolling terrain until, just a few miles short of the Missouri River valley, the relaxed slopes pull themselves to full attention in ranks of steeply pitched hills.

Next slide. A color-infrared image taken in the spring from 40,000 feet above the Hills brings a few murmurs, pointed fingers, and head-to-head consultations. Photographs taken from the air show the Hills from a vantage point that really highlights their unique topographic expression. A corrugated segment of ribbed hills with alternating ridges and ravines stands in sharp contrast to the flat-lying, rectangular, cultivated fields of the adjoining Missouri River floodplain. The scrambled pattern of crooked roads and irregular fields within the Hills demonstrates the effects of steep slopes and high relief. From this altitude, the intricately carved appearance of the Hills emphasizes the dense network of drainageways cutting into the landscape. The Missouri River valley floor, on the other hand, has been neatly manicured into geometric patterns of cropped fields. Long, narrow, parallel embankments confine the channel of the Little Sioux River, which shares this enormous valley. I always enjoy pointing out the subtle shadows that wind through these fields, marking the former meanders of the Little Sioux. Slight differences in soil texture and moisture still can be clearly seen from the air, revealing the true character of the river, even though its channel has been straightened and its former bed veneered with tilled and fenced fields. This aerial view helps me emphasize how tenuous our human hold on the land really is and allows me to explain clues in the landscape that reveal the deeper, more durable geologic processes that affect land—and on occasion reclaim it.

In the next sequence of slides, lower altitude aerial photographs provide a closer, more detailed look at hill shapes and features. Each narrow ridge line is a series of rising and falling peaks and saddles. Every long crooked ridge crest is forked with numerous shorter branching sidespurs. Many of the steeper slopes are horizontally scored with dozens of tiny treads called catsteps. Near their base, the hillsides fall away into more gently inclined aprons of eroded silt. Occasionally the valleys are deeply sliced by narrow, steep-sided, often tree-lined gullies—a characteristic feature of the fragile, easily eroded loess.

Vegetation accentuates these shapes. Trees and shrubs often cover the leeward backslopes that face east and north, growing right up to the ridge crest where native prairie grasses take over the hotter, drier, more exposed west- and south-facing slopes. Variations in slope angle, exposure, and soil moisture provide special niches for plant and animal communities that are as interesting to biologists as the Hills themselves are to geologists. In fact, this combination of landforms and habitats merited recognition by the U.S. Department of Interior, and in 1986 more than 10,000 acres of the Loess Hills in Monona and Harrison counties were designated as a National Natural Landmark.

The slide tray clicks forward and returns us to more familiar earth-bound views of the Hills, including some slides taken along back roads where the loess is well exposed in road cuts that resemble small canyons because of their nearly vertical sides. The gritty, uniformly textured loess is typically tan to gray in color and is composed of closely packed grains of lightweight quartz silt. Road cuts frequently display a distinct orientation of upright columns and channels forming slabs that separate and slump along deep vertical fractures through the loess. Loess will stand indefinitely in these sheer faces as long as it remains dry. Exposed faces can become fluted by scouring wind and etched into arcs by swaying exposed tree roots. But a soaking rain or a rising water table can quickly change the loess's consistency to something like toothpaste. Then, unable to hold together or bear its own weight, the loess collapses easily, sometimes in serious landslides. This instability and susceptibility to erosion cause engineering and land-use problems throughout the Loess

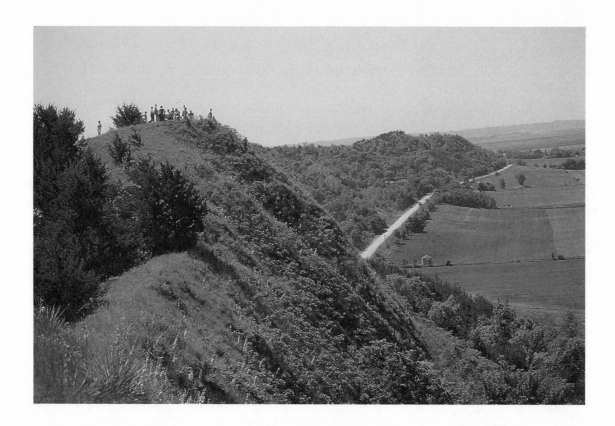

Hills. However, in the larger scale of things, these traits are part of a dynamic, rapidly evolving landscape that has been undergoing similar episodes of erosion and deposition for thousands of years.

Next slide. Another map appears on the screen showing most of the upper Midwest and Great Lakes area. Overlapping shades of greens and grays outline the limits of major glacial advances into the midcontinent. I am reminded of my recent travels by car to Ohio and northern Minnesota. During each trip back to Iowa, I became aware of the dwindling presence of trees and the expanding presence of the midcontinent's glaciated plains.

Without trees to break the view, I could see the glacier-shaped rise and fall of the surrounding countryside and even translate some of the topographic variations into specific events of Ice Age history. I could picture the hummocky hills emerging from the decaying margins of a stagnant ice sheet, the chaotic release of dirt and stones that accompanied glacial melting, the churning torrents of meltwater carving new valleys or retrofitting old ones, and the relentless movement of airborne silt, blown from exposed valley floors during seasonal lulls in the meltwater floods.

The map on the screen shows that Iowa is located along the

southwestern margins of all this midcontinental glacial traffic, which hit a rush-hour peak between 30,000 and 12,000 years ago. Iowa's land also is positioned between two of the continent's most heavily used routes of glacial meltwater flow, the Missouri and Mississippi Rivers, and Iowa itself is drained by numerous streams that once channeled water away from ice fronts—it is little wonder that so much of the state's land today is mantled with the windblown grit from these glacial and hydraulic grindings.

Click, next slide. An artist's sketch of the Missouri River valley appears on the screen, a view as it might have looked during the fall or winter any time between 30,000 and 12,000 years ago. The broad floodplain was then a maze of braided river channels, diverging and rejoining around islands of dried flood deposits. The sky filled with rising, swirling columns and plumes of dust winnowed from the barren valley floor by strong winds which trailed to the east across the valley margins. There, air currents were deflected, and large amounts of the dusty load were dropped. Through thousands of seasons, the rate of loess deposition varied. Sometimes it was intense, sometimes slow enough for soils to begin to develop and darken the deposit with organic material. But always, the greatest accumulation was closest to the valley source. Where loess reached thicknesses of sixty to one hundred feet or more, it buried the preexisting land surface and became the dominant element shaping the terrain.

Next in view is a photo of the modern Missouri River, and I emphasize again the vital role this valley has played in the geologic history of the Loess Hills. I point out that, while the river today seems puny compared to the broad expanse of its floodplain, the floodplain's great width is a clear indication of its excavation by glacial meltwater floods that coursed here thousands of years ago. More than a hundred feet of meltwater-

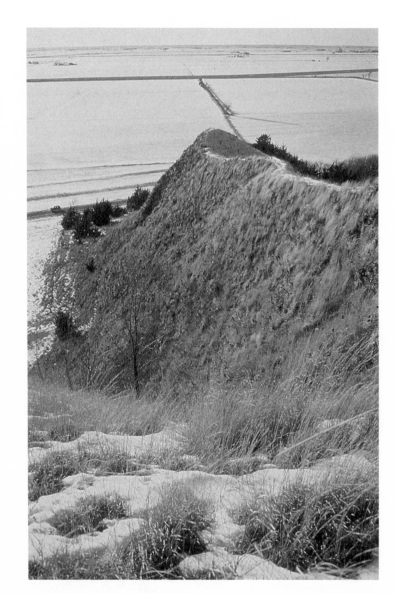

sorted sands and gravels lie in storage beneath the valley floor. The Missouri is thus responsible not only for contributing the silt that formed the adjacent Hills but also for shaping the great valley width and the sweeping curves along the valley's edge.

As a geologist, the work of floodwaters is never far from my mind. Rivers are today's legacy of the glaciers that came before them. Their flow is the most significant geologic process shaping Iowa's landscape today. I am often reminded of a phrase from my Ohio childhood that was part of our family vernacular, "Oh, see the muddy gush!" This was usually blurted out with glee while riding in the car and viewing a roadside gutter or field awash after a heavy rainstorm. In 1993 Iowa experienced rainfall and flooding of historic proportions. The rivers accomplished a lot that year. The color of chocolate milk and as impressive as any "muddy gush" of my youth, they carried lots of loess away from the Iowa landscape, where it had lain since the last glacier had Iowa in its sights. During that summer of floods, the rivers returned the silt once again to the great floodplains from which it had come.

Click, click. The next few slides point out what several people in this group have already noticed—there is more than loess in these Hills. Outcrops of limestone containing 100-million-year-old fossil clams can be found. Sand and gravel deposits behind this very town hall bear fossils of Ice Age vertebrates: an artist's drawing showing a mammoth, mastodon, giant beaver, ground sloth, musk-ox, caribou, and horse flashes onto the screen. The next slide shows an outcrop of glacial-age material that includes a fifteen-inch layer of light gray volcanic ash—another airborne deposit that arrived about 600,000 years ago from eruptions of now-extinct volcanoes in what is today's Yellowstone National Park in Wyoming.

Next slide. A somber-looking, bearded man in Civil War–era clothing gazes from the screen. Orestes St. John was a predeces-sor of mine at the Iowa Geological Survey. In 1868 he sketched some views of the Hills, and in 1978 another artist, Carolyn Milligan, and I revisited his sites to record them with pencil and camera. It is interesting to compare our views to his. The basic elements of the landscape are intact—the bluffs, the floodplain, and the river. But timber is gone from the floodplain and replaces the prairie on the bluffs, and the nineteenth-century pastoral setting has become an urban scene, complete with a sewage treatment plant, interstate highways, and electric transmission lines. The striking changes are thought-provoking. Human progress has come at a cost to the natural communities and habitats of this landscape. Those that remain provide an enduring link to our past and will be a valuable asset in the years ahead. The future will unfold within this same setting of river, floodplain, and bluffs that hold the timeworn fossils and relics of prehistoric inhabitants. That future will be more harmonious for those who follow if the geologic deposits and the processes, resources, and habitats that accompany them are considered in shaping decisions about the land.

My program closes with familiar scenes of the Loess Hills Seminar weekend—a woman writing in her journal while seated on the ground outside her tent, a field class on foot scattered across a steep prairie-covered slope. I remind my audience that their participation in this seminar is part of the history of Iowa's Loess Hills. Then chairs scuffle, people stretch, conversations begin, and the town hall's door is opened. Small groups emerge once again into the brightness, this time taking in the broad sweep of the Missouri and Maple River floodplains that join just south of Turin, the sand-and-gravel pit in the town hall's backyard that yields fossils of Ice Age mammals, and the bluff of wind-deposited silt looming above. Careful to lock the door behind us, and grateful to the citizens of Turin for their shelter and electricity, we return to our cars and head north-

ward, following the gravel road along the base of the bluffs to the Turin Loess Hills State Preserve. In the small parking lot, we talk for a few minutes about Iowa's state preserves system and the importance of setting aside examples of Iowa's natural and cultural history. Then we start walking. The trail into the preserve follows along level ground at first and then turns abruptly uphill to the north. We begin the steep climb to take in the panoramic view that unfolds from the summit—the majestic breadth of the Missouri valley and the windswept cresting hills that border the valley margin. The scenery and its geologic explanation merge into meaning.

EARLY PEOPLES OF THE HILLS

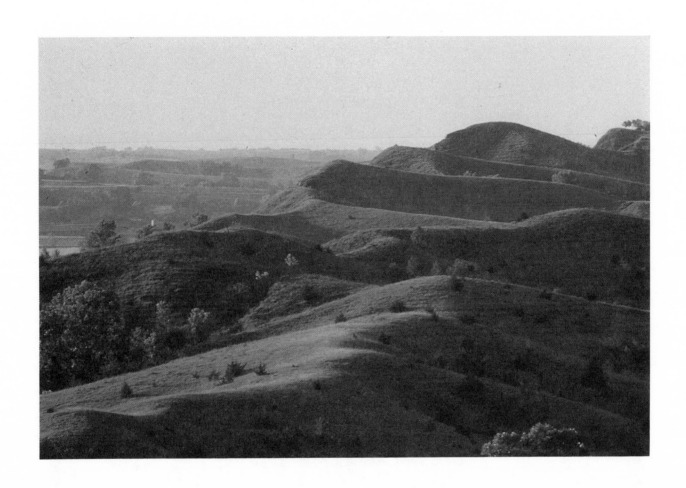

The first humans and the prairies arrived in the Hills at approximately the same time, and they matured here together, culturally and physically responding to the evolving landscape. By this time the glaciers had retreated far northward, major deposition of loess had ceased, and water had replaced wind as the major force shaping Loess Hills topography. Washing sheets of wind-lifted particles downslope, the water buried and thus preserved remains left by the early human inhabitants, even while it carved the bluffs into ever more delicate and dissected shapes. And then water acted in a different way, cyclically cutting gullies downward into the valley bottoms, unearthing remains of the now-extinct cultures and organisms that had previously inhabited the Hills. The following two essays outline the cultures of these prehistoric Loess Hills humans and examine the significance of the gully-slashed valleys that both sheltered certain Native Americans and preserved their remains.

As a child growing up in Lincoln, Nebraska, David Mayer Gradwohl traveled frequently along both sides of the Missouri River and through the Loess Hills and developed an interest in the prehistory and early history of the Native Americans in that region. He graduated from the University of Nebraska with majors in anthropology and geology, then completed his doctoral degree in anthropology at Harvard University, where his dissertation involved a study of thirteenth-century American Indian villages along the loess bluffs. "My desire to live close to my research interests in the prairies and plains was happily accommodated when I joined the Iowa State University faculty in 1962," David states. There, he was a professor of anthropology until his retirement in 1994 and for a number of years chaired the American Indian Studies Program.

E. Arthur Bettis III grew up in Sioux City, Iowa, where as a youth he had ample opportunity to explore the Hills and become familiar with their natural features, in particular their deeply carved gullies. Leaving home to obtain undergraduate and graduate degrees in anthropology and agronomy at Iowa State University, he was drawn back to the haunts of his youth through examining gullies, in the process discovering that these were formed cyclically as predictable, natural events. He simultaneously investigated the leavings of prehistoric cultures that were unearthed when gullies cut through alluvial deposits of past millennia. Art continues these studies as a research geologist for the state's Department of Natural Resource's Geological Survey Bureau in Iowa City, where he also scrutinizes ancient ecosystems, soils, and geological features. Through his continuing work in the Hills, he blends the visceral pleasures of his youth with the intellectual passions of his profession.

Prehistoric Native Americans in the Hills

DAVID MAYER GRADWOHL

For thousands of years humans have lived along the loess bluffs and glacial drift hills bordering the Missouri River valley. Using stratigraphy, carbon-14 assays, and other techniques for establishing chronologies, archaeologists and geologists have demonstrated the presence of prehistoric Native Americans in this region at a time when the last of the major glaciers was melting and retreating to the north. The evidence consists primarily of stone spear points, knives, and scrapers which humans used to kill, skin, and butcher the animals they hunted. The skeletal remains of those animals have been identified by paleontologists, scientists who study ancient forms of life. At the end of the glacial episodes, American Indians were hunting mammoths, mastodons, and a now-extinct species of bison. When those large mammals died off, the hunters pursued modern forms of bison, elk, deer, and smaller animals.

As a child growing up in eastern Nebraska, I was generally aware of these facts. I was fascinated by antiquities and spent a good deal of time peering into the display cases at the University of Nebraska State Museum and the Nebraska State Historical Society Museum in Lincoln. I knew that Pawnee Indians had once inhabited Nebraska. Furthermore, I had seen Omaha, Ponca, and Winnebago Indians occasionally in Lincoln and had driven through their reservations in northeastern Nebraska en route to remote parts of Minnesota and Ontario to go fishing on family vacations. I wondered, Were the prehistoric Indians represented in museum display cases related to the Pawnee? To the Omaha, Ponca, or Winnebago? Indeed, what were their lives like? What did they eat? Whom did they marry? Who were their enemies? Did they believe in gods? My intrigue and these questions intensified during my freshman year in college when I had the opportunity to help excavate a prehistoric Indian earth lodge village along the Missouri River in South Dakota. That site is now covered by the waters impounded behind Fort Randall Dam. Today, more than forty years later—after majoring in anthropology and geology at the University of Nebraska and writing a doctoral dissertation at Harvard on the subject of prehistoric Indian villages—I still cannot answer most of those questions as specifically as I would like.

Part of the problem (and, yes, the enticement to continue pursuing those questions through the necessary field work and laboratory analysis) has to do with the nature of archaeological evidence and the fact that only a small part of human activities involves tools, utensils, buildings, and other things that anthropologists call material culture. What we as humans think, whom we marry, and the gods we worship are most often not expressed or preserved as a material residue which archaeologists can excavate hundreds or thousands of years after the fact. While we may know specifically what tools prehistoric people made, what animals and plants they ate, where they settled, and how they built their houses, we will probably never gather much definite information on their kinship and marriage patterns, political structures, or magic-religious belief systems. And while many material cultural patterns have existed on the prairies and plains for hundreds of years, we cannot link any of the

material residues found by archaeologists to specific tribes until the time of written documents and maps produced by European explorers, traders, and missionaries in the early eighteenth century. At that time, we know that speakers of the Chiwere Siouan language group (i.e., the Ioway and Oto) lived near Lake Okoboji and the other "Great Lakes" in northwestern Iowa and along the Upper Iowa River in the northeastern part of the state. There, in time and space, the Chiwere speakers can be linked to distinctive archaeological remains which archaeologists have labeled Oneota. But historical tribal connections with the earlier archaeological remains along the Missouri River valley are more difficult if not impossible to reconstruct.

The earliest human inhabitants of Iowa are referred to as Paleo-Indians or the Big Game Hunting Tradition. Archaeologists use the term *tradition* to indicate a cultural continuity which persists through time. People of the Big Game Hunting Tradition lived in Iowa from approximately 12,000 to 6000 B.C. In western Iowa, this period is represented by the lowest cultural zone at a dig in Cherokee County (the Cherokee Sewer Site) and by isolated spear points found on the ground surface of sites in Monona and Mills counties. Particularly distinctive of the Big Game Hunting Tradition are large, elongated, leaf-shaped projectile (spear) points. The large spears were probably thrown by use of an atlatl, a hand-held device which extends the reach of the arm and thus allows a more forceful launching of the spear.

As the glaciers retreated from the Missouri River valley region, the environment changed radically. Human hunting and subsistence patterns changed accordingly. Archaeologists refer to cultural remains from this time period—roughly 6000 to 500 B.C.—as the Archaic Tradition. In western Iowa, the Archaic Tradition is represented in the upper cultural zones of the Cherokee Sewer Site in addition to remains of a bison kill at the Simonsen Site near Quimby in Cherokee County. At the Turin Site in Monona County, construction workers excavating a gravel quarry accidentally discovered four human skeletons associated with the Archaic Tradition. The remains of those prehistoric Indians, incidentally, have been reburied according to Iowa's state code, which also prohibits the unauthorized removal of human burials. Projectile points of the Archaic Tradition are typically medium-sized and bear side notches for use in attaching the stone tips to wooden spear or arrow shafts. A point of this style was associated with the Turin burials.

Overlapping and following the Archaic inhabitation of this region was the Woodland Tradition, which continued until approximately A.D. 1000. The prehistoric people of this time period are often mistakenly referred to as the Lost Mound Builders. They, of course, were not lost. As a matter-of-fact, they were American Indians with some new and different cultural practices. Many of them did, indeed, build mounds in which to bury their dead. On the prairies and plains, burial mounds marked a new mortuary pattern. These Indians also built the effigy mounds in northeastern Iowa and settled westward throughout the state to the Missouri River and its tributaries. They were the region's first manufacturers of pottery. Woodland Tradition ceramics are relatively thick, are impressed with twisted cordage, have conoidal bases, and are decorated with punched and incised designs. In addition to hunting, fishing, and gathering, people of the Woodland Tradition also experimented in the domestication of plants.

In western Iowa, spreading into the Loess Hills between A.D. 900 and 1000, three distinct archaeological complexes replaced the Woodland Tradition. All of these groups subsisted in part on domesticated plants and lived in semipermanent village settlements, giving up for the most part the continuously shifting seasonal campsites of earlier cultures. The Great Oasis

Culture was named for a type site in southwestern Minnesota and extended into southeastern South Dakota and northeastern Nebraska. In Iowa it continued from the northwest down the Des Moines River to the middle of the state. Great Oasis pottery is globular in shape and is typically decorated with fine, parallel, incised lines around the upper rim. Projectile points of the Great Oasis Culture and most other post-Woodland complexes are small, triangular, and often side and/or basally notched for attachment to wooden arrow shafts. In northwestern Iowa, along the Big Sioux and Little Sioux Rivers, was the Mill Creek Culture, which was closely related to archaeological sites along the Missouri River in South Dakota. These people lived in long, rectangular, gabled, wooden structures. Their houses were grouped together in small-to-medium-sized villages which, in some locations, were surrounded by fortification banks, ditches, and palisades. These defense works are among the data used to infer intergroup warfare at that time. In that respect and in several other ways, the Mill Creek Culture differed from the third contemporaneous culture, the Nebraska Culture, whose people lived in settlements of earth lodges in southwestern Iowa and Nebraska.

One of the best-known prehistoric archaeological complexes along the loess bluffs and drift hills bordering the Missouri River was investigated early in this century. Based upon the excavation of distinctive architectural remains, it was initially called the rectangular earth lodge culture. During the 1920s, several publications designated it as the Nebraska Culture since most of the sites investigated up to that time were located west of the Missouri River. Today many of those sites have been destroyed by the urban sprawl of Omaha and its suburbs. East of the Missouri River, near Glenwood in Mills County, Iowa, archaeologists discovered similar earth lodge settlements along

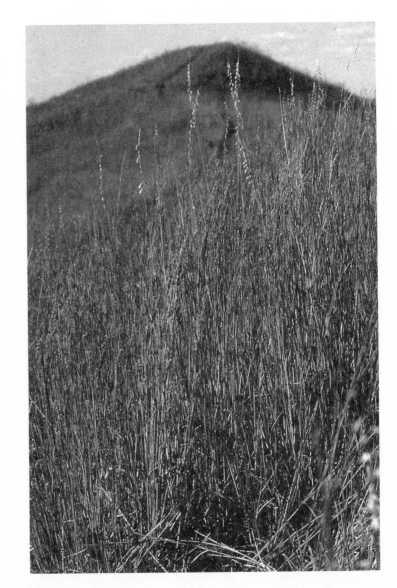

Pony Creek and Keg Creek. That geographic concentration led to the label Glenwood Culture for the settlements in southwestern Iowa. All of these earth lodge communities along the Missouri River and its tributaries are related to other complexes farther west, namely the Upper Republican Culture and Smoky Hill Culture in south-central Nebraska and north-central Kansas. Archaeologists group the Nebraska Culture (including Glenwood) with the two western complexes into the Central Plains Tradition, a cultural continuity which existed from approximately A.D. 1000 to 1400.

Having identified the biases of my childhood experiences and dissertation research at the beginning of this essay, I will now state that I think the Nebraska Culture represents the very quintessence of American Indians in the Loess Hills. Why? Not just because they lived in this region. As discussed previously, Native Americans inhabited the Loess Hills both before and after the people whose remains archaeologists call the Nebraska Culture. Rather, it is the nature of their houses and the relationship of these structures to the landforms and soil types diagnostic of the Loess Hills that make these people special. Either as apparent single dwellings or as more concentrated settlements representing hamlets or small villages, the Nebraska Culture earth lodges near Glenwood were typically situated on the ridge tops of loess hills or on loess bluffs or high terraces overlooking stream valleys. Furthermore, Nebraska Culture earth lodges were semi-subterranean; that is, their floors were excavated down into the soil, sometimes to a depth of several feet below the then-extant ground surface. The excavated soil was then placed over a wooden support system to form the aboveground walls and roofs of these structures, appropriately called earth lodges.

Archaeologists are able to infer such architectural details with reasonable certainty on the basis of the remains of collapsed earth lodge walls and roofs. Supplementing the archaeological data are ethnographic parallels or analogies with historically known American Indians who lived along the Missouri River in what is now South Dakota and North Dakota during the eighteenth and early nineteenth centuries. In floor plan, the Nebraska Culture earth lodges were square with rounded corners, typically measuring twenty to thirty-five feet on a side. Each earth lodge had a central fire pit, four large wooden posts which supported the central portion of the roof, closely spaced vertical wall posts, and an elongated entrance passageway which extended out to the east or south—away from the prevailing winds and toward the morning sunlight. Benches, storage platforms, drying racks, raised beds, and perhaps a wooden post mortar and pestle comprised the interior furnishings of the earth lodges. One can experience a good deal of the structure and ambience of these dwelling places by stepping inside the reconstructed Nebraska Culture earth lodge completed at Glenwood in 1992.

People of the Nebraska Culture subsisted on the products of horticulture as well as by hunting, fishing, and gathering. In their gardens along the fertile stream valleys below their villages they grew varieties of corn, beans, squash, sunflowers, and chenopodium (also known as lambsquarter or goosefoot). Animal bones excavated from trash heaps testify to the hunting of deer, elk, bison, rabbits, raccoons, muskrats, skunks, squirrels, and other small mammals in the surrounding prairies and woodlands. These animals provided not only meat but also skins for clothing and containers, tendons for sinew, and bones for the manufacture of tools and utensils. For example, gardening hoes were made from the scapulae or shoulder blades of bison and elk; skin-working awls, needles, fleshers, and beamers from long bones; fish hooks and arrow straighteners from split ribs. Wildfowl were also hunted and provided a source of food and feathers, which no doubt were utilized to decorate cloth-

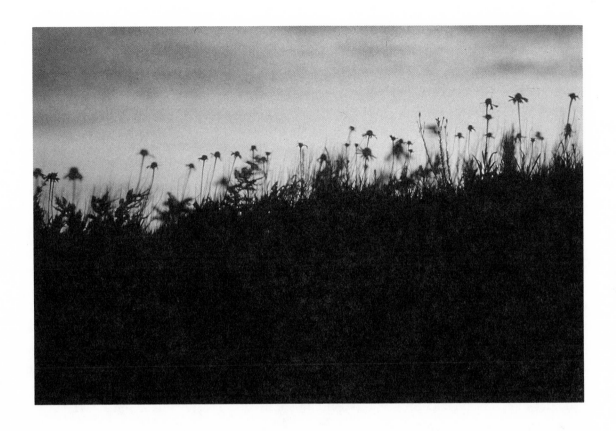

ing and ceremonial items as known from the region's historic tribes. Bird bones were often fashioned into flutes, whistles, and jewelry. Fish hooks, along with the bones of catfish and buffalo suckers, indicate that food was obtained from the nearby rivers and streams. Freshwater mussel shells also reflect that part of the regional subsistence base. Beyond that, these people collected available nuts, roots, seeds, and berries. They accumulated the abundant food resources as surpluses, which were stored in underground cache pits. These storage pits—analogous to the root cellars of the later Euro-American farmers—were located either inside the earth lodges or outside in the surrounding village area.

The Nebraska Culture people utilized a variety of stones to fashion arrow points, knives, and other tools for piercing, cutting, and scraping animal skins. Some chert or flint was available locally; other cherts appear to have been collected at more distant places, perhaps in association with bison-hunting activities. Sandstone from regional outcrops provided a source for manufacturing grinding stones, whetstones, and arrow shaft smoothers. Hammers, mauls, and chopping tools were made from granite and diorite cobbles brought into the area by glaciers.

The pottery jars and bowls found at Nebraska Culture sites are particularly distinctive. Vessels are typically globular in shape,

have outer surfaces which were either smoothed or roughened by impressions from a cord-wrapped paddle, and exhibit rims which are upturned and often thickened or S-shaped. Incised, finger-pinched, punctated, and tool-impressed motifs normally decorate the vessel rims. Loop handles and perforated tablike extensions also occur; these appendages probably facilitated the transport of the vessels as well as their suspension over fires for cooking. Most of the ceramics were tempered with sand or crushed granite. Some of the ceramics, however, were tempered with crushed mussel shells, suggesting trade or other contacts with contemporaneous American Indians farther down the Missouri River or to the east in the central Des Moines River valley, where Oneota Tradition sites are known from this time period. In any case, the Nebraska Culture people were not an isolated group. Gulf Coast marine shell beads, "foreign" stone types such as pipestone from Minnesota, and other evidence indicate that they were part of a widespread trade and communication network throughout the prairies, plains, and southeastern culture area. This is not surprising considering the extensive trade networks which eighteenth-century Euro-Americans described among the American Indians.

Given the nature of archaeological evidence, other aspects of the lives of the Nebraska Culture people are more difficult to reconstruct. Drawing analogies from various historically known American Indians, archaeologists have suggested that the early earth lodge dwellers lived in extended family groups (i.e., households including more than just a father, mother, and children), that they were matrilineal (i.e., reckoned kinship through the female line), and that they were organized politically into small autonomous bands rather than large interconnected tribes. The absence of fortifications at Nebraska Culture sites suggests that these people did not engage in warfare. While all these reconstructions are quite probable, none of them is completely demonstrable. The presence of stone and ceramic pipes may be associated with the growing of tobacco. My bet, beyond the strict axioms of archaeological science, is that ritual tobacco smoking was practiced by the Nebraska Culture people as it is today throughout American Indian country.

At this point I can perhaps take at least one more step toward the bluff edge separating scientific logic and fantasized uncertainty. Although I cannot definitely prove the matter, it is tempting to speculate that the number of central roof supports in Nebraska Phase earth lodges reflects the sacredness of the number four among historic and contemporary American Indians. In North Dakota, for example, the documented eighteenth- and nineteenth-century Mandan, Hidatsan, and Arikara Indian earth lodges typically had four center posts representing the four cardinal directions. These historic earth lodges, which were larger than the Nebraska Culture houses and circular in floor plan, were depicted by artists Karl Bodmer and George Catlin in the 1830s; many of their original paintings and lithographs can now be viewed in the collections of the Joslyn Art Museum in Omaha. The expression of the sacred number four continues today in various contexts. Contemporary blessings of sacred tobacco and pipe ceremonies involve presentations to the four directions. And modern American Indian writers often organize their prose or poetry into units of four—four chapters, four stanzas, etc. Suffice it to say that the number four has a long-standing symbolic significance in American Indian ideology.

At the present time, the occupation of Iowa's Loess Hills by American Indians cannot be documented, much less inferred, for the period between A.D. 1400 and 1700. Some scholars suspect that sites of that time period exist but have not yet been discovered by archaeologists; other scholars suggest that the

early earth lodge dwellers migrated up the Missouri River, perhaps as a response to changing climatic conditions in the prairies and plains. The bottom line is that the people who lived in the Glenwood earth lodges cannot be linked to any known historic American Indian tribe with absolute certainty, although Caddoan-speaking connections (i.e., Arikara and Pawnee) have been posited. Nonetheless, much of their cultural tradition continued into historic times and is a meaningful part of the heritage of living American Indians, just as people of the Western cultural tradition draw from antecedents in Europe and the Near East covering hundreds and even thousands of years. In that way we all experience the lives of our ancestors at a general if not specific level. The past lives in us and is transmitted to our children and grandchildren. John Twobirds Arbuckle, a writer of Chippewa and Choctaw descent, expresses this idea in his poem entitled "Poems of a Past."

Each one of us
Has suffered
The ten thousand deaths
The ten thousand births
Of each of our ancestors
The proof of this
Is our very presence
In each of us
There is a reason
For being
Some of us
Remember
This reason
For being
In the ten thousand songs
In the ten thousand ways
Our ancestors taught us
The proof of this
Is in our very presence
In all of us
There is a poem
Of a past
Some of us
Remember.

It is said
By some of my people
That a man's future
Is his past
That is his present.

It is said
By others of my people
That a man's present
Is all he needs to know
About his past.

It is said
By others of my people
That a man's future
Is all he needs to learn
About his past.

It is said
By some of my people
That a man's present
Is his past
That is his future.

The meaning of this poem is further enhanced as one studies its structure and layout. The introductory stanza consists of twenty-four lines. I doubt that the number of lines is fortuitous, since it consists of the sacred number four times six. Six is also a significant number in American Indian ideology, since it symbolizes the four cardinal directions plus those that are above and below. Arbuckle's final stanzas—four in number—are arranged in a circular fashion.

The composition of this poem may initially confuse people of the Western cultural tradition because they perceive time and existence in linear terms. In the Native American worldview, however, time and existence are circular. This concept has been expressed in material ways for hundreds of years trailing off into the archaeological past: the arrangement of high plains tipis in a camp circle, the circular Sun Dance arbors, the circular shields of buffalo skin, the stone-lined medicine wheels, the circular shell gorgets from a thousand years ago, and so forth. Further-

more, each of the final stanzas in Arbuckle's poem consists of five lines. For many American Indians, the number five represents the fingers of a hand, a distinguishing physical characteristic of human beings. Even more significant, the number five symbolizes the four cardinal directions plus the direction *here*, that is, where we *are*. *Here* may also be symbolized by the blank space within the circle of the final four stanzas in Arbuckle's poem—a place where we can see around us—a place to view the past, the present, and the future as they encompass us from the east, the south, the west, and the north. From above, and below, and here.

At this juncture, I have clearly stepped out of my scientific role and into the humanities. I have that prerogative since anthropology studies humankind from all possible vantage points and has often been called "the most scientific of the humanities, the most humanist of the sciences." So it is at this place where I pause and contemplate. Here along the Missouri River.

Here where prehistoric people we call the Nebraska Culture built their lodges of earth. Here where Pleistocene glaciers ground huge rocks into fine silt. Here where the winds picked up that fine silty sediment from the glaciers and the rivers and formed the Loess Hills. Here where the winds of time still blow around us and will for millennia to come in our imagination. Here.

REFERENCE CITED

John Twobirds Arbuckle. 1978. *Singing Words*. Word Services Publishing, Lincoln, Nebraska.

Reflections on Gullies

E. ARTHUR BETTIS III

The gully next to our house in Sioux City was the last frontier in my ten-year-old universe. The deep dark gash through our neighborhood harbored a Loess Hills jungle filled with curious sounds, seldom-seen creatures, and earthy smells that enchanted the boy who inhabited the other world beyond the gully's edge. What made that sound and rippled the water? Would the phantom slither from the gully and into our house at night?

When exploration of the gully finally became reality, the phantom turned out to be turtles, minnows, birds, muskrats, and a host of other creatures that were at home in the thread of wildness winding through the city. Almost every day the world of moms and dads, houses and schools faded rapidly from consciousness as the Cook Street expedition, led by Patty McGraw—the toughest kid on the block—descended the narrow path into the green twilight canyon where discoveries of nature and self abounded. A golden cloud of dust enveloped us as we scrambled down the narrow path clinging to the gully's side. The nearly vertical, forty-foot-high walls of the gully closed around us, and the world above vanished behind an emerald canopy of box elder, silver maple, willow, and elm.

Orioles and robins darted in and out of the trees, box turtles plopped into the tepid water of Perry Creek, and schools of chubs darted to deeper, darker pools as we scampered through the nettle and horseweed jungle on the gully floor. We, too, were creatures of the gully, allied with those that swam, flew, and walked on all fours. In this place, grown-up rules no longer reigned. The gully world had its own rules; getting dirty, muddy, and sometimes wet was inevitable. Anything light enough to move could be thrown into the water, and breaking a bottle bobbing along in the creek moved you up the social ladder. The gully was more than a secluded playground: it was otherworldly, a rarefied blend of earth, organisms, water, and filtered light that diffused through our civilized rind and jostled the wild within.

Gullies are the greatest physical environmental problem in the Loess Hills. In a typical year, 5,000 to 10,000 acres of cropland are destroyed or damaged by gullies in the western part of Iowa. In spite of forty years of soil and water conservation efforts, gullies still plague farmers, engineers, and anyone who tries to tame them. Sediment washed from gullies chokes drainage ditches on the Missouri River floodplain and necessitates a continuous dredging program. A bridge's age out here can be judged by the number of extensions that have been added to keep the span connected to the receding gully wall. An incredible investment of planning, time, and money on the local, state, and federal levels has gone into attempts to stop, control, and understand gullies; yet gullies and associated rill erosion and high sediment yields still rank as top environmental concerns. No one wants a gully on the farm, county engineers cringe at the sight of those forty-year-old bridges stretched to their safety limit, and Soil Conservation Service engineers shake their heads at the thirty-year-old gully control dams filled to the brim with sediment, just waiting to be breached by new gullies

during the next big storm. Can the force that tears the earth and melts away the soil be arrested?

Gullies are as unpredictable as the Iowa weather. One may remain relatively unchanged for a decade or longer, then chew its way a thousand feet up a valley during the next few years. A three-foot-high waterfall moving up a gully floor may cause the gully to double its width. Even the most stable gully, one with trees growing in its bottom, will in the next century or two be a raw gash tearing at the landscape with renewed strength. In this landscape, gullies are eternal. Like the phoenix rising from its ashes, new gullies occupy the filled courses of ancient gullies in an endless cycle of landscape development.

Scientists have a knack for making simple things sound complex. The cause of gullies is no exception: they form because of a decrease in the erosional resistance of the land surface or an increase in the erosional forces acting on the land surface. In other words, why a given gully forms where it does is anyone's guess, as are the rate and future extent of its march up a valley. We know that gullies were present well before the first geological observations of the Hills were made from horseback in the late 1800s and that gullies increased in abundance and destructive effect with the spread of grazing and the breaking of the prairie in the late 1800s and early to mid-1900s. Geologic studies of sediments exposed in the towering walls of gullies conclude that, although agriculture has had a hand in the present gully problems, the fact of the matter is that gullies are as native to this place as the corrugated hills covered with golden prairie. Long before the prairie went under the plow, before corn was domesticated, gullies were here. The deeply crenelated form of the landscape, the very essence of the Hills, is a product of the repeated gnawing away of these thick piles of Ice Age dust by gullies for two hundred centuries.

These things I know as an earth scientist—as one who tries to unravel the geologic history of this place by piecing together clues preserved in the mineral deposits that make up the landscape. As unpredictable as gullies are, they still obey physical laws that have applied since the beginning of time. The youngest deposits are always on top, and successively older sediments are encountered with depth. Gullies cut into the deeper, older deposits as they grow, and differences in layering, color, and fossil content of gully-wall sediments make it possible to distinguish individual episodes of gully cutting and filling. Thanks to the natural radioactive decay of carbon, one of the building blocks of all life on earth, it is also possible to know the age of wood, charcoal, bone, and shell enclosed in the gully-fill sediments. With these earth science techniques, I try to solve the mysteries of the landscape. What happened here, and when did it happen? Did similar events take place in the valley over the ridge or in the next county to the south? Did the Loess Hills always look like they do now?

My interest in the Loess Hills landscape emerged long after I and the other kids on Cook Street grew into adulthood and abandoned Perry Creek's gully. The childhood gully world had retreated far from consciousness by the time I was in graduate school. As a student of archaeology, soil science, and geology, I learned to view the world as a scientist and grasped all the proper words and ways to convey what I observed to other scientists. My studies focused on the forest soils and thin loess, rock-dominated landscape of northeastern Iowa, the antithesis of the Loess Hills. That's when I met Dave Benn, an archaeologist at a small college who was about to begin an archaeological dig along Held Creek in the Loess Hills near Sioux City. That dig would lead to an awakening in understanding Loess Hills archaeology, present important geologic discoveries, and leave me standing once again in the gully world.

Held Creek's gully looked like thousands of other gullies in

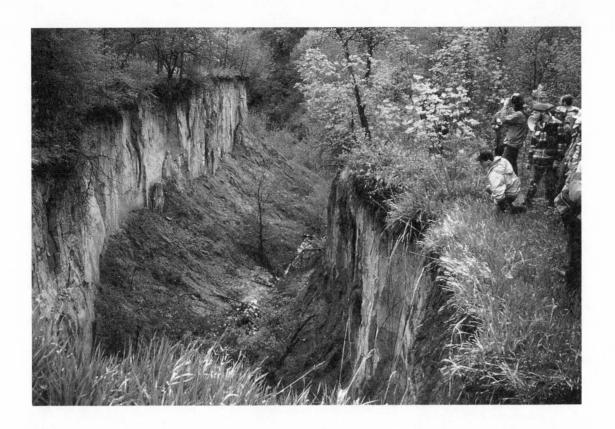

northwest Iowa, a ragged seam of cottonwood trees and tall weeds on the monotonous corduroy of the cornfield landscape. Valuable farmland was being destroyed by the advance and widening of the gully, and the Soil Conservation Service was in the process of trying to tame the untamable: building dams to stop the gully's advance, terracing the bordering hills to hold the soil. While examining the project area, an archaeologist had discovered remains of a prehistoric campsite, including bits of pottery, broken and burned deer bones, and a fragment of a ceremonial pipe protruding from a gully wall. Now Dave, ten student archaeologists, and I were going to learn what we could about this ancient camp before it was destroyed by dam con-

struction. So once again I scrambled down a narrow path clinging to a gully's side and entered the gully world, this time searching out phantoms of the deep past.

Cradled deep in the tan-and-black layers of mud in the walls of the gully were clues about the lives of the Hills' prehistoric inhabitants and the position gullies held in their way of life. Centuries before earth lodge villagers congregated in the Glenwood area and along the Little and Big Sioux valleys about a thousand years ago, other Native Americans, known as Plains Woodland Indians by archaeologists, made the Hills their home. These people, who lived in extended families of about ten, made their living by hunting deer, small animals, þirds,

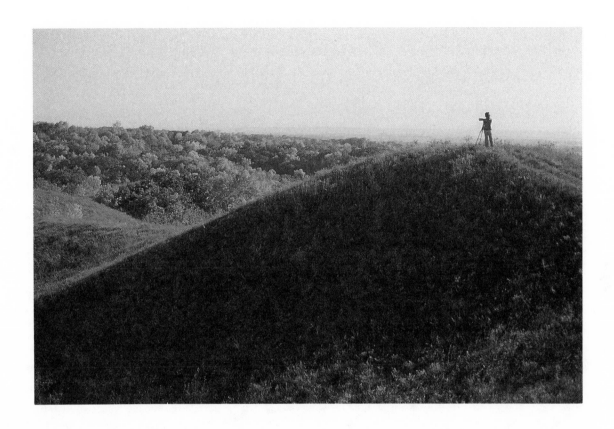

frogs, and other animals and by searching for insects and plants, all of which would carry them through the seasons in the endless prairie on the eastern edge of the plains. People were not plentiful, and the landscape was rich with resources. Most of the time life was relatively comfortable, but winter must have been another story.

Today's western Iowans know winter: blinding snow coming in horizontal sheets, snow drifts that swallow up cars and paralyze towns, and afterward the "Alberta Clipper"—the deep freeze. Surviving such conditions in a skin-walled hut huddled around a small, open wood fire without down sleeping bags is unimaginable to me. Yet the evidence in Held Creek's gully wall—bits and scraps of pottery and burned deer bone, the orange stain of an extinct fire pit inside a dark lens marking the floor of a dwelling—left no doubt that the hunters did survive winter in the Hills, just as others had done for thousands of previous winters and as their descendants would do for hundreds of winters to come.

This camp was not an isolated occurrence. Layer upon layer of remains were exposed as we dug deeper into the mud of the extinct gully, deeper into time. Soon after the first high V's of geese passed northward, signaling the approach of spring, the band left its winter camp in the gully. Not long afterward the creek sprung to life, as runoff from melting snow and spring

rains trickled down the slopes and rushed into the gully. With the runoff came sediment that sealed the remains of the camp under a new layer of mud, writing another page in the gully's story, part of the chapter on human history. Charcoal from the ancient fire pits we unearthed told us that bands of Woodland hunters stayed here many times between about 1,800 and 1,200 years ago. They stopped visiting this place when the ancient gully was almost filled with sediment, a shallow swale on the valley floor that no longer afforded wood, water, and protection from the winter wind.

Archaeologists now look for and routinely discover remains of the Hills' prehistoric inhabitants exposed in gully walls. During the last fifteen years, the discovery of other prehistoric gully campsites several thousands of years older than the Woodland occupations at Held Creek have opened a new view of past people's relationship with the Loess Hills. Gullies were the winter cornucopia of prehistoric Loess Hills residents. These places provided game, water, wood, and, most important, shelter from the relentless wind when winter storms rendered ridges, slopes, and wide valleys off limits to people. Gullies were an essential element in the aboriginal landscape. Yearly movements of the group were planned around the location and characteristics of certain gullies. When a favored gully location finally silted in over the span of several centuries, a younger, deeper gully was sought out for the winter stay. To prehistoric inhabitants of the Hills, deep gullies were an asset, nature's gift, beauty.

Along with this new view of the Hills' past inhabitants comes a more complete picture of the timelessness of gully activity in this landscape. The number and extent of gully-cutting episodes recorded in the walls at Held Creek are the same as those found by soil scientists along other creeks farther south in the Hills. Subsequent geologic studies in hundreds of valleys in the thick loess areas of western Iowa, eastern Nebraska, northeastern Kansas, and northwestern Missouri demonstrate that the behavior of Held Creek's gully during the last 11,000 years was not random. Gullies in most other valleys throughout the region cut and filled in unison repeatedly, sculpting the landscape into the Loess Hills of today.

It's interesting that the landscape can be viewed so differently by different cultures and by different groups in the same culture. Today's environmental problem was the environmental necessity of the past. The unsightly ravine ravaging prime agricultural land was my childhood world of discovery and wonderment, habitat for creatures squeezed off the landscape by human land use, and a window into the past for geologists and archaeologists. Gullies speak to me about some of the consequences of our economy, about the human past and long-term perspectives on the landscape, about the nature of the Hills, about people's place in the environment, about myself. Human arrogance lets some of us believe that we have upset the natural order of things and caused a "gully problem" when, in fact, present gully activity is just one of several gully growth-and-filling episodes that have formed the distinctive landscape of the Loess Hills during the last 20,000 years.

Gullies are a thread in my life. The enchantment I experienced in the gully world as a child emerges again as I stand in the canyons of the Loess Hills, wondering How? When? Why? and awestruck by the human and landscape histories recorded in the sediments of the towering gully walls.

SETTLING IN THE HILLS

At first the Euro-Americans trickled through the Loess Hills, a trading party here, an expedition there. Then in the 1840s Oregon-bound pioneers and Mormons heading for Utah streamed into the southern Hills. Soon the federal government was doling out cheap land to settlers who nestled their homes into Hills ravines. A few short decades later, human patterns lay like a grid upon the ancient natural features of the Hills, which were sprinkled with cities and farms laced together by sophisticated transportation networks. The newcomers had almost instantaneously transformed the wilderness to a land more to their liking, calming the raging rivers and fires, substituting domesticated animals and crops for organisms of a wilder bent, carving the loess into shapes that would hold homes and roads. For the most part, the new settlers enacted their wishes as they had on flatter, more cooperative lands to the east, without realizing the profound effects of their actions on this unique landscape, without seeing that they did not need to cut this particular diamond to make it glitter and that their "betterment" of the land often led to increased erosion and the decline of a rich assemblage of unusual native species. The following two essays examine the patterns and approaches of Euro-American settlement and the return of some Hills residents to a sensitive appreciation of what was always here.

Margaret Atherton Bonney spent her early years in California, earned a degree from Whittier College, and then taught in the California public schools. Following her move to Iowa, she developed an interest in frontier history and became an educational specialist and curriculum developer at the State Historical Society of Iowa in Iowa City. She wrote teachers' guides for the Iowa Public Television series *The Iowa Heritage* and *Land between Two Rivers*. "My involvement with the Loess Hills began in 1983," she explains, "when the Conservation Commission asked me to study the settlement history there and see if it was influenced by the unusual landform." In the course of her research, Margaret drove through the Hills from one county courthouse to another, researching records. "I found that routine frontier settlement patterns prevailed in this part of the state. The unusual Loess Hills topography and vegetation had exerted little impact. Although I never climbed the Hills, their uniqueness became apparent during my travel. The soft, talc-like texture of the soil left a lasting impression. During subsequent presentations about Hills settlement, I carried soil samples along so that others could share my experience."

Don Reese was born on the family's home place that his grandfather had homesteaded in 1858, which is nestled into the Loess Hills near Turin, Iowa. After graduating from the University of Iowa and serving for four years as a pharmacist's mate during World War II, he came back to live on the farm and raise four children with his wife, Luella. During part of that time, Don was a mail carrier out of Turin and Onawa. "The Loess Hills are a beautiful place to live but a darn poor place to make a living," Don says. "Our place isn't a profitable farm. It isn't big enough anymore. Of 274 acres, only 100 are tillable. The rest are hills. And I wasn't even conscious of their significance until relatively recently. I became more attuned to them by attending the Loess Hills seminars through the years, and then Luella and I were featured on the segment of the Iowa Public Television series *Land between Two Rivers* which dealt with the Loess Hills." Now Don and Luella's son, David Zahrt, and his wife, Linda, have returned to the family farm where they have converted the main house into a bed and breakfast and begun a honey business, raising bees that feed on the flowers of the surrounding native prairies.

A New People Come to the Hills

MARGARET ATHERTON BONNEY

As our car speeds over the interstate toward the Missouri River, my anticipation heightens as we cross the Nishnabotna River. With a friend as guide, we near our destination—the Loess Hills, the area I have studied for the past several months. Early explorers viewed the steep, west-facing Loess Hills bluffs from the Missouri River, a much more dramatic vantage point than ours. We approach from the east, as did the early Euro-American settlers and westbound overland immigrants. Thus, we first see rolling hills, which gradually increase in ruggedness. Soon we are traveling through the prairie uplands. Finally reaching the western edge of the Hills, we stop at the observation tower to view the spectacular panorama of the bluffs as they drop precipitously to the alluvial plain of the Missouri River. I reach to the ground to sample the soil. The dirt between my fingers is as fine as talcum powder. As I turn to look behind me, I recall the many streams and sharp ridges that people crossed in their jolting wagons to reach this point. What a challenge it must have been to pick a trail through this terrain! Did this unique topography significantly change the way first Euro-American settlers used the land, and, in turn, what sort of impact did these new people have on this land? It was for the land that the new people came.

Before Euro-Americans began to move into the region, the Loess Hills were a hunting ground for several native tribes. At the beginning of the eighteenth century, French fur traders made an unsuccessful attempt to establish trade with the native inhabitants. The region moved from French to Spanish control in 1763, but the later transfer back to France and then to the United States with the 1803 Louisiana Purchase precipitated the movement of explorers, fur traders, missionaries, and government agents into the upper Missouri River region.

To assess the value of and explore the new purchase, the United States government sent an expedition under Meriwether Lewis and William Clark to investigate the enormous land acquisition. They reached what is now western Iowa in July 1804. From their journals come the earliest written descriptions of the Loess Hills region:

> July 28th. At one mile this morning we reached a bluff on the north. A little below the bluff . . . is the spot where the Ayauway Indians formerly lived.

> August 20th. [Just below the site of present-day Sioux City] Here we had the misfortune to lose one of our sergeants, Charles Floyd . . . He was buried on top of a bluff with the honors due to a brave soldier; the place of his interment was marked by a cedar post. We called this place Floyd, also a small river about 30 yards wide. (Jackson 1962)

Floyd's Bluff became a landmark for travelers on the Missouri River. Poetic descriptions appear in the records of artists and naturalists attracted to the upper Missouri River wilderness. Among them was artist George Catlin, who in 1832 found the Floyd gravesite a place for contemplation:

> I often landed my skiff and mounted the green carpeted bluffs, whose soft grassy tops invited me to recline, where I

was at once lost in contemplation. Soul Melting scenery that was about me! A place where the mind could think volumes; but the tongue must be silent that would speak, and the hand palsied that would write. . . . My pencil has faithfully traced thy beautiful habitation; and long shall live in the world, and familiar, the name of "Floyd's Grave." (Briggs 1926)

When the German naturalist and explorer Maximilian, Prince of Wied, traveled to the United States, he brought along artist Karl Bodmer to sketch and paint a record of the country. The expedition arrived on the upper Missouri River in 1833 before frontier settlement had reached the region, yet Maximilian sensed that animal population changes had taken place as a result of the hunting and trapping created by the European demand for furs:

> April 26. . . . before the picturesque chain of hills trails a narrow prairie which runs up from the nearby outlet of the Nishnebottoneh. . . . The river just mentioned is beautiful and was formerly rich in beaver which have given way to European greed and destructive expertise.

> April 29. The view of the chain of hills, before which the Nishnebotteneh flows, is noteworthy. . . . A few are covered with timber. Once one could see here hundreds of elk and deer, now only a few. Here in this region the Otos, Ayawas, Sakis, and Muskoke [Mesquakie] hunt in accordance with a general agreement. (Orr and Porter 1983)

Pressure of frontier settlement in Illinois and Wisconsin caused the United States government to relocate the Potawatomi tribe to a southwestern Iowa reserve in 1837. Dr. Edwin James, subagent to the tribe, established an Indian agency in present-day Mills County opposite the mouth of the Platte River. He penned one of the finest contemporary descriptions

of both the Loess Hills and the alluvial plain, although he failed to accurately predict the future use of the land:

The Missouri Bottom—This tract commencing near the narrows of the Nishnabotna on the south and running northward to the mouth of Boyer's Creek is about five miles wide—everywhere low and contains many lagoons and low swampy parts unfit for cultivation. There is no one point where the Missouri washes the foot of the bluffs as it frequently does on the west side, and very few places where a road can be had from the river to the hills without great trouble and expense . . . the great extent of marshy ground will probably make this portion of the country sickly while improvements made here in the Missouri bottom will be very liable to be washed away by changes in the course of the stream.

The uplands—Near the river these occasionally assume the aspect of sharp broken and rather sterile knobs, very difficult to pass through with teams and wholly destitute of arable land or timber of any value except for fuel. Access to the uplands must be had along the principal creeks, both because these act as drains to the small lakes and marshes affording a dry margin and because where the creeks flow from the hills these are less precipitous and broken than elsewhere. After rising to the general level of the country which may be from two to three hundred feet above the Missouri we find many tracts of fine soil sufficiently smooth and level for cultivation, but there is in general a great want of timber for the purposes of permanent settlement. (U.S. Office of Indian Affairs 1824–1881)

Even while native tribes remained on the land, overland migration through the Loess Hills region began. In 1843 emigrants from previously settled states and territories crossed southern Iowa in unexpected numbers and headed for Oregon. At the end of 1846, Iowa had achieved statehood, and the federal government proceeded to remove the remaining native peoples to other reserves across the Missouri River. This action opened the entire Loess Hills region for legal frontier settlement.

In that same year, the Mormons commenced their journey from Illinois to their new lands in the Great Salt Lake Valley. As part of their plan for emigration, the Mormons established way stations to grow food, supply necessary provisions, and repair equipment for westward-bound Saints. When the Mormons reached the Missouri River, they established permanent camps on both sides. Kanesville, their settlement in the southwestern Loess Hills, served as a staging place for the long journey across the plains. Kanesville eventually became a part of Council Bluffs, which continued as an outfitting center for many years to come. (The name "Council Bluff" was first applied to a bluff and then to an Indian agency at Bellevue on the Nebraska side of the Missouri River, then to the subagency at Trader's Point in the northwestern corner of present-day Mills County; finally, it was perpetuated when the city of Council Bluffs was incorporated in 1853.)

Many overland diaries contain special comment about the Hills. Jane Augusta Gould paused with her party at Council Bluffs during a journey to California in 1862. Smitten by the bluffs, she wrote about her friend's hopes to one day return:

[We] climbed the bluffs at the back of the town, and got an excellent view of the whole place. When Fanny gets rich she is going to have a house built on one of the highest bluffs here. May I live to see it! (Babbitt 1916)

Routes crossing the bluffs presented a real challenge to early travelers, as westward-bound missionary Thaddeus Culbertson confirmed in his journal:

Yesterday . . . we had a great deal of level road but just before coming to the river we had to cross the steepest bluff that I have yet seen. We descended quite a steep bluff and I expected something of a declivity on the other side but judge of my fearful surprise to find that I had to turn at a right angle to prevent it from going down the other side and then in a few feet I had to start down a very long and steep ridge scarcely wide enough for two carriages to pass. This was rather a fearful undertaking for so unskillful a driver but summoning up all my courage I started and thanks to the good mules, we got down in safety. (Culbertson 1952)

As land and town promoters began to invest in Loess Hills real estate, literature aimed to attract additional permanent settlers circulated in the East. The 1856 immigrants' guide, *Where to Emigrate, and Why*, presented a description to attract farming people, pointing out the unusual drainage properties and richness of the soil:

Near the Missouri and all the large streams, high and precipitous mountain bluffs range up and down the streams, while the region contiguous is generally very rough and hilly. . . . The valleys formed by this roughness of surface are immensely rich, of very easy cultivation, and capable of producing to an enormous extent and, what is a strange peculiarity, the crops are not materially affected by either flood or drought, the soil possessing the peculiarity of sustaining and maturing crops through severe and prolonged drought. . . . The highest hills are covered with verdure, grass, or timber, and if cultivated, would produce good crops of various kinds of grain or vegetables. Although the soil is light, and to appearance poor, it is loose and sandy, and very easy to cultivate. (Goddard 1865)

The *Council Bluffs Times* in 1870 encouraged farmers to consider western Iowa. The unusual topography received notice, along with advice on cultivation in the Hills:

A remarkable topographical feature of this portion of the county [Pottawattamie] is the bluff system. They rise to a height of about two to three hundred feet, and on their river or westward face are devoid of timber except a tree here and there. They are thinly clothed with grass, and are transversely cut with ravines. Their sides are in most places almost perpendicular and will never be fit for cultivation. The soil on these hills and hill sides is rich and sufficiently accessible for tillage. Many of them are already brought into subjugation and clothed with fruitful orchards or vineyards. (Tostevin 1870)

Popular notice of worldwide uniqueness appeared in an 1892 Sioux City Jobbers' and Manufacturers' promotional publication:

The soil in portions of the region, commercial tributary to Sioux City, is identical with the soil of the famous Yang-Ste-Kiang, China, which has been cultivated for ages without exhaustion, and is considered one of the most fertile spots on the globe.

A failure of the corn crop, either by reason of excessive rainfall or drought is unknown in this section, as the peculiar composition and construction of the soil which is rich alluvial loam, renders it impervious to either.

The system by which newcomers purchased public land from the government was based on the Ordinance of 1785. A rectangular survey located boundaries for townships, which were then subdivided into thirty-six sections one-mile square. This

grid of boundary lines, which ignored topography, became the definitive basis of land purchase records, farm size and shape, school locations, roads, and township and county governments. When one flies over this region, the land takes on the appearance of a tidy quilt of squares.

Most people came to farm. The newcomers, whose former pioneer and agricultural experience had been in the wooded areas of Ohio, Indiana, and Kentucky, ignored the Loess Hills prairies, clinging instead to the wooded creeks and streams where wood for home building, fuel, and fencing was plentiful and water was available for general use and to power grain mills. The United States government surveys made between 1851 and 1858 clearly document the cabins and cultivated lands adjacent to streams, rivers, and wooded areas.

From the moment of their arrival, the pioneers actively converted the Loess Hills environment to meet their own needs. They felled trees, broke sod, plowed ground, and removed the natural vegetation to plant crops and orchards. They cut prairie grass for hay. Wildlife, still available in some abundance, was killed for food. They built dams on rivers and streams to create power sources for gristmills and sawmills. When they dug wells to tap the plentiful underground water resource of the Loess Hills, settlers discovered an unusual characteristic of loess soil. "The subsoil [is] so firm that the walls stand firmly if protected above the water in the well . . . the soil does not cave; wells seldom have to be walled except for a few feet from the top and at the water edge" (White 1870).

Eventually, as more people came, farmers began to occupy the Loess Hills grassland. Here they began to plant trees. This activity increased after the 1870 State Geological Survey report noted that trees would thrive in the Hills and that it would be useful to plant forests for fuel, beauty, shelter, and shade. In

Pottawattamie County, the Board of Supervisors encouraged timber growing by providing a tax advantage for tree-planting landowners.

Although farming methods from past experience were in general use, new technological advances became available during the Loess Hills settlement period. For instance, labor-saving horse-drawn farm machinery appeared. In 1868, the Iowa State Agricultural Society reported that "most all the improved modes of cultivation are brought into full play. The corn planter, cultivator, reapers, mowers, and threshers are . . . universally used." Newcomers were also advised that, although there was a shortage of farm laborers, "all the modern machinery necessary to supply the want of manual labor is easily attainable" (Tostevin 1870). The Harrison County Agricultural Society reported in 1868 that farmers had not experimented with a wide variety of crops as had farmers in eastern Iowa counties. Loess Hills farmers had raised very little oats, rye, barley, buckwheat, hemp, flax, cotton, or tobacco. They preferred corn and wheat.

Nonetheless, the unique qualities of the bluff soil motivated farmers to plant vineyards, and grapes succeeded very well. The 1877 Iowa State Agricultural Society report stated that, in Pottawattamie County, "the bluffs in the neighborhood of the Missouri River are best adapted to the vine because of the warm porous nature of the soil and the sheltered condition of the ground. The prairie is too much exposed for so delicate a fruit." Many carloads of grapes left Council Bluffs. In addition, by the end of the century, apple orchards had matured. Apple shipments from Fremont and Mills counties exceeded those from any other county in the state.

Although farmers could sell their livestock locally and steamboat traffic on the Missouri River provided transportation to more distant markets, prospects expanded after railroads arrived. "We want more stockgrowers who will bring improved cattle, horses, sheep and hogs," the Monona County agricultural report stated. "We have a few fine herds. A few are shipped to Chicago" (Iowa State Agricultural Society 1869). According to the 1868 Iowa State Agricultural Society report, corn-fed hogs "were plenty" in Harrison County, and the hills produced "a most excellent" quality of grass, deemed to furnish "the best sheep pasture in the West." Stock raising and dairy business increased substantially after the 1870s' grasshopper invasions caused a shift away from cash grain crops such as wheat.

Frontier towns developed during the late 1840s and the 1850s. Just as farm settlement in Iowa followed a pattern built on years of frontier experience throughout the United States, town development followed a similar age-old plan. Frontier towns depended on and provided services for the surrounding agricultural region. These small urban centers arose where transportation was accessible—in this case, on the alluvial plain along the Missouri River, on established overland routes, or in valleys of Missouri River tributaries. Often these townsite locations were former fur trade or military posts. In 1847 Augustus Borchers began to trade with native people in his store at the foot of the bluffs in Fremont County, located on the Nishnabotna River three or four miles above the river's junction with the Missouri. Then, years later, this site became the market town of Hamburg, named for its founder's German home.

Another example is Council Bluffs. An American Fur Company trader first built a cabin within the present-day city limits in 1824. The future townsite also served as the location for two military posts and later as an outfitting center for the Mormons and other immigrants on their way west. Council Bluffs gained added importance when a federal land office opened there in 1852. As permanent, less transient people arrived, the town's character matured. In one generation, according to *Homes for*

Millions: The Cheap Lands of Western Iowa, the Missouri Slope, Council Bluffs had evolved from "the original town sheltered in the bluffs" to a city with "handsome residences . . . partially concealed from general view by the bluffs. The most romantic spots are the avenues that lead up through the glens. Here the well-to-do have made themselves suburban homes, that rival in anything ever seen" (Tostevin 1870).

As the town of Council Bluffs spread out onto the low-lying Missouri River plain, settlers built dikes and ditches to drain the wet lowlands and control flooding. Some of these activities created unexpected problems. Council Bluffs citizens straightened Indian Creek, a stream meandering through the town. The result was an eroded, water-filled chasm. The redirected water destroyed bridges and swept away homes.

Meanwhile, a different but still traditional sequence of events took place upstream. In 1849 a group of fur traders settled at the mouth of the Big Sioux River. More permanent activity took place in 1854, when surveyor John Cook, a partner in the Sioux City Townsite Company, located a claim and laid out Sioux City. The first stage and mail arrived at the Sioux City post office the next spring. The federal government established a federal land office there, and by winter, seven log houses, including an inn, stood on the newly platted site. The following year local settlers voted to move the county seat from Sergeant's Bluff to Sioux City, and the first steamboat arrived.

Sioux City became the market center for farm produce in Woodbury County and the surrounding region. "Its population of six thousand people are consumers," the 1876 agricultural report stated, "while the merchants have lay-government contracts for supplies for the army and Indians on the Missouri River" (Iowa State Agricultural Society 1877). This gave the thriving agricultural frontier an additional market, independent of that along the Missouri and Mississippi Rivers.

Sioux City also had a developing suburb. In this case, the bluffs were perceived as an obstacle and were cut down and filled to meet the people's needs. In 1890, a long-time resident wrote:

> With the exception of a small bottom-land plateau on which the original city plat was made, Sioux City was left by one of Nature's freaks with a very uneven, hilly and broken surface. To the person who never visited this point prior to the railroad era . . . it would indeed be difficult to picture the . . . view held by the little band of pioneer settlers who came here in 1855–56. They looked out upon hillsides and corresponding valleys which today have been reduced to dead level, with cable and electric street-car lines diverging in almost every direction, and which run at low grades over land that one time was too steep for a horse to travel over.
>
> A ten-minute ride on a cable car brings one to the northern portion of the city where man's tact and ingenuity have been taxed in leveling the score and more of Hills and filling the intervening valleys. This is destined to become the principal residence part of the city. (*History of the Counties* 1890–1891)

A good transportation network was vital for successful agricultural settlement and urban enterprise. Rivers provided the earliest major transportation routes. Even before permanent Euro-American settlers arrived, steamboats had ascended the upper Missouri River in 1831 to supply goods for the fur trade. As the business of the frontier region changed from trade with native peoples to agriculture, steamboat cargoes changed, bringing settlers and their goods and supplies. The boats returned downriver with agricultural products instead of furs.

Dirt roads connected farms to market towns. One early route followed the base of the bluffs, moving north from Hamburg.

Frontier wagon roads meandered in relation to topography, sometimes following old native trails. In Woodbury County, wagon trails followed the Loess Hills ridgetops as they connected with one another. Rural roads eventually joined a main road to a town or market center such as Council Bluffs. By the 1880s, these rural roads were realigned where topography and technology would permit, most often on section or quarter-section lines. Road building and grading had a significant impact on the land, and the unique qualities of the soil had, in turn, an impact on road construction. Loess soil was useful for building up roads across the lowlands. In the Hills, roadside excavations stood perpendicular without change for many years. According to State Geologist Charles White (1870), in one instance the names of carvers remained on a loess bank long after they would have ordinarily "softened and fallen away to a gentle slope" in another type of soil.

After the Civil War, railroad lines reached the region, adding a new dimension to town development. When a railroad company needed a town where one did not exist, the company proceeded to create one. Missouri Valley Junction is such a place. Located at the base of the bluffs, the Sioux City & Pacific Railroad established machine shops at Missouri Valley. Only three years after its founding, the town boasted a population of 1,500. The arrival of the rail connections with Chicago and St. Louis in 1867, and with St. Paul and the western mountain country by 1872, changed prospects for marketing agricultural products. Railroads provided a year-round link with eastern markets. Railroad transportation raised farmers' expectations for success, as the 1876 Harrison County agricultural report illustrates:

> As we have one railroad now completed and running diagonally through the centre of the county and another one commenced running north and south, our farming prospects

seem of the best character. Stock raising will especially prove very profitable to those engaging in it. (Iowa State Agricultural Society 1877)

Rail transportation also brought an abundant supply of building and heating materials to support an expanding population—pine lumber from Michigan, Wisconsin, and Minnesota and a continuous supply of inexpensive coal from the Des Moines River valley mines. Loess Hills region land sales boomed, and the population soared.

As local businesses and small industries developed, they discovered ways to take advantage of the unique soil properties. Paving-brick manufacture became a flourishing business. Brickmakers sold loess clay bricks for local and regional use. Lime kiln operators used the loess's "peculiar property of standing secure with a precipitous front" to fashion kilns carved in the side of a hill (White 1870). Potters built kilns in this manner as well. An enterprising Council Bluffs brewer tunneled into the Loess Hills bluff behind his brewery and created cellars for storage. In some instances, small, temporary, arch-roofed stables or cattle shelters were excavated in the side of a steep bank. State Geologist White, in his 1870 report, also noted that the soil provided a secure base "for the most massive structures." He went on to suggest that "if future emergencies should . . . require," subterranean passages could be built for underground protection.

Although the Loess Hills environment was unique to the newcomers, the abrupt bluffs, hilly topography, and relatively treeless environment did not significantly alter the process of people claiming land for agriculture. Both agricultural and townsite settlement patterns were determined by past frontier experience which had been repeated and refined for more than 200 years. The new arrivals began an era of intensive land use and continued population increase which altered the land-

scape. The land and its natural resources were the basis for both sustenance and personal gain.

What does the future hold for the relationship between humans and this extraordinary region? Now, almost 150 years after initial Euro-American settlement of the Loess Hills, I look to ecologists to help us balance human needs with this environment. I like to think that people in the future will stand at the top of a bluff, view the Missouri River valley panorama, and experience a walk over the rugged ridges and river valleys of the Loess Hills.

REFERENCES CITED

Babbitt, Charles. 1916. *Early Days at Council Bluffs*. Press of Byron S. Adams, Washington, D.C.

Briggs, John Ely. 1926. "George Catlin, Artist at Large," *Palimpsest* 7 (November).

Culbertson, Thaddeus A. 1952. "Journal of an Expedition to the Mauvaises Terres and the Upper Missouri in 1850," edited by John Francis McDermott. *Smithsonian Institution, Bureau of American Ethnology Bulletin* 147. United States Government Printing Office, Washington, D.C.

Goddard, Frederick B. 1865. *Where to Emigrate, and Why*. Frederick B. Goddard, New York.

History of the Counties of Woodbury and Plymouth, Iowa. 1890–1891. A. Warner & Co., Chicago.

Iowa State Agricultural Society. 1868. *Report of the Secretary of the Iowa State Agricultural Society for 1867*. State Printer, Des Moines.

———. 1869. *Report of the Secretary of the Iowa State Agricultural Society for 1868*. State Printer, Des Moines.

———. 1877. *Report of the Secretary of the Iowa State Agricultural Society for 1876*. State Printer, Des Moines.

Jackson, Donald Dean, ed. 1962. *Letters of the Lewis and Clark Expedition with Related Documents, 1783–1854*. University of Illinois Press, Urbana.

Orr, William J., and Joseph C. Porter. 1983. "A Journey Through the Nebraska Region in 1833 and 1834: From the Diaries of Prince Maximilian of Wied," translated by William J. Orr. *Nebraska History* 64 (Fall).

Sioux City Jobbers' and Manufacturers' Association Bureau of Information. 1892. *Sioux City, Its Growth, Interests, Industries, Institutions, Prospects*. Morgan Printing House, Sioux City.

Tostevin, David. 1870. *Homes for the Millions: The Cheap Lands of Western Iowa, the Missouri Slope*. Times Printing Co., Council Bluffs.

United States Bureau of Indian Affairs. 1824–1881. *Letters Received by the Office of Indian Affairs, 1824–81. Council Bluffs Agency, 1836–57*. Microcopy No. 234, Roll 215.22. National Archives, Washington, D.C.

White, Charles A. 1870. *Report of the Geological Survey of the State of Iowa*. 2 vols. Mill & Co., Des Moines.

The Reese Homestead

DON REESE

I lived in the Loess Hills fifty years before I knew that I was living in the Loess Hills. The ridge back of the barn was just a barrier that I had to climb every night to get the cows. And these hills were steep. (A few years ago, my wife was helping us round up cows in the pasture. She was expected to climb over the ridge at the steepest point to meet the rest of us on the other side but found it completely impossible to surmount.) Only in recent years have the Hills been recognized as a geologic treasure. They are a spiritual treasure, as well, for those of us who have always lived among them.

It is a long time between generations in my family, and my family's roots are as deep as those of the yucca that grows on the sunbaked slopes of the pasture. My great-grandfather, Edward Reese, was born in Wales in 1797, died in 1860 in Monona County, and was buried near the Little Sioux River at the foot of the Loess Hills on land still owned by the family. His bones have long since been washed downstream by the meandering river. It is said that he was run out of Wales or at least left under a cloud. No explanation of this has survived, but the family has noticed that some of its older members bore a striking resemblance to the British royal family. It all makes for interesting speculation.

His son, R. T. Reese, my grandfather, was born—where? The oral history of the family holds that he was born in Wales and came to this country with his father when he was seven years old. But the *History of Monona County*, published in 1890, states that he was born in Ohio. My father pondered this discrepancy for many years, then suddenly had an insight. When his father first came to this area, it was very sparsely populated. R. T. Reese was active in civic affairs and even held a minor political office most of his life. It is likely that he never was a naturalized citizen and didn't dare acknowledge that in 1890.

In 1855 R. T. Reese and his sixteen-year-old bride left Ohio by wagon with her family to go to the California goldfields. My grandfather was a saddle and harness maker, and when they reached Kanesville—now Council Bluffs—he saw a good business opportunity, so he and his wife left the party to settle there, while the others moved on. The following year he laid claim to 160 acres of land along the Little Sioux River in Monona County. He erected a cabin on the land and settled his family there while he continued to ply his trade in Kanesville. It is said that he would close up shop Saturday night, mount his horse and ride the seventy miles home to spend Sunday with his family, then ride back to Kanesville Sunday night to go to work Monday morning.

My grandfather later established his permanent homestead in the nearby Loess Hills, where he spent the rest of his life. When his sons became old enough to manage the farm, he established a general store in Turin. He boasted that he stocked "everything from pins and needles to threshing machines." And apparently he really did carry everything.

The primary occupation in the Loess Hills has always been farming, but the farming pattern has undergone a partial rever-

sal since the first Euro-American settlers arrived. The Hills drop off to the west very abruptly and meet the Missouri River flood-plain with practically no transition zone. Originally, this bottom ground was inclined to be swampy during part of the year and was covered with wetland grasses. The early white settlers created their homesteads in the Hills and grew their feed crops there. Then they went out on the bottom and acquired a piece of the prairie, sometimes several miles from home, where they harvested their hay for winter feed. This pattern of ownership can still be found occasionally. Now, however, most of the bottomland has been drained and tamed, and descendants of these farmers grow their row crops on the bottom ground, while they tend to raise their hay on the home place in the Hills. This practice needs to be extended to protect the Loess Hills from erosion.

A huge gully in the hollow on the other side of the ridge from our house illustrates the kind of erosion that can result when the loess soil is disturbed. My grandfather once broke up the hollow to grow broom corn. When it was ready to harvest, a group of Indians from the Omaha reservation in Nebraska came over and camped in the field until it was all gleaned. Once the soil at the bottom of the hollow was disturbed, it was possible for rainwater to wash the topsoil and underlying loess down toward the outlet of the hollow. As the ground continued to be plowed in subsequent years, this erosion continued until a huge ravine was hollowed out.

There have been sporadic attempts in the past at soil conservation. One early farmer created some of the first erosion control structures in the United States on his hill land by constructing dams, terraces, and grassed waterways to slow the progress of rainwater and to hold the topsoil in place. And in the 1930s, the young men in the Civilian Conservation Corps built dams and other erosion control structures. Now, of course, the U.S. Department of Agriculture is placing more emphasis on soil conservation.

When not carried to extremes, pasture is the least destructive use of the Loess Hills. However, if the land is grazed too intensively, the soil is denuded, leaving it subject to water and wind erosion.

Cattle raising, naturally, has always been a major enterprise in the area. My grandfather once owned about 2,000 acres of bottomland in addition to his holdings in the Hills. He mowed and stacked the prairie hay during the summer, and in the winter the cattle were turned out to shift for themselves among the haystacks. They watered at the Sioux River, and it was the job of a hired hand to ride out and break the ice every day. It was a rugged life for the cattle, and my father said that if they didn't lose more than a hundred cows by spring they considered themselves lucky. Today they would be cited for cruelty to animals.

The cows were so weak by spring that they would get mired in the mud along the river. It was often difficult to rescue them because they would give up. My father learned that if he poured a bottle of whiskey down their gullets, they would be stimulated enough to make an effort to free themselves. One morning he sent his brother Richard—my drinking uncle—out on a good horse with a bottle of whiskey to rescue one of the cows. In due time he returned with the cow, and my father asked him if he had given her the whiskey. "No," said Uncle Dick, "I drank the whiskey myself and pulled her out."

One winter there was a terrific blizzard from the northwest. When the weather cleared, the cattle were nowhere to be seen. When spring came, they were found in a protected hollow in the next county south.

The Loess Hills have served purposes other than agriculture. Much soil has been removed to build railroad and highway

grades. It was a simple matter to dig caves into the sidehills, and some early Euro-American settlers lived in caves until they could construct more suitable living quarters. More recently, a family took advantage of this terrain to build a lovely, two-story earth-sheltered house. They have grass growing on the roof, which they mow with a regular field mower. They call it "The Little Prairie on the House."

The Loess Hills were also great places for criminals to hide out. There have always been scary stories about strangers repeatedly seen wandering through the Hills. Around the turn of the century an extended family came to the Loess Hills area and settled on a farm in an isolated hollow. The Haneys seemed to have had money and were good neighbors. They mingled with the local populace, threw good parties, and were highly regarded in the community, but made no secret of the fact that they were racketeers of some sort from New York, hiding in the hinterland from the authorities.

They occasionally took trips, presumably to New York. My Uncle Dick traveled extensively in Minnesota and one day was on a train to Minneapolis, accompanied by one of the Haneys, who left his seat for a while to wander through the train. When he returned he had a gold watch, which he handed to Uncle

Dick to put in his pocket. "See how easy it is?" Later, authorities came through the train searching everyone. Uncle Dick, with the watch in his pocket, was terrified. But when they got to him the conductor said, "I know him. He is all right." And Uncle Dick wasn't searched.

There is a high and quite symmetrical peak rising up directly behind our farmstead. Many years ago my dad decided to accentuate it by planting a cedar tree at its very apex, which prospered over time. I once was hiking the Hills with a girlfriend who was a stranger in the area. When we reached this peak she commented that my father must have been very romantic. She had noticed that he had set out not one but two trees—a male and a female. Their progeny now cover that part of the ridge.

My father died in 1979 in the house where he was born nearly ninety-eight years earlier. I was born in the same house and still live with my wife on the same homestead, although in what was once the tenant house. Our kids have scattered to the far corners of the earth, but most of them have not taken root elsewhere and still regard the old homestead as their home. At one point several years ago, each of our four children was on a different continent. We hope to set up our estate so that the homestead will always be here for them. Our son and his wife did return home recently to live in the ancestral house.

As the Loess Hills themselves are unique, our four kids, raised in the Hills, are also unique. Somehow, as they roamed the ridges and peaks back of our house, they must have had visions of far-distant horizons. One daughter became a professional mountaineer, teaching climbing, leading treks, and climbing mountains in the Sierras, in Alaska, and in the Himalayas. Another daughter and our son have spent years doing community development work in such out-of-the-way places as Australia,

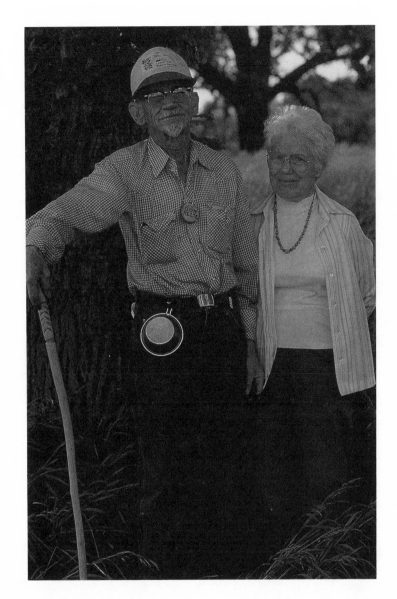

Nigeria, Kenya, Egypt, and Jamaica. Our youngest daughter has chosen a more conventional life as the wife of a businessman in San Francisco.

My wife and I have led a life rooted in the land. I have farmed by choice and worked an outside job in order to support the farm. And we have lived vicariously through our children. I am grateful for the privilege of having been born and raised in the unique Loess Hills, and so, I believe, is my family.

RESPONSES TO THE LAND

Even as we have marked the land, so it has marked us. Today, nearly 150 years after the onslaught of modern human settlement and its technologies, the Loess Hills continue to evoke strong responses from their human residents. Yes, many of the prairies have been bulldozed or grazed to oblivion, the rushing whir of the rivers replaced by the din of highways, the sharp contours of ridge lines obscured by brush and buildings. Yet these mountains in miniature remain a place of natural extremes: here are found not only the highest erosion rates in the state but also Iowa's largest remaining prairies and roadless areas, retreats for some of the rarest plants and animals in the state. The Hills still claim a greater diversity and dominance of native species than most of Iowa, associations of plants and animals unlike those found elsewhere in the state, and of course the rugged and defiant landform itself. And although the original wilderness voices no longer shout out, still the whispers remain for those who listen—for signs of the past, for remnants that have survived. The next two essays are written by modern-day Loess Hills residents who have heard those voices and shaped their lives in response.

Michael Carey, born in New York City and raised in New Jersey, moved to Iowa to attend the Iowa Writers' Workshop, where he received his M.F.A. degree in poetry writing. In Iowa City he met his future wife, Kelly, and soon after they married the two of them began farming Kelly's family's home place in Farragut, Iowa. There Michael discovered not only the intricacies of managing 800 acres of corn and soybean fields but also the beauty of the Iowa landscape itself. "I was a city boy," Michael says. "In the beginning, I didn't know anything about tractors or combines or the feel of the land." But almost immediately the farm in Fremont County near the Loess Hills became a source of inspiration for his two books of poetry, *The Noise the Earth Makes* and *Honest Effort*. The myths, folklore, and natural history of the area have found their way into Michael's nationally published poetry, essays, and other writings. His knowledge of the legend of Chief Waubonsie, the Potawatomi who, under very different circumstances, also traveled westward to make his home in the Loess Hills, has become important to Michael's work and to his wide-reaching lecturing and teaching around Iowa.

Dianne Blankenship grew up in Nebraska, where "winter evenings meant trips home from cultural events with Orion, the Pleiades, and other constellations peeking at me from their dark home above. Summer vacations found us vacationing in Colorado among mountain wildflowers and alpine meadows or just driving through deserted farmsteads in Nebraska where I'd pick flowers from long-abandoned gardens." Although she was introduced to the natural world early, Dianne's love of nature and the prairie didn't come to fruition until after she'd married, spent time in New York working as a financial researcher, and then returned to the Midwest to make her home in Sioux City. When she attended her first Loess Hills Seminar, prairie was still a vague concept to Dianne, but through a process of self-education, she has become an ardent prairie preservationist and has won numerous honors for her conservation work. Joined by the efforts of her husband, Bill, Dianne has volunteered thousands of hours to raising the necessary money and consciousness to save Loess Hills prairie tracts from obliteration. When she isn't sitting on the Sioux City Planning and Zoning Commission or serving as a prairie advocate in other ways, Dianne can be found teaching kindergarten in Sioux City.

Farming, the Hills, and Chief Waubonsie

MICHAEL CAREY

The picture of Iowa for many outsiders, at least where I came from, is that it is flat and boring. Imagine my surprise then, when I moved to Farragut in southwestern Iowa from New York City, married a local woman, learned to farm, and each morning found myself staring out toward the silent wonder of the Loess Hills and wondering just who on earth put them there, at the edge of our place, and why.

Thirteen years ago, when I came, parts of our farm were losing topsoil at the rate of twenty-eight tons per acre per year. Certain fields were useless before my wife's family even came to own them. In the last hundred years, half of Iowa's topsoil, perhaps the richest in the world, has been given away by Euro-American settlers and their descendants to the Mississippi River delta. Most of it was transferred in the last thirty or forty years—since soybeans, with their small root systems, became popular and since the modern cash-crop rotation of corn/beans/corn/beans, which omits the old-fashioned insertion of three years of grass or pasture. After years of terracing and no-till farming, our family farm has reduced erosion to about three tons per acre per year, about the weight of the cornstalks that fall so lightly behind the combine.

What outsiders view as static and solid, the insider sees as fluid and changing, as vanishing slowly, like all of us. Even the earth we walk upon has its own slower kind of weather. The longer you are here, the more you feel it. This land is our mother, our brother, our child—we and it growing, at all times, ever closer to leaving.

When I think of Iowa now, I think of the Loess Hills, those "fragile giants" looming up on our western edge. We don't farm them, we farm *around* them. We make our living off lesser slopes and heavier soil farther east, while they just sit before us: green, mute, unfathomable, as if fallen from another world, an older one that remembers but doesn't speak except in hushed tones, and only to those who are receptive and ready.

They are symbols now, as much as anything, untouchable with our implements, diminutive mountains of dust almost, that will blow away as mysteriously as they came if you farm them, that will slump down in terraces even if you don't. Water rushes down chutes in the soil that once housed rotting tree roots and turns the whole thing liquid, dissolving it like sugar.

What could be more emblematic of humankind's mighty but tenuous hold upon the earth—humans, the most transient of transients who, through technology, allow themselves to be filled with an infinitesimal fraction of God's power and glory and then mistake this greatness for their own?

In the thirteen years or so I have lived here, I have come to know every crest and hollow of our southern Hills: the names of the pioneers who first settled them (moving in with clouds of mosquitoes along the swampy banks of the Missouri River bottom), where the houses and churches used to be, how and when each hollow got its name (even though nothing but echoes lives up most of them now), who killed the pronghorn and the black bear and bobolinks, and who were the first of the advancing hordes of white settlers (the news of whose coming was

enough for the government to push the Potawatomi off the land). I watch history now repeat itself as the land and the economy clear themselves of those very settlers' descendants.

Better said, I have come to know what people believe happened or is happening and where. I hear what the remaining inhabitants continue to tell themselves to define themselves and their forebears and the land they live on. Sometimes their stories are more truth than fact, more story than history. Still, they tell me who I am and how I fit in with those I live among. They help me write poetry.

One of the stories I like the best concerns Chief Waubonsie. There are many things around here that bear his name: the beautiful state park outside Hamburg with its tracts of virgin prairie, Waubonsie Mental Health, the Waubonsie Chapter of the Girl Scouts and Boy Scouts, the Waubonsie Optimist Club, etc. When I first moved here, it seemed like it was always Waubonsie this and Waubonsie that. Yet when I asked, "Who was this Waubonsie?" no one seemed to remember. He seemed a metaphor for the Hills. I wondered what he did, what he stood for, if he could speak for me. Most had the vague notion that he was some sort of early camp counselor. So I began asking and snooping around. For better or for worse, this is the picture that emerged.

In the beginning of historic times, it seems, there were not Native Americans indigenous to this far corner of Iowa. Some Sioux probably passed through the area, as well as some stray bands of Sac and Mesquakie (Fox). It is said by some historians that the Missouri River Indians on the Nebraska side (including the Oto, Pawnee, and Omaha tribes) used southwestern Iowa not for settlement but solely as their sacred burial grounds. The Potawatomi, who were here when the first Euro-American settlers arrived, had been pushed here mostly from Illinois and were given the Loess Hills of southwestern Iowa as their home

by the president himself. Then white settlers started to come, and they at first had the notion that if the dark earth of the prairie was only strong enough to push up a few blades of grass, if it could not throw up a huge forest of wood, then it must be a weak and sickly soil. Look for trees if you want to find real farm ground! The Great Plains was first called the Great American Desert. Also, the extensive root system of native prairie plants proved too much for the early primitive equipment, so the pioneers looked west to the light soil of the Hills, where they saw a smattering of trees on eastern slopes.

The threat of imminent, intensive white settlement meant another government treaty and another forced farewell for the Indians. Many were feeling defeated by this time and would give in to anything. Many were ready to fight it out for their new "homeland." There were numerous Potawatomi bands in southwestern Iowa and at times in southeastern Nebraska. From time to time, they would meet and hold council in the bluffs outside the Mormon settlement of Kanesville (now known as Council Bluffs). Chief Waubonsie, it is believed, was the oldest and most respected of the elders. He along with a few others went to Washington, met with President Polk (as Waubonsie had met with President Jackson earlier), and worked out the best and most practical deal possible. Then, legend has it, by the gift of Waubonsie's forceful oratory, he persuaded his compatriots to leave peacefully, to give up their homes and travel to the distant and vague promise of Kansas.

Even now, I try to imagine what he (and the other chiefs) said to get the people to go and to make their leaving not an act of defeat or cowardice but of love and courage and, maybe, defiance. What could he have possibly said that would have calmed the youthful warriors yet at the same time given hope to the hopeless?

It is said that back in the eastern Potawatomi territories (most

notably at the attack on Fort Dearborn) Waubonsie had stopped massacres as they were about to happen, meeting the onrushing braves with nothing but words and successfully turning them around. As a young man he had been a fierce warrior, fighting in many wars and siding at times with the French, the British, and a confederacy of Native American tribes against the United States. It is reported that his friend, the great Shawnee Tecumseh, who was shot by American troops, died in his arms. Yet he met in Washington with both Presidents Jackson and Polk to resolve differences peacefully. His portrait now hangs in the Smithsonian.

The real origin of his name, like everything else, is a murky puddle of stories. He spoke little English, but accounts from old settlers say he defined the name Waubonsie as Light-A-Little or Break-Of-Day. The most repeated story around here of its origin (one told, certain settlers would have us believe, by the chief himself) says that one day, when he was a teenager, his best friend was killed by a neighboring tribe. That night, demented by grief and anger, he stole out of his lodgings and walked the many miles to his enemies' campground, where he silently scalped the heads of that tribe's seven greatest warriors. When his people saw him coming home on the horizon with the sun awakening behind him and the scalps on his belt, they changed his name from Nah-K-Ses to Waubonsie to commemorate the dawn of the new day of peace they were now to live under.

Fact or fiction, the story captures his legendary fierceness and bravery. He was also known as a man of great medicine, a holy man of sorts, which would explain the calm center needed to face down unarmed, as mentioned earlier, a hostile army.

Some reports claim he never returned from his last trip to Washington, that his stagecoach overturned in Ohio and he died en route. I have found, however, sworn testimony of settlers who said they saw him after his return. Most likely, in his

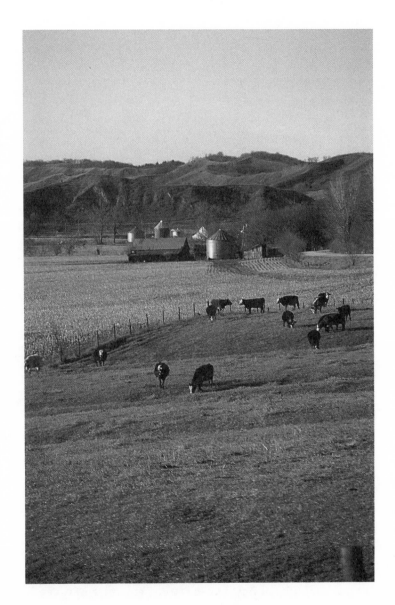

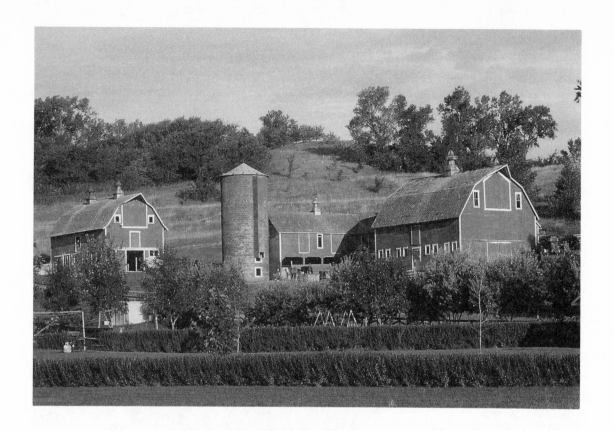

nineties and injured, perhaps dying, he stayed watching over his people's soon-to-be-abandoned campground. When he did finally pass away, those who remained wrapped the body in a blanket and hung it in a tree. A year later, two braves returned and buried his remains under a cairn of stones. Neighboring children had already pilfered all the belongings hung with him. There is nothing left now but the stones and the empty campground hidden in the Hills about a mile outside Tabor. His brother's grave is thought to have been paved over by Highway 2.

In the following poems, I express the timeless image of Waubonsie's story. People were right, I think, to keep his name alive, although they no longer remember why. It is time for the Hills' children, lovers, farmers, townspeople—their whole struggling population—to reinvent the reasons, not only to use and walk upon the land but to love it, for to love the land in a deep and lasting way, as William Least Heat Moon in *Prairyerth* says, is "sooner or later to dream it."

THE FAREWELL SPEECH OF CHIEF WAUBONSIE

I have walked these hills in darkness.
I have walked these hills in light.
The more silent my step, the more I hear
and the more I hear, the more I see
that the dark and the light are the same.

For how many moons has the soft grass
stirred to pad our treading?
How many happy mornings has it woken with us
and waved in a trail of green fire?

Our thoughts then, were the stars
and our laughter, the song of wild birds.
We look to them now, as they look to us,
for guidance.

I can see what the Whiteman
does not, that we are the same—
ourselves, the earth and the heavens,
the blinding light and its shadow.

Some say if we leave now,
the sky will fall harder
than it has ever fallen upon us;
the shadow in our hearts will never leave.
But the sky has already fallen.
See the blue behind your heads;
see, now, the black. And the Whiteman
like locusts among us.

Young men want to paint
their faces black, but
violence is not wisdom.
Old men know this and mothers.

For many long moons
I have listened to the Great Spirit
and I have talked to the Great White Father.
He will give us land again, he says, in Kansas:
cattle, seed and schools.
I am not fooled by such gifts
but we will take them.

The Whiteman considers great
those who take and keep.
We know the mighty by what they give away.
From the moment we were born,
we were leaving, our hands
our feet, our sky—our warriors
were warriors because they gave
us their lives and we prospered.

These bluffs are beautiful sand.
You can make your mark
with your finger in the land
that holds the Whiteman's houses.
Give him your shadow.
Listen to the thunder.
The Whiteman will learn
that is us.

Whatever we touch is sacred.

Wherever we are
is the center of the world.

We are brothers,
we and the Whiteman.
I have seen this.
He, too, has his shadow.

It touches him and all his houses,
and guns, and trinkets. Our
spirit will never leave here
even though our bodies go.
Our shadow will call to the shadow
of the Whiteman and
his shadow will listen
and its darkness will make
what he owns heavy
until his strong arms weaken
and he leaves what he has taken
or it leaves him. Someday.

Day is night. Night is day.
For the Whiteman
for Waubonsie,
Light-A-Little,
Break-Of-Day,
what the earth has given
she will take away.

Go in peace.
Follow the trail
to Kansas.

THE POSTHUMOUS SONG OF CHIEF WAUBONSIE
for Jim & Kathy Andersen

When the time came
I couldn't leave,
even though
I sent my people.
So I sat down
by a log cabin
in a field
in the bluffs
with two braves
beside me.
Day and night,
night and day,
I made them
fill their drums
with thunder.
That is how
the power comes
and when its
dark cloud passes,
everything lifts
its head
and is bright
in the greenness.
North, East, South,
West, my old body
beat its circle.
And when my eyes closed,
they had me lifted
in a blanket
in the sacred oak

above the river.
I don't know
how many moons
I lay there dreaming
while birds came
to do the Spirit's bidding:
hawks and vultures
and owls and eagles.
Soon my flesh was torn and lifted,
my heavy heart, light
with feathers, and now
from where their wings
have beat me, I can see
that even the sadness
that beats through the earth like blood,
even the sadness
that flows in our veins like water,
all the sadness there is,
all the sadness there was,
all the sadness to come
is beautiful,
this land, this world
and all its people.
After a year
they planted my bones
under a pile of stones
in *the beautiful land*,
Iowa.

You who hear me
listen, it may be
that a root
of this tree
lives still
in the beautiful land
you stand on.
Find it,
nourish it,
love it
that it may
spread and blossom
and fill the air
with song.

NOTE

"The Posthumous Song of Chief Waubonsie" was originally commissioned by the Riverside Theatre Company of Iowa City for the play *Dear Iowa*. There are many definitions for the word *Iowa*, but the one I like best is "the beautiful land." Stanza ten of poem one and the last stanza of poem two owe their spiritual insight to the great visionary Black Elk. Although he and Waubonsie were from different tribes, I prefer to believe that the sacredness of their visions transcended specific cultures.

Making Friends with Giants

DIANNE BLANKENSHIP

There was hardly a trail to follow as we left the gravel road and headed up the Loess Hills at the Prairie Seminar near Onawa, Iowa. We walked in single file through the thick brome grass, past the trees that edged the ravine. Starting our ascent, we passed a few more trees and then hiked through lots of brush. The trail was a thin, somewhat uneven path, going mostly up. Suddenly we were above the trees, and the shrubs were behind us. A steady breeze was blowing on the ridge. There was no shelter from the sun, and the sunlight and sky at first dominated the view from horizon to horizon, before giving way to the pleasing undulations of the ridgetop. The vast expanse of floodplain and the distant Missouri River next drew my attention. The hike leader allowed us to catch our breath and take in all we could see. Amazed at the beauty of it all, I felt the trail tugging at me to move on, to follow it along the narrow spine of the ridge. Focusing in closer, I realized that this was something new to me. The Hills were not nearly as green as the brome I'd seen below, and last year's dried vegetation was very visible. Everything had a shaggy texture, with grasses growing in clumps and isolated seed heads providing a variety of textures and shades of brown.

Suddenly the other folks started asking, "What's this?"

The leader looked pleased.

For the next hour I met wildflower after wildflower. Each was introduced by name. Then its special characteristics and secrets were shared. The leader, an expert, was eager to answer my questions and extremely patient when I'd fail to recognize a flower we'd already met. Wildflowers were everywhere—hidden treasures in the grasses. Learning about the wildflowers and realizing that a story goes with each one were inspiring. I couldn't remember much of it, but the seminar was so much fun!

I do remember having this funny feeling about the prairie. I had grown up in what had once been a treeless Nebraska, and I knew the images of *Little House on the Prairie*. But prairie remained such a vague concept. Even after the first Loess Hills Seminar, I visualized the prairie primarily as grasses with some different and pretty wildflowers mixed in. I think it is interesting how few people can recognize prairie, although it once covered more than 85 percent of Iowa. I was certainly confused. I had been introduced to the wildflowers of spring and I'd seen slides of summer and fall wildflowers, but I had no grasp at all of prairie grasses and certainly no idea of how important the Loess Hills and the prairie would become to me.

In small-town Nebraska, both of my parents had taught school for a while, but by the time I arrived, Dad was busy at the family business and Mom was a homemaker. We had an abundance of books, took long weekly rides into rural areas, and annually vacationed in the national parks. We seemed always to have had time to explore and enjoy nature.

At home my favorite place to play was in an undeveloped "woods" that included a creek and former brickyard. Mom established flower gardens everywhere in the yard, and Dad started growing vegetables when he retired. I remember being

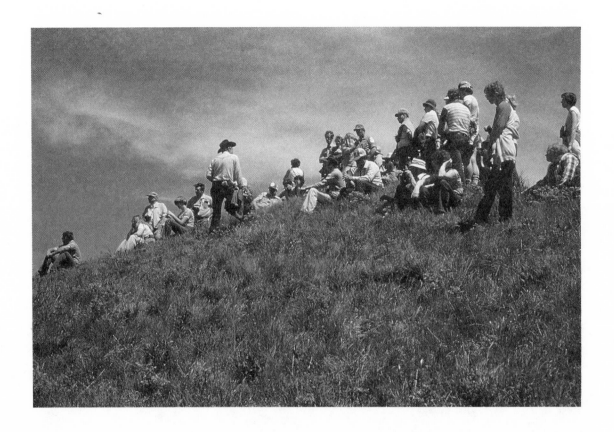

given a space to plant some seeds as a child. I loved to work in the dirt. I loved the solitude and the big sky overhead. It was in that little garden of my own that I felt the presence of God. I attended church all the time, but God was outdoors. No doubt about it!

I enjoyed flowers as a child. I picked wildflowers that were destined to wilt on our car's dashboard. At college I took botany, but only to meet a science requirement. Truthfully, age fifteen to thirty, my outdoor experiences were very limited. They included a few camping trips, visits to a few gardens, several visits to Central Park during my four years in New York City, and a few trips to parks in upstate New York while living in Rochester.

I'd married during college and started a family. My career went from financial research and writing, back to student, and then to teaching. My husband, Bill, pursued his medical education during our first ten years of marriage. Our return to the Midwest was to begin a new era of home ownership. This, of course, meant having a yard and garden. We selected Sioux City because of its excellent medical community and its proximity to grandparents. It was a nice size, with an urban and rural mix. I liked the open space. I was aware of hills but not of the Loess Hills. I was not aware of prairie at all.

At first Sioux City took some getting used to. House selection was determined by the need for a level block with sidewalks

for tricycles and Big Wheels. Terraces and retaining walls in the back provided garden space. The parks were hilly. The streets were hilly. The first winter's ice meant negotiating a new, safer route to work. Taking walks required considering the return trip.

My first teaching position was in Riverside, on the western edge of Sioux City. At a school function, I met Larry and Carolyn Benne, both of whom worked at the Western Hills Area Education Agency. A Loess Hills Prairie Seminar was being planned through the AEA. It sounded as if it would make an enjoyable family outing.

The seminar was great! It was a small gathering of people who quickly got to know one another. Four experts shared their knowledge. Sylvan Runkel, one of Iowa's foremost naturalists, introduced us to wildflower citizens and the woodland community. Jean Cutler Prior of the Iowa Geological Survey educated us about Loess Hills geology. Dean Roosa, then State Ecologist of Iowa, told about how special Iowa and its prairies are, particularly those in the Loess Hills. Roger Landers, an Iowa State University botany professor, taught us about the plants. Carolyn Benne tied everything together at a personal and spiritual level. Her contagious enthusiasm permeated the seminar.

I came away from that seminar having fully enjoyed myself and having made a connection with the natural outdoors. It seemed amazing that flowers could grow without being planted and that a community of plants and other organisms could actually act together to improve the soil. The garden and agricultural approach had dominated my thinking for so long that this really felt new. Nature seemed so miraculous. It brought back those feelings of awe and closeness to God I had experienced so long ago.

Following this first introduction to the prairie, my concepts of this ecosystem and the Loess Hills were not very clear. I was still one of those people who lives in the Hills but believes that *the* Loess Hills are somewhere down by Onawa. Since I'd lived naively for so long, it took a while to assimilate these new concepts into my understanding. In particular, I needed more firsthand experience.

The experience my husband had at the seminar was similar to mine. Bill had also been raised in small-town Nebraska in a home with an emphasis on books, learning, and education. His family had also taken many vacations. But not until our own family's vacation later that summer did it become evident that we had both been smitten by wildflowers. Suddenly each nature walk, interpretive center, and bookstore became only as interesting as its information about wildflowers. We purchased several wildflower guides and began exploring on our own. What pride we had as we added species to our lists of plants identified! Campgrounds, roadsides, each new location was a potential site for additional flowers. Bill took slides of many. We had found a new hobby.

But again the transferal of this interest to Sioux City, the Loess Hills, and Iowa's prairies was not immediate. It would take a few more years of visits to Stone Park and a few more seasons of participation in prairie workshops and seminars before we'd realize we need not travel hundreds of miles to enjoy wildflowers. We could stay close to home. We could experience Iowa's woodlands and prairies on a free afternoon. We could explore them at will in Sioux City. They were beautiful.

Meanwhile, we decided to purchase property for a future home site. We looked at many acreages in Sioux City, including one next to Briar Cliff College and one on the northern edge of Sioux City. We bought the latter property. We had hiked the area and had been told by the seller that it was prairie, but somehow the concept just didn't sink in. This property clearly offered the best southeast-facing hill for an energy-efficient home. As

we were closing the deal, we traveled one October weekend to a prairie workshop in Kansas. When we returned, we visited the property and were in shock. It was prairie! We'd been told that, but we required an introduction to prairie grasses in Kansas to recognize these same grasses in our own backyard. So no home has been built there. We manage the prairie and might someday build a house on a disturbed area nearby.

The Loess Hills Seminar had introduced us to spring wildflowers and we'd started meeting mountain wildflowers on our vacation, but we hadn't gotten to know fall prairie. Prairie wildflowers dominate throughout the growing season, gradually getting taller as the year progresses and as the grasses grow. Then suddenly in late August through October, the grasses reign, creating a very pleasing display. Echoing the rich colors of the sunset, their bunches transform the Hills into bumpy mounds from a distance, which upon closer inspection display flowers of purple and gold and white. In Kansas I'd learned to recognize a few of these grasses, and sure enough they were on our Hills! Additionally, the Kansas experience had been a "Save the Tallgrass Prairie Conference" and had intentionally tried to whip up sentiment for prairie preservation. Although we hadn't participated in the political workshop, the enthusiasm for prairies certainly had its effect on us.

It felt wonderful owning prairie. During the winter, I looked through what was quickly becoming a sizable collection of field guides of wildflowers. I read the short snatches on each flower, especially flowers that grow in the Great Plains. Since many of the Loess Hills are steep, are exposed to the hot afternoon sun and drying wind, and drain well, they support plants more like those found a hundred miles to the west and less like the rest of Iowa, where tallgrass prairie used to dominate. Loess Hills prairies are usually described as mixed-grass prairies, which include many tallgrass species.

That next spring couldn't come too soon. I was eager to find out what plants existed in our prairie. I visited our patch regularly and recorded in my journal each new bloom as it was identified. I couldn't assess the quality of the prairie; I didn't have an eye for that. That would take a person with much more experience. I was learning and having a great time of it. I was enjoying myself so much that I even wrote poetry as I visited our prairie.

I later attended an Audubon Society meeting in Sioux City at which Ted Van Bruggen, a University of South Dakota professor, discussed prairies. He suggested some indicator species that one might use when identifying a high-quality prairie. I also took my journal to the North American Prairie Conference in Missouri the next summer. When people were being kind, I'd get it out and show them the species we'd identified on our patch, getting their opinions about it. I also shared my poems, and some were published the next year.

Late one summer we invited Larry and Carolyn Benne for a picnic on our land and, of course, a hike on the prairie. Carolyn was her usual self, always a learner, keenly interested in the plants as we hiked from flower to flower, trying to recognize each one. She created an attitude of discovery, of joy and excitement at unraveling the mysteries of nature.

A few days later came news of Carolyn's sudden and unexplained death at the age of forty-one. I was not surprised when Rachel Carson's quotation was included on the funeral pamphlet: "If a child is to keep his inborn sense of wonder . . . he needs the companionship of at least one adult who can share it, rediscovering with him the joy, excitement and mystery of the world we live in." Carolyn had kept her inborn sense of wonder and had shared it with thousands of children through her work. With adults, she had a similar effect. She really had helped me rediscover that childlike quality. A love of nature—of prairie and the Loess Hills—was seriously taking an important position in my life, largely as a result of my experiences at the annual Loess Hills Seminar begun by Carolyn Benne.

It seemed only fitting that a natural area in the Loess Hills should be preserved in honor of her. This time a professor from Briar Cliff College told Bill and me about the prairie adjacent to the school—the same land we had visited in a realtor's four-wheel-drive jeep. Earlier we had been oblivious to its being prairie, but now we knew. Also, we knew the realtors had been unable to sell any lots or acreages in the 156-acre parcel. A bank was taking it over. How to preserve this Loess Hill prairie in honor of Carolyn Benne was to be my next challenge, one that would take several years to accomplish.

How does one even begin to preserve and manage a prairie? The prairie near Briar Cliff College was located in the city, which complicated management issues such as prairie burns. We already owned one prairie and knew what a task management can be—from fencing and burning to cutting sumac. The complexity and size of the prairie near Briar Cliff would necessitate an existing organization to manage it over the years.

After some discussion, the Nature Conservancy (TNC), a conservation organization dedicated to preserving natural areas, purchased an option to buy the property. I sat back as time flew by and the option expired. It took some urging, but after several months another option was purchased. TNC was skeptical that the necessary money could be raised, so I created a handwritten letter which I decorated with drawings of prairie plants. I mailed copies to all kinds of people who had known Carolyn Benne from the Loess Hills seminars and solicited pledges in support of the project. My husband offered a generous donation to start the fundraising. It was a "go" this time, and the next phase of my life began.

Management work commenced, and I organized work parties at what by then was named the Sioux City Prairie. At that time, thistles were a problem along one border. These quickly disappeared with the cessation of overgrazing and the introduction of the labor-intensive removal of seed heads. We pulled them off with leather gloves and hauled them away in garbage bags. A highlight of our field efforts was sighting the prairie moonwort, a newly discovered plant species. The fern had first been found during the Loess Hills Seminar the year before. The discovery brought professors and graduate students from Iowa State and the University of Michigan to Sioux City. We all had a fantastic time combing the Hills for more of the fern, which we did find.

Meanwhile Bill and I tried to learn everything possible about the Loess Hills and prairies. Bill registered for the plant taxonomy course at Iowa Lakeside Lab on Lake Okoboji. I accompanied him and drove home weekly to mow the lawn, do the laundry, and do management work at the prairies. I did not attend the classes, but I got to attend most of the field trips. Being with young, bright college students and leaders in the natural sciences made it a very stimulating summer. We had developed the ability to recognize prairies by car at up to fifty miles per hour. The time for the trip to Okoboji depended entirely on how long we spent stopping to visit native plants next to the railroad tracks, a prime site for prairie remnants.

That winter, meetings about the prairie brought together many interested local people who were eager to help with different studies, and by the next summer prairie studies were in full swing. I helped with the plant transects. One group was busy studying the early morning bird life to determine breeding species. Their findings were later published in *Iowa Bird Life*, the journal of the Iowa Ornithological Union. Tim Orwig, of Morningside College, identified fifty-six species of butterflies at the Sioux City Prairie, several of which were threatened species in Iowa.

I knew that I would need to keep everything going and lead the least-desired task related to any project—fundraising. I created a slide program with my husband and took it to service and study clubs. Sometimes we were able to do programs together, but usually I was alone. Bill took on the task of writing weekly wildflower articles for the Sioux City newspaper as I scampered about locating information on individual prairie species in dozens of reference books and field guides. We led countless prairie hikes, I introduced many children to the prairie through on-site activities, and I organized extensive Iowa Prairie Heritage Week activities. I also created a packet of enlarged photographs with short commentary to introduce local third graders to our prairie heritage.

Asking for money meant writing letters and bringing in lots of checks of all sizes. Mailing lists were created by a committee. One time I organized a massive personalization of the letters before they were to be mailed. Dozens of people added notes to the letters. It took several years and some generous help from TNC, but the campaign finally was successful and the Sioux City Prairie became permanently preserved. Donors and workers were known as Friends of Sioux City Prairie, and I kept them informed through a newsletter.

But a prairie does not just get preserved—it needs to be managed. Many problems beset Loess Hills prairies: invasion of woody species including cedars, invasion and proliferation of plants introduced from Europe and Asia, destruction due to development, and degradation from overgrazing. Sioux City Prairie is threatened by a very aggressive noxious weed, leafy spurge. I spent innumerable hours on the hottest summer days on "spurge patrol"—dressed in long sleeves and pants, squirt-

ing leafy spurge with herbicide in an attempt to control it. It would decrease for a time and then gradually rebound if not retreated. Thankfully, TNC has mapped all infestations and now has a roving group of workers who visit the prairie and accomplish in two days what it took me weeks to do.

I was just one of many people who learned a great deal while working on the Sioux City Prairie. There was never a shortage of willing volunteers when something needed to be done. Most of these people came from the Audubon Society and Sierra Club. Their dedication and their support of this local project were essential to its success. Also, the Woodbury County Conservation Board's cooperation with TNC in managing the prairie has been extremely valuable.

My knowledge of and concern for the Loess Hills did not develop quickly. A sensitivity in viewing the natural topographical features of the Hills took some time. Skilled recognition of plant communities took even more time to develop. It took many experiences, much education, many "rubbings of elbows" with experts who were generous with their time and talents. It took a childhood that had prepared me to appreciate nature and had encouraged me to be a hard worker and a learner. It took an understanding family that enjoyed the Hills and prairies and encouraged my conservation passions and commitments. It took friends and colleagues who shared my interest or who were willing to learn.

My wish is that more people will come to recognize and appreciate native prairies and the Loess Hills natural topography. If people could learn to distinguish these from brome fields and altered hills, they would realize how few such native areas still exist. We've lost almost all prairies in Iowa, and the prairies that remain are worth protecting in some way. Protecting does not have to mean public ownership—private landowners can effectively manage natural features.

When I drive Interstate 29 from Sioux City to Omaha, my eyes are constantly drawn to the Hills. I look for changes, alterations, differences in species due to different uses. I cherish the times I'm able to drive the smaller scenic byways, which run close to the bluffs and into the rural Hills. I am particularly drawn toward the "first bluff" prairies that exist on the steep face adjacent to the Missouri River floodplain. These prairies are highly visible, scenic, and botanically significant due to their extreme exposure to the elements. Unfortunately, these prairies are very diminished in size. As I gaze up at the prairies that struggle to survive, I wish I were dressed for a climb and had the time to go up and take a look. I remember climbing similar bluffs with botanists and vividly recall the thrill of discovery at the top. I am sometimes overwhelmed by the sense of urgency to get these prairies into management before they are lost to invading trees or development projects.

My eyes are always scrutinizing the Hills, searching for the natural prairies and undisturbed features, and I am saddened by the wounds brought on by "progress." Fortunately, through educational and organizational efforts, a different kind of progress is being made in increased awareness and protection of the Hills.

I remain committed to the Loess Hills and prairies. And I don't pick wildflowers anymore.

PLANTS AND SURVIVAL IN THE HILLS

These fragile giants are no place for the timid or meek or for lovers of the easy. Wind beaten, one day parched by the sun's scorching heat, the next washed with gushing torrents of water, only those with strong resolve have been able to cling to the Hills and call them home. Today, as a group, they constitute an odd assortment of plants and animals much more typical of drier areas to the west than of Iowa, an assemblage found in Iowa only here on the steepest and driest bluffs of the Hills. Many of the species have migrated here from western plains and are at the eastern edge of their distribution; many are rare. As a group, they parade their multiple adaptations to this harsh climate: their forty-foot roots, their thick waxy coverings or whitish reflective hairs, the burrows where they escape the sun, their ability to become dormant when water is scarce. The following two essays examine some of the unusual native inhabitants of the Loess Hills and question how through the millennia the Hills became home to such a unique assemblage.

Donald R. Farrar, professor of botany at Iowa State University, came to Iowa from Missouri by way of the University of Michigan, where he received his doctorate. A widely published fern expert and co-author of *Forest and Shade Trees of Iowa*, Don knew nothing of prairies when he first came to Iowa. The discovery of the prairie moonwort (a fern) at the Loess Hills Seminar in 1982 changed that. Finding a new higher plant is now quite rare in the United States. Thus, Don was drawn into describing, naming, and studying this tiny fern and also into seeking it elsewhere. He and his colleague, Cindy Johnson-Groh, annually monitor over a thousand marked plants in Iowa and Minnesota, following their response to different prairie management practices. Don reports, "I had never really appreciated the complexity and tenacity of prairie communities until we began the moonwort studies. Then it became necessary to establish intimate familiarity with prairie vegetation and its history. Now prairies, particularly those in the Loess Hills, have become very special to me."

Lois H. Tiffany, chair of the Department of Botany at Iowa State University (where she received her doctorate), reports that she first became interested in the Hills long ago, while on a field trip with students to Waubonsie State Park. "It was one of those warm, crisp fall days, and we hiked out to the western bluffs that drop off to the Missouri River bottoms. As we worked our way among the bunch grasses, I noticed a bright pink-orange area on the moist ground—a soil lichen. I dropped to my knees to look carefully. I had read about them but never really seen one. I was hooked."

Since that day, Lois—a much-honored professor and expert on Iowa's fungi—has collected lichens extensively in the Hills and co-authored a book on midwestern mushrooms. Anyone who attends a Loess Hills Seminar warmly remembers Lois, her vasculum over her shoulder and a smile on her face, leading field forays during which she shares her intense love of small, simple plants. "The seminar groups are so responsive, such a joy to work with, even in the occasional year when we foray in the rain," Lois states. "I think I am basically a prairie person—I feel at home in wide vistas with their endless horizons, especially those of prairies undulating over the Hills."

Time, Cycles, and the Prairie Moonwort

DONALD R. FARRAR

Winter's gym workouts seem never to prepare me for the first big hike in the spring, especially this one in the Loess Hills. Down one hill, up the next, down again, and now up the third and highest ridge. Fortunately, a biologist can always find something along the trail that requires investigation, a pause for closer inspection, a time to catch one's breath.

My botanist colleague Cindy Johnson-Groh and I left Sergeant Bluff at seven o'clock this morning. Each year we stay in this little town along the Missouri River in western Iowa, appropriately named for the prominent bluffs of loess soil that erupt from the Missouri River floodplain along its eastern border. This is our seventh year to return to the Loess Hills, to the Nature Conservancy's Five Ridge Prairie, to study the mysterious prairie moonwort. And just ahead, just over the crest of this third ridge, is the first of our study plots.

What will the moonworts be like this year? A year ago the plants did not look good—there were fewer than usual, and the ones present were unusually small. We think this was because of exceptionally hot and dry weather the preceding summer. Our records indicate that one summer month with above-normal temperatures and almost no rainfall is enough to cause poor growth of the plants the following spring. Last summer was exceptionally cool and wet. Will that be reflected in especially good growth this year?

But why, in the first place, are these tiny ferns growing in Loess Hills prairies where, by midwestern standards, normal summers are hot and dry and where drought is exacerbated by the porous loess soil, the steep topography, and the exposure of the prairie vegetation to hot sun and drying winds? Until the discovery of the prairie moonwort in 1982, no ferns were known that grew primarily in natural prairies in the Midwest. We still don't know why this one does, but our studies are beginning to answer some questions and to suggest a fascinating history behind the current presence of this species in Iowa's Loess Hills.

Other fern species of the moonwort group, *Botrychium* subgenus *Botrychium* in botanical Latin, can be found in northern regions across the United States and Canada. Mostly they grow in forests, but a fair number of them seem to prefer grassy vegetation not totally unlike the Loess Hills prairies but differing in location—grassy meadows around northern lakes and especially meadows at high elevations in the Rocky Mountains. They thrive there in the brief warm and wet summers, conditions similar to those present in the Loess Hills for only a few months in spring. And that's when you must visit the Loess Hills to see the prairie moonworts, between the first of April when their leaves begin to emerge from below ground and the first of June when the leaves wither after shedding spores which, if conditions are right, will produce more plants in future years. During the other ten months of the year, when the climate is much harsher for ferns, their stems and roots lie dormant underground.

Is it possible that the prairie moonwort ferns of the Loess

Hills, now in a habitat so vulnerable to summer heat and drought, arrived in Iowa at a time when the general environment was more similar to that of their northern and western relatives? The Hills are ancient. Their origin certainly dates back to a time of different climate, in fact, to a 'time of climate so northerly that great glaciers covered the northern United States and most of Canada. Then the Missouri River must have run milky white with its load of glacial flour, tiny grains of rock ground by the glaciers into dust-sized particles. During the summers, when melting ice and snow swelled the river beyond its banks, the Missouri would have spread glacial flour across its broad floodplain. When winter temperatures halted melting and the river settled between its banks, the flour was left to dry and to be picked up by west winds. Most of the flour, now called loess, and especially the largest particles, was dropped when the winds met their first obstacle on the eastern edge of the floodplain. Thus, the Loess Hills were built, like enormous drifts behind a gigantic snow fence.

Dust-sized particles of loess were also blown beyond the Hills and deposited as a thin mantle across the state. However, no loess is present in central Iowa north of Des Moines, in the area called the Des Moines Lobe, where the last glacier in Iowa still covered the land 14,000 years ago. From this we can deduce that building of the Loess Hills through loess deposition had ceased before that glacier began its final northward retreat. Fossilized pollen, needles, wood fragments, and even, in one site in western Iowa, buried stumps from this period until about 10,000 years ago indicate that spruce forests first covered much of Iowa after the retreat of the glaciers. Prairies did not become widespread until later, about 9,000 years ago in the Loess Hills, but it seems likely that grassy openings, especially on the steep western slopes of the Hills, would have been present during the earlier cooler times. I can picture, in these early Loess Hills,

grassy meadows surrounded by spruce forests much like the verdant fields in the midst of Englemann spruce now present at Cameron Pass in northern Colorado. Several years ago Cindy and I were taken by Denver naturalist Peter Root to observe three species of western moonworts thriving there among the luxuriant carpets of grass and mountain wildflowers. I find it intriguing to think that perhaps 10,000 years ago, when Iowa's climate was more benign to ferns, the meadow-loving prairie moonworts may have first migrated onto cool grassy slopes in western Iowa. As Iowa's summers steadily became warmer and drier, the plants would have gradually adjusted their growing season to that time of year when their Iowa home most closely matched the habitat of their mountain-meadow relatives.

Back on the trail, Cindy and I reach the crest of ridge three and get our first good look at this year's prairie growth. Last summer's weather set records in Iowa for the absence of hot, dry periods. Will last year's abundant rainfall and cool temperatures result in a strong showing of prairie moonworts this spring? We don't have to wait long for an answer, as we head through open prairie toward our first study plot. In poor years the ferns seldom reach a finger's length in height, a fact which undoubtedly accounts for the many years they remained undetected by biologists working in the Loess Hills. But this year, before beginning a serious search, we already spot several robust individuals poking through last year's dried grasses. In our first study plot, analysis of the plants tagged in previous years supports our notion that this is going to be a good year for moonworts. The ferns are larger than average, and there are many new individuals, a distinct turn-around from a year ago when we recorded almost no new plants. And this year, although it's after June 1, the plants are still fresh and green, a week or two from withering, indicating that the weather has remained unusually wet and cool.

After a morning of locating and measuring moonworts, lunchtime on the prairie brings further opportunity to muse, to sit on a ridge crest and let our minds be drawn by the sights and sounds of prairie life. These also tell us that the hot, dry weather typical of Loess Hills summers has not yet set in. We hear the usual wrens and robins, but this year we don't yet discern the high-pitched song of the grasshopper sparrow which emanates from these prairies each summer. The early-blooming pasqueflower or prairie crocus is just now sending up its silky seed heads, the Missouri milk vetch which is usually in fruit by now is just beginning to flower, and the skeleton weed—whose leafless green stems are easily missed except when flowering—is still nearly invisible. Unlike prairie moonworts, these species thrive in the summertime heat and drought of the Loess Hills, conditions which this year have not yet arrived.

It seems almost instinctive that when musing on these prairies I look westward, toward the hot sun and the source of the dry winds and also toward the source of the drought-tolerant species which give these prairie communities their distinctive character. The yucca, scarlet globemallow, ten-petaled blazing star and nine-anther dalea, the western prairie clover, and two dozen or more other plant species; the plains spadefoot toad, prairie rattlesnake, northern grasshopper mouse, and white-tailed jackrabbit, all are more generally found on western plains. And it is not simply that the Loess Hills region forms the eastern edge of most of these species' ranges. Traveling eastward from Wyoming or western Nebraska, you cease to find these plants and animals in abundance long before reaching easternmost Nebraska; then here they are again, displaying themselves in fine form in the western hills of Iowa. Why?

Certainly the drought-prone loess soils on the steep west-facing exposures provide a habitat with conditions similar to those of soils far to the west, but is that as much as these pecu-

liar residents of the Loess Hills can tell us? How did western species get from there to here? If we could read a family history written by one of these species, would it recount a long march to this eastern outpost? Would it tell of relatives left behind, of communications broken? Would it speak of a time when a climate drier than now was widespread across Iowa and eastern Nebraska, at that time bridging the gap in distribution that currently exists between the Loess Hills and the western plains?

The probable answer to this last question is yes. Fossil pollen records from Lake Okoboji in northwestern Iowa present unmistakable evidence that a change from forest to prairie vegetation occurred in that area about 8,000 years ago. Perhaps a thousand years earlier prairies first spread over the Loess Hills. That transition heralded the beginning of a march of prairie vegetation across the Midwest which, at its maximum, reached into Ohio. The result was the tallgrass prairie so well documented throughout the Midwest by the first Euro-American settlers. But the fossil record tells more. From about 6,000 to 3,500 years before present (and somewhat earlier in the Hills), the climate reached its warmest period, averaging about 7°F warmer than now. When I imagine an Iowa summer where every 95° day becomes a 102° day, I have no difficulty in believing that this ancient elevation of temperatures escorted species of the western shortgrass prairies into western Iowa. Did these species settle in the Loess Hills as a last refugium when eventual change to the present climate made the surrounding country inhospitable? How long will they remain in the safe embrace of native Loess Hills prairies?

The prairie moonworts, with their love of moist springs, along with the many drought-tolerant western species, form a community of survivors. They have survived many wet and cool summers like this one, when woodland species accelerated their encroachment upon the prairie. They have endured the

hottest and driest of epic droughts and thrived. They have witnessed the turn of countless seasons and tolerated global climate change. And still they are here. They are uniquely suited for life in these Hills.

Immersion of the mind in this prairie stirs deep feelings. For some it rekindles a precious relationship with nature and a sense of belonging. For me the strongest feeling is a profound sense of time and cycles. I try to understand the existence of a tiny fern through the study of yearly cycles, and I am drawn into contemplation of cycles so endless and so large that I question the possibility of ever truly comprehending them. I consider the events of geologic time that must be included in explaining the presence of these Hills and the plants and animals that are their native residents, and I realize that even this is an infinitely small span of time in the history of our universe.

Tiredness that comes with evening contains the comfort of renewed communication with the Hills. Yes, this is a good year for prairie moonworts. It will be a good year for grasshopper sparrows, plains pocket mice, and spadefoot toads. It will be a good year in the Loess Hills for skeleton weeds, tumblegrass, and buffalo berries. It has been another good year for me, and I'll be back, next spring, not only to check on the prairie moonworts but also for my annual dose of humility and rejuvenation of spirit fostered by these Hills.

Lichens: Partnership in Survival

LOIS H. TIFFANY

It rained in the Loess Hills last night, a quiet, tentative, almost reluctant drizzle from gray skies. This sunny morning everything on the prairie is soggy and sparkling with reflected water. My jeans become soaked and chill my legs as I slowly make my way upslope; I am grateful for the warmth of the early summer morning. The prairie around me is a green world, shades of that color forming irregular patterns of height and texture. Tufts of the prairie grasses, visible at a distance, cut sharp accents against the slopes. The brilliant flowers that will make a dramatic tapestry of the later summer prairie—the purple spikes, the creamy clusters, and the many shapes and shades of yellow—are not yet born. Farther up, on the ridge, the yuccas have already flowered, and fat green seed pods are developing in regular rows along the stalks.

Between the clumps of prairie grasses, the soil lichens lie in a diverse mosaic of shape and color. Smooth and mottled, the rounded to angular segments are dark greenish black, bright green, or even pinkish orange. Interlocked mounds of color, they cover the soil surface. These inconspicuous inhabitants are well adapted for survival and colonization in this harsh, desertlike Loess Hills terrain. When the searing summer sun bakes the Hills or the harsh winter winds rake them with driven sleet and snow, the lichens are exposed, dried, and almost crisp. Their necessary life-sustaining activities can proceed at a low survival level indefinitely. They are incredibly tough and tenacious but also small and vulnerable. The erosive hills share their vulnerability.

Before the first raindrops fell late yesterday afternoon, the shriveled lichens lay drab and obscure. As the rain continued, the lichens absorbed water, swelling and sealing the soil surface. Later, as water flowed between the clumps of prairie plants, the underlying soil remained in position, covered by the expanded lichen blanket. Rain in the Hills is often a mixed blessing, necessary for life but destructive, removing soil as it flows down the steep slopes. The inconspicuous lichen cover helps to hold the Hills intact, stabilizing the soil between the clumps of grasses, maintaining that environment.

I carefully kneel for a closer look, then drop flat on the soggy ground for an even better entry into this lichen world. From this intimate viewpoint both similarities and differences of lichens are apparent. The individuals appear like flat chunks tightly sealed to their neighbors or like tiny overlapping lettuce leaves set at a ninety degree angle to the soil surface. As I move carefully to view them in a different light, I see darker circular areas on the surface of some of the flat lichen discs. Others have slightly rounded, cuplike areas with a rim the same color as the lichen but with the cup's inner surface colored differently. When sprawled full-length on the warm, wet prairie slope, an observer has no hint that these inconspicuous living pebbles are a unique happening, a compound organism involving a cooperative enterprise that was first established millions of years ago.

The Loess Hills soil lichens, like all lichens, are composed of two distinctly different living entities, a fungus (the mycobiont)

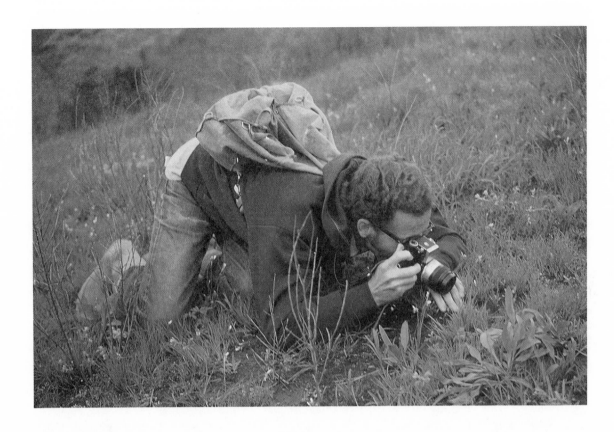

and a green or a blue-green alga (the phycobiont), combined to make a discrete, distinctive organism. The resulting lichen has little resemblance to either the free-living fungus or to the alga. The two organisms are interwoven in a typical arrangement best recognized and understood when the lichen is sectioned and examined under a compound microscope. However, one can see an indication of this internal structure if a single plant (thallus) of a soil lichen is carefully separated from its neighbors, then cut at a right angle to the surface. The view is somewhat like looking into the cut edge of a sandwich with a green filling between bread slices of different thickness. Below a relatively thin upper layer is a distinct green band, then a thicker lower layer that lies in contact with the soil. The algal cells concentrated in the green middle band are spherical, scattered in a loosely interwoven mesh of fungal threads. Similar fungal threads (hyphae) are more tightly compacted to form the upper and lower layers of the lichen. Clumps of hyphae often form ropelike strands which extend into the soil like anchors.

In a few of the soil lichens that are common in the Hills, there is no such middle layer of concentrated algal cells. Instead, scattered short chains of globose algal cells held within a gelatinous sheath intertwine randomly and loosely among the fungal threads. Surface layers of fungal hyphae alone, if present at all, are inconspicuous. Thus, a cut slice of this lichen looks uni-

formly pale green and has a less firm, almost gelatinous feel. The blue-green algal component of these lichens is capable of fixing nitrogen, thereby increasing the available pool of that necessary nutrient for other plants. Prairie legumes are the major nitrogen fixers in the Loess Hills; however, soil lichens may also be significant nitrogen contributors in local sites where these lichens are the only nitrogen fixers present. Elsewhere, these lichens may contribute to the available soil nitrogen in subtle partnership with a variety of prairie plants.

In both types of soil lichens, the algal cells, utilizing the sunlight that penetrates through the fungal surface layer plus carbon dioxide, water, and nutrients—some channeled to them via the fungal partner—build complex compounds that are essential for both alga and fungus. In the laboratory, cells of the two partners can be separated and grown independently. The algal cells—identical or certainly similar to the independent green algae of freshwater habitats—do well, given appropriate conditions in culture. However, the highly modified and dependent fungal partner typically grows slowly, if at all. Commenting on fungal partnerships in his book *The Molds and Man*, C. M. Christensen writes:

> Fungi have had a far longer space of time than we have had to explore the possibilities involved in partnerships. Some of their cooperative associations were going concerns at least 350 million years ago, long before man was even a gleam in the cosmic eye. They afford us an insight into biological teamwork and the subtle exploitation of one partner by another, and so it is both interesting and instructive to see what they have done, and who has done what to whom.

I think of other times in semideserts similar to the Loess Hills where I have lain flat on the ground, my face inches from the soil surface and my mind cataloging lichens. On the ground of Squaw Flats in Canyonlands National Park, Utah, surrounded by sandstone turrets and domes, and on the slopes along Green Gulch in Big Bend National Park, Texas, not far from agaves and junipers, I have seen the same mix, the same mosaic of flat lichens covering the soil between widely scattered plants. Many of the lichens are identical to those of the Loess Hills, as well as to lichens growing in similar habitats anywhere in the world. In those semiarid areas, where these lichens are referred to as cryptogamic earth, they accomplish the same significant function, maintaining the soil in position even when summer thunderstorms rumble through and lash the ground with sheets of rain.

Not all soil lichens are so inconspicuous. In some shortgrass prairies far to the west of the Hills, there are also larger, flat, lobed lichens only loosely attached to the soil like irregular green plates. They branch and grow from the edges of the lobes, forming plants that may be several inches in diameter. An edge view of a slice from one of these lichens would again be like a sandwich with a thin green filling of algae. Drab gray-green, curled and almost crisp during the dry periods of summer and the cold days of winter, these lichens also absorb water quickly when it rains, swelling and becoming a vivid green. Lichens are opportunists and survivors, regardless of size or shape.

Even more conspicuous are the soil lichens sometimes called reindeer mosses. They are present on this Loess Hills prairie only as clusters of thin, pale green, upright lobes. However, on sandland areas along the Mississippi River in eastern Iowa, these lichens grow like miniature forests of crowded, upright, highly branched plants, often three to four inches tall. Reindeer mosses are the groundcover plants in the broad, treeless areas of many of the cold regions of the world, a major food source for animals in those locales. Some reindeer moss lichens have thin, white-bordered, scattered leaflike pieces on the pale green branches, exactly like those lettuce-leaf-like clusters on the

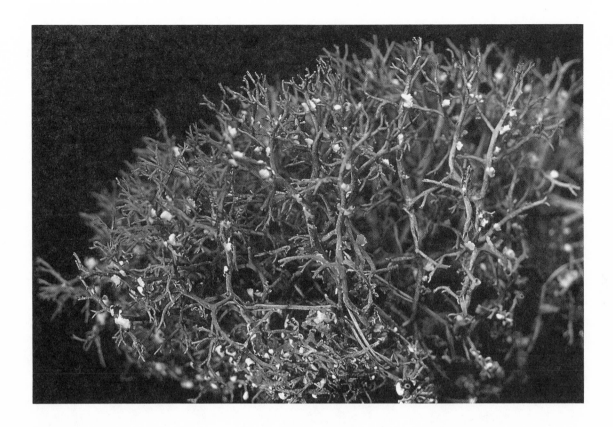

Loess Hills prairies. Others branch from the edges of funnel-shaped stems, the branches ending in expanded cups, the structure becoming ever more gracefully sprawling. These "pixie-cup" lichens have a special charm. Another group, usually less elaborately divided, has thicker branches ending in a cluster of tan-brown or brilliant scarlet red lobes. I can see these lichens from a standing position, an advantage during a wet morning visit.

Soil lichens, in common with most other lichens, grow slowly, often only fractions of an inch each year. The fungal partner eventually produces fungal reproductive cells, spores, in special fruiting bodies buried in the lichen thallus or in the flat saucerlike structures on the upper surface of the lichen. In free-living fungi, spores like these would be carried by the wind or water, eventually germinating by threadlike hyphae and forming a new individual if the infant fungus can find food at its landing place. But the lichen fungal spores have no associated algal cells sharing their journey; thus, the spores cannot reproduce the lichen and are simply wasted. In contrast, lichen reproduction occurs when tiny pieces of the lichen—clumps of a few algal cells held together by a network of fungal hyphae—are blown or carried by wind or water to new sites. Chances of a successful journey are indeed precarious and the odds do not favor survival of the lichen, but the presence of the same lichen

species in similar habitats throughout the world is proof of success.

I linger, my chin now on my arm, pondering the microcosmic world before me. Why are these lichens so important to me? They have captured my curiosity, become almost special friends. Each time I return to the Hills, I am compelled to visit particular slopes to be sure certain lichens are still there. So stable, so cosmopolitan, yet so very fragile. They can be destroyed in seconds by the sliding foot of a hiker, by the spinning wheels of a vehicle. They can be regenerated, but lichen time moves at a painfully leisurely pace. Once damaged or destroyed, reconstruction is a precarious gamble. Carefully, I rise. Carefully, I move up the prairie slope.

REFERENCE CITED

Christensen, Clyde M. 1951. *The Molds and Man*. University of Minnesota Press, Minneapolis.

VISIONS OF THE HILLS

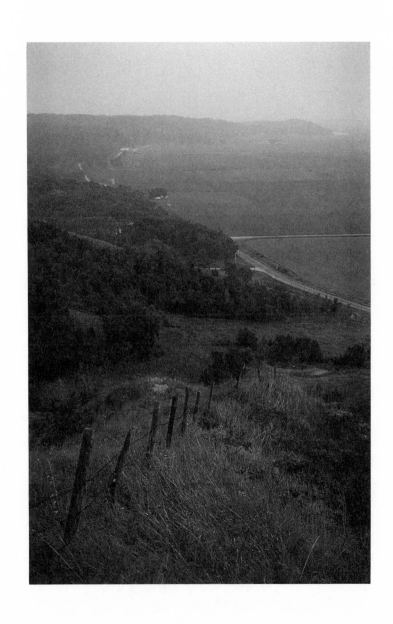

To any who love the Hills' natural features, the prairies shine as the brightest jewels. Symbols of times in the not-that-distant past, their nodding blades re-create visions of millions of Iowa acres of ancient flower-speckled grasslands waving free and wild, untrammeled, unharnessed by the plow's iron hands plying a world's supply of grains from deep prairie soils. Within Iowa's borders, only here in the Loess Hills have the once-dominant prairies survived in expanses that exceed the mind's eye.

Yet survival is a relative term which does not imply sustainability, health, or even long-term protection from outright destruction. Even as we celebrate the prairies, we need to struggle to justify their value and continued existence to others. And we need to fight the aggressive, rapid invasion of woodlands through cutting, burning, and otherwise managing these fire-starved grasslands, thus helping them maintain the integrity that once was theirs naturally. The final two essays, written by persons who have studied the Hills' plant communities and natural features, defend the natural communities and native inhabitants of the Loess Hills and present visions of their long-term grandeur.

Tom Rosburg grew up on a farm on the eastern edge of the Loess Hills in Monona County. As a teenager, he remembers hiking near his home and thinking that "there was something different about the Hills that was really neat, but I didn't know exactly what because I didn't know anything about prairies." He left home in 1973 to attend Iowa State University and then worked as a wildlife biologist in Wyoming, Colorado, and Iowa. But his early agricultural life beckoned, and a few years after graduating from college he returned to farm the home place. In 1986 he decided on another career change and—with the specific intent of completing field research in the Loess Hills—returned to Iowa State University and to graduate studies in the Department of Botany. Through his doctoral thesis, which focused on the ecology of native grasslands in the Hills, Tom has become Iowa's expert on those plant communities. He hopes to devote future research efforts to further defining them.

Cornelia F. Mutel, author of *Fragile Giants: A Natural History of the Loess Hills* and scientific historian at the University of Iowa, claims she didn't feel completely at home in Iowa until she visited the Loess Hills. There, on the high bluffs overlooking the Missouri, she once again sensed the pleasure of mingling intellectual pursuits with her gut-level bond to natural ecosystems, a pleasure she had relished as a graduate student of plant ecology at the University of Colorado. Having written natural history books on Colorado and tropical rain forests (as well as books on more technical subjects), she decided to write *Fragile Giants* as a midlife gift to herself, a gift that would allow her to investigate these unique wildlands while giving meaning to her quest through transcribing her knowledge for other persons. She hopes that her writing efforts will lead to more mindful preservation of natural areas and of lifeforms that cannot speak for themselves.

Grassland Legacy of the Hills

TOM ROSBURG

It's the middle of June, about one week before the summer solstice and the time that purple coneflowers bloom and ottoe skippers hatch. From my perch high atop a ridge in the southern Loess Hills, I can follow the Missouri River floodplain 200 feet below as it stretches like an immense checkered tablecloth toward the western horizon. To the north and south, bluffs and hills roll as far as the eye can see, flanking the eastern edge of the floodplain with a craggy wall of loess.

The hillside directly below me quickly steepens and plunges into a deep ravine that seems to have a grip on the entire surrounding ridgeline, pulling it down into a yawning wrinkle in the earth. Above me, powered by updrafts guided by the loess escarpment, two turkey vultures practice an aerial waltz in an empty sky. Birds of death, these vultures, and for a moment I sense a ray of symbolism in their presence, because on this ridge, where nature seems to be in control, the prairie is dying.

It is dying just as surely as the sun and moon rise and set. And because it has been this way since before the reach of anyone's memory, those who see the Hills often believe they are seeing them as they should be. This is a huge misconception, for nowadays, even though most of the Loess Hills appear to be in a natural state, very little of the vegetation present at the time of Euro-American settlement remains. Where trees and woodland now prevail, grasses, wildflowers, and prairie once flourished. In the Loess Hills, the prairie continues to die with every tree that lives.

While that may sound like a bit of an exaggeration, none is intended. During the last three years, I have undertaken a variety of studies aimed at investigating the ecology of native prairies in the Loess Hills. I have seen a few real gems, prairies as pristine and pure as any remaining in the entire Midwest. But much more often I have seen sick and suffering prairies, and what I have learned has made me gravely concerned about their future.

A climb to the top of a loess ridge, like a climb up high places anywhere, injects a healthy dose of inspiration into one's imagination. I have climbed and dawdled on high loess ridges in all nine Loess Hills counties, seven in Iowa and two in Missouri, and every time, as I gaze across the unending drifts of loess, I prod my imagination for a glimpse of the past. What were the Hills like before Euro-Americans arrived? What animals and plants should be here? My heart aches to see the grassland wilderness that could have been, had only a John Muir or a Bob Marshall set foot in the Loess Hills while the prairies were wild and thriving.

Formulating a vision for the future of the Hills requires retrospect, a look back at their original vegetation and the evidence of the demise of prairie. There are at least two lines of evidence that present a good sense of the character of the Loess Hills before Euro-American settlement. One is the historical information recorded by people who observed the Hills firsthand. These accounts are usually limited in their detail, but they do conjure

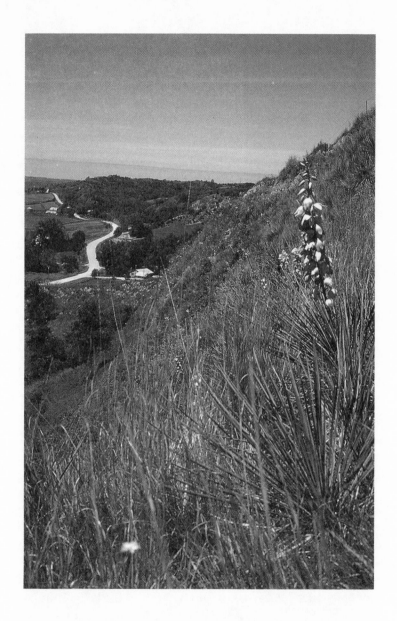

an image of the general appearance of the landscape. A second lies in an ecological appraisal and interpretation of the present vegetation, soils, and habitats. Much like a detective piecing together bits of evidence, a plant ecologist can use ecological relationships as clues to piece together a vegetation history of an area.

Historical observations come mainly from three sources: diaries and journals of explorers traveling through the area, descriptions written by early Euro-American settlers and often published in county histories, and the reports filed by the land surveyors who mapped the original township boundaries.

Because the nearby Missouri River provided an accessible route into the upper Midwest, it became a major thoroughfare, and many expeditions, from Bourgemont's exploration of the river in 1714 to Audubon's foray in 1843, did battle with the "Big Muddy." The Hills lying to the east enticed many river travelers to stray from the winding channel and climb their flanks. Listen to these voices from the past.

John Bradbury ascended the Missouri River along the Iowa border in 1811 and made these observations of the southern Hills in the present-day area of Fremont and Mills counties:

> . . . I ascended the bluffs, and found that the face of the country, soil, &c. were entirely changed. As far as the eye could reach, not a single tree or shrub was visible. . . . The bluffs forming the bounds of the river are no longer in part rocks, but a continued chain of rounded knobs of stiff clay. . . . The flat valley of the river, about six or seven miles in breadth, is partly prairie, but interspersed with the clumps of the finest trees. . . .

Henry Brackenridge followed closely on Bradbury's heels and recorded his observations at several locations in present-day Fremont and Mills counties in April and May of 1811:

. . . ascended the hills or bluffs, which, though steep, are not much more than two hundred feet above the level of the river. . . . There is an immense extent of prairie on both sides of the river. The hills are not always abrupt, but in many places rise gently, and are extremely beautiful. . . . The country hereabouts, is entirely open, excepting in some spots along the river, where there are groves of cotton-wood, and on the hills a few scattered dwarf oaks. . . . A close wood is not to be seen. . . .

farther north in present-day Pottawattamie and Harrison counties, he noted:

Some woody country hereabouts; but that on the upland is very inferior, chiefly shrubby oak. . . . At most of the points on the river, the timber, principally cotton-wood, is large, and tolerably close, but the prairies and upland are entirely bare of trees.

Finally, he described the northern terminus of the Hills in present-day Monona and Woodbury counties:

The scenery now undergoes an entire change; forests are seen no more; the wooded portions of the river are composed of small cotton-wood trees . . . [rather] . . . than the huge giants on the lower part of the river. . . . The bluffs and the upland on the N.E. side, are not high, and without any appearance of trees and shrubs.

John Bell was the official journalist for the Stephen Long expedition that crossed what is now Mills County in May 1820. He wrote: ". . . rode some distance over the sand hills [i.e., the Loess Hills] which are barren of timber, in the vallies is a small growth of timber principally of oak. . . ."

County histories, which are chronologically later than the ex-

plorers' journals, are not a particularly rich source of early natural history information. They are primarily a cultural history, devoting hundreds of pages to such topics as early settlement and businesses, agriculture and railroads, political and religious events, and biographical sketches. Still, there are occasional tidbits that either directly or indirectly convey a picture of the early landscape. Because many county histories were published forty to fifty years after Euro-American settlement began, landscape descriptions must be interpreted with care. Most useful are personal reminiscences by old-timers who often reach back to a more wild and natural time.

In *The History of Harrison County*, published in 1891, D. W. Butts remembers riding on a freight wagon from Council Bluffs to Preparation in southeastern Monona County in the autumn of 1853. Their route followed the Missouri River valley and the Soldier River through the Loess Hills. He remembers that, even sitting up high on piled loads, he could not see other teams except in places where the trail happened to be straight and the teams came quite close. The grass was so high and luxuriant for miles and miles that riders on horseback might hide from each other at a distance of 200 yards. He emphasizes that a mere forty years later, much that was "wild and grand, and rich in verdure and foliage had become barren, crossed with deep beaten paths and interspersed with weeds and numerous cattle, horses, hogs and sheep ready to nip the last vestige of wild grass as fast as it appeared." His story shows how dramatically the land can change in just forty years and just how important historical information is because of the great potential for humans to erase the ecological evidence of pre-Euro-American-settlement vegetation.

There is some ecological evidence of such vegetation, however, that cannot be undone. It is found underfoot in the soils. In the same way that zoologists and botanists classify and name

animals and plants, soil scientists can classify and name soil types, in particular with reference to the type of vegetation that was present as the soils formed. It requires a minimum of about 500 to 1,000 years for vegetation to impart its imprint, so the identification of forest or prairie soils implies the long-term presence of either type of vegetation.

One of my studies involved detailed observations of the relationship between soils and vegetation throughout the entire Loess Hills. I trudged up and down long winding ridges and steep bluff faces carrying buckets, tape measures, sampling frames, and soil probes to make more than 240 soil and vegetation samples. All of my soil samples associated with present-day woodland vegetation were more characteristic of soils formed under prairie than under forest. In fact, all of the Loess Hills soil types identified and mapped by soil scientists and published in county soil surveys appear to have formed under prairie. Thus, the soils are strong indirect evidence that over the last several thousand years or so, prairie vegetation has dominated the Loess Hills landscape.

Another clue ecologists can use is the present vegetation. A bird's-eye view of the Loess Hills is the best place to start. From above, the pattern of the vegetation on the whole landscape is easily seen. Main ridges winding in long, mazelike fashion and buttressed with spur ridges are separated by pesky, odd-shaped valleys. Throughout most of the Loess Hills, the upper portions of the ridges—especially those portions staring into the southern and western sky—are yet the domain of the prairie. Most of the rest have been lost to woodland. The overall impression is one of incongruity, a lack of harmony in the way prairie and woodland fit, as though something is being forced. It is like an immense battlefield with each combatant, prairie and woodland, struggling for a foothold. And here and there, the prairie, forced onto inhospitable slopes, clings for its very life.

On the ground the encroachment of woodland can be seen on a smaller and more local scale. Several times I have hiked over a woodland slope or ridge in the dim light cast by an interlocking canopy and stumbled unexpectedly upon a breath of sun. Forest ecologists call these sunny patches sunflecks or canopy gaps. Sunflecks are small and consistent sunlit patches resulting from small, natural openings in the canopy, while canopy gaps are caused by tree death punching a fairly large hole in the canopy. But these pools of bright, warm sunlight are different. How do I know this? Because at my feet, in a spotlight of sun about the size of a kitchen table, sit a handful of prairie plants. Some big bluestem and side-oats grama, some leadplant and wind flower, they're imprisoned by woody stems and murky light on all sides. They are the survivors, the last of the prairie that a long time ago lay under a wide open sky. These isolated scraps of prairie are the most direct evidence I have seen that prairie once grew wild where woodland now lives.

Even the woodlands cannot deceive. A springtime hike in a mature forest is like wading through a floral smorgasbord. The herbaceous layer of plants covering the ground is a species-diverse potpourri of shape, color, and scent. But in the Hills, this component of an aged forest is mostly nonexistent. Upland forest spring ephemerals—such as hepatica, rue anemone, yellow violet, and trillium—are not known to occur in any of the woodlands in the Loess Hills, and other species—such as yellow bellwort, wild geranium, false solomon's seal, spring beauty, wild ginger, false rue anemone, May apple, and toothwort—are only known from a few locations, mostly sites in the southern end of the Hills.

In contrast, throughout most of the Hills the woodland herb layer is extremely depauperate. I have traversed woodland slopes that are for the most part bare, colored only by the dull, brownish gray of tree trunks and half-decayed leaves. The inter-

mittent patches of green foliage usually indicate one of three common, widely dispersed plant species, namely white snakeroot, black snakeroot, and the ubiquitous Virginia creeper. Such an herb layer testifies that the woody vegetation is a very recent occurrence.

The vision of the Hills as the early explorer Maximilian, Prince of Wied, described them in 1833, is now very difficult to imagine: the "chain of hills . . . sometimes like entrenchments and bastions . . . rather bare of wood, but of grotesque form, and covered with a fine verdant carpet. . . ." But the historical and ecological evidence is overwhelmingly in its favor.

So what was the verdant carpet of prairie like before so much of it became frayed and choked by woody invasion? One day in mid-May I climbed out to the westernmost bluffline just north of Pigeon Creek near the city of Crescent. The spring rains had been plentiful, and evidence of the original nature of the Missouri River floodplain was unmistakable. Far below at the foot of the bluff, the squawking of yellow-headed blackbirds rose from a marsh rimmed with cattails, prairie cordgrass, and bulrushes. Low swales filled with rippling water meandered out from the marsh onto the floodplain. It was not difficult to imagine the floodplain as a vast wetland complex, an intricate mosaic of marsh and wet prairie.

On top of the west-facing bluff were some nearly leafless green stems appropriately named skeleton plant and short tufts of the grayish green leaves of lotus milk vetch. I had climbed up this ridge in search of scarlet globemallow, one of Iowa's threatened species, which is also known, perhaps more affectionately, as cowboy's delight. These plants and many others on this bluff are species adapted to the dry habitats of the Great Plains. They represent a midgrass community that, in a geographical sense, should be living several hundred miles farther west. But they do just fine in western Iowa's Loess Hills, because steep slopes com-

bined with well-drained loess and southwesterly exposures produce a dry microclimate that provides midgrass species with a suitable home in an otherwise inhospitable tallgrass prairie climate. As I stood on this high bluff and scanned the Hills, most of the prairie I saw tucked along ridgelines and in open hillsides fit the description of midgrass. It is the community that currently dominates native grassland in the Hills, because this community most naturally resists the invasion of trees. It is the community that makes the Hills such a special place, but it is not the only prairie community native to the Hills.

Loess Hill prairies originally occurred along an extremely steep moisture gradient, from very wet floodplain prairie to very dry ridgeline and bluff prairie, the driest found anywhere in Iowa. There is also good evidence, both historical and ecological, that bur oak savannas, grassland communities characterized by scattered bur oaks, occasionally intermingled with tallgrass prairie. These tallgrass communities, which occupied floodplain, valley, and lower slope positions and which encompassed the lower three-fourths of the moisture gradient, were an extensive component of Hills prairies. They were also the first prairies to die, either from the rip of the plow or the suffocating growth of woodland.

Diversity in the landscape leads to a diversity of plant communities clothing the landscape. In the Loess Hills, the innumerable combinations of slope position, steepness, and direction constitute a moisture gradient that "geographically" extends from eastern Iowa to the middle of South Dakota, creating an incredible mosaic of prairie communities. These many combinations suggest that the original Loess Hills grassland was the most diverse found in Iowa, perhaps even within the entire tallgrass prairie ecosystem. Unfortunately, most has been lost, and what precious pieces are left continue to fade into woodland.

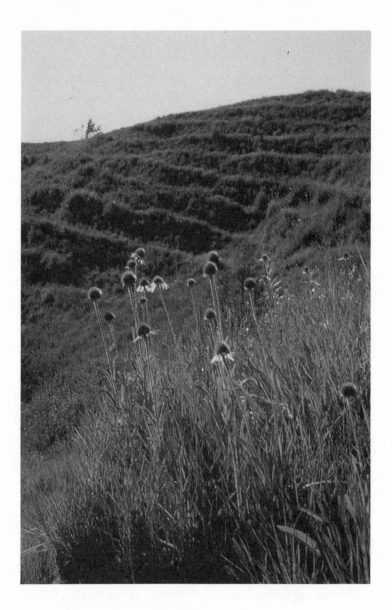

For me, the acres and acres of woodland vegetation in the Hills are just as unnatural as the acres and acres of corn and soybeans that overflow the rest of Iowa. How could so much have been plowed up so quickly? For most of the Iowa prairie, John Deere's moldboard plow, invented in 1846, brought direct and immediate death. But in some sections of Iowa, and especially on the steep slopes of the Loess Hills, the plow had little effect. Instead, it was an encroaching woodland, encouraged in part by the suppression of wildfire, that infected the prairie with a malignant growth and eventually choked the light and life out of the prairie.

Wildfire was often mentioned in the notes of early explorers, and Euro-American settlers quickly learned the effect fire suppression had on the landscape. *The History of Harrison County* comments that "there is vastly more timber in the county now than in 1852, owing to the fact that prairie fires have been kept out, and . . . that fencing is no longer made from native timber. . . ." There is very good ecological evidence that the outright death of fire-susceptible trees or the repeated top-killing of fire-resistant trees from frequent grassland fires is an enormously important factor explaining the treeless character of the prairie.

Grassland fire ecology is a large and complex topic, and developing an understanding first requires an understanding that fire is a manifestation of climate, not unlike wind, rain, and cold. Natural wildfire is a product of lightning during thunderstorm activity, which is clearly a function of climate, and of combustible vegetation, which is also directly related to climate. Certain climates are characterized by natural wildfire. Human suppression of wildfire inflicts a significant, unnatural change in the environment and in native vegetation.

As important as fire is in maintaining the prairie, it is cer-

tainly not the only factor involved. At least three other influences can also be linked to the maintenance of the prairie. One is the impact native ungulates had through browsing and rubbing on the smaller trees that initiated the woody invasion. A second is the remoteness that much of the prairie had from sources of woody vegetation. Prairie that was miles from the nearest trees could not be easily invaded. The third factor is the general climate, specifically temperature and moisture trends. Wet and cool periods favor trees and forest, hot and dry periods favor grasses and prairie. The complexity inherent in fire ecology arises from potential interactions among these factors. When fire and drought occur together in the same growing season, for example, their combined effect may be much greater than either of the two factors separately. Or fire and herbivory may interact, inasmuch as the suckers sprouting from woody species top-killed by fire may be more attractive to browsing ungulates.

All four of these factors were undoubtedly important in accounting for the original vegetation in the Loess Hills. And since Euro-American settlement, all four have favored woodland. Only one is natural: the apparent trend toward a slightly cooler and wetter climate over the last several hundred years. The other three—the suppression of fire, the removal of native ungulates, and the widespread establishment of trees on farmsteads—have hastened the demise of the prairie and are a direct result of Euro-American activities.

Mainly because of today's widespread seed source of woody vegetation, fire may be more important now than it was historically. However, its importance in prairie ecology goes far beyond its role in suppressing woody growth. Even without woody encroachment, a prairie would still need an occasional fire to maintain a healthy community for both the plants and the many prairie-dependent animals. This very important aspect of grassland fire became clear to me as I collected vegetation samples. I literally crawled on my hands and knees through the prairie to record the abundance of species in more than 9,000 small quadrats. The differences I observed between sites recently burned and those not burned was amazing. On unburned sites the plants usually appeared to be weak and suffering, rarely producing flowers and seed. On burned sites plants were growing strong and often flowering profusely. In a tallgrass prairie, just three or four years' worth of accumulated litter builds a formidable layer of mulch that suppresses the early regrowth of plants in the spring. Natural fire very effectively removes the suffocating mulch and re-creates the open and sunny environment to which prairie species have adapted.

It's not just for the sake of the prairie and prairie ecologists that future management goals should be directed toward prairie conservation. Loss of economic vitality also is at stake. Talk to people who make their living from the land in the Loess Hills and, more than likely, they will express a deep-rooted disgust for woody encroachment.

Phil Hall has lived most of his sixty-seven years on a farm sitting under the bluffline next to Possum Creek in Fremont County. His mailbox identifies the farm as the home of the Possum Hollow Seed Company. He was busy mowing grass the day I stopped to ask permission to investigate the very steep, west-facing bluff standing across the road, a site that I knew contained two of Iowa's endangered plant species, biscuit root and cobaea penstemon.

Phil's fondness for the Hills was easily evident. He mentioned that the bluff is part of 300 acres that, until recently, has always been used for pasture. When he was a young boy the west-facing bluff had no trees except for a couple of cottonwoods

near the bottom. On the east-facing hillside, there were only a few scattered large cedar trees. Phil had a vague memory of a few grassland fires which were quickly attacked by a group of vigilante firefighters. There hadn't been a fire in the pasture for at least fifty years. Today a cow would need to search high and low to find just 40 acres of decent pasture. The rest has grown up into a shrubby woodland that has no potential for economic use. The Hills Phil is fond of mostly exist in his memory.

Imagine the prairie ecosystem and economic resource the Loess Hills could offer if only the early Euro-American settlers had recognized the region's natural potential and managed the land as did those who settled in the Kansas Flint Hills. The Loess Hills and Flint Hills were both draped with a blanket of prairie, and for the most part, both were spared the plowshare. The Flint Hills soil was too shallow to plow, and much of the Loess Hills landscape was too steep. Both were destined to become rangeland, but that is where the similarity ends, because in the Flint Hills most of the landowners adopted the practice of spring burning their native pastureland to invigorate plant growth. That tradition never took hold in the Loess Hills. The Flint Hills are one of only a few tallgrass prairie landscapes still surviving; the Loess Hills could have been even better.

In order to salvage our prairie heritage in the Hills, prairie and pasture management must be applied at the landscape scale. I once thought that Henry Thoreau's observation, "a man is rich in proportion to the things he can afford to leave alone," was profoundly true. Now I know that it is only a half-truth: it is really only true for landscapes spared from inept human meddling, places where all of nature's ingredients still are in control. Only the largest and most remote wilderness areas can really be left alone. Contrary to Thoreau's statement, we cannot afford to leave the Loess Hills alone. In a sense, leaving them alone has contributed to the loss of prairie.

Time is running out. Prairie management, restoration, and reconstruction all need to be stepped up on both public and private land. I have seen many native prairie pastures that are just feeling the initial squeeze of woody invasion. Tree cutting and prescribed burning can still rescue these sites. The fragmented nature of the remaining prairies demands that prescribed burning be used cautiously and in a natural and diverse manner. Fire is fundamentally destructive and can potentially cause local extinctions of susceptible organisms, particularly sessile invertebrates and plants. Isolated prairie fragments require subdivision into natural burn units, with only one unit burned at a time. Prairie restoration and reconstruction is a growing science and is the only hope for rebuilding the lower valley and floodplain component of Loess Hills grassland. I hope that restoration will become a more vigorous feature of the management goals on our public lands. Despite all that's been lost, there is still a lot of high-quality prairie, more than in any other part of Iowa, with which to work.

Recently I visited one such high-quality prairie surviving along the serpentine backbone of a ridgeline south of the Camp Hitchcock Nature Area in Pottawattamie County. A heavy dew from earlier in the morning soon soaked through my shoes and socks and put an uncomfortable squish underfoot. I was anxious to dry out, so when I stopped for lunch on a sunny and breezy ridgetop, I pulled my waterlogged feet out and plopped them into the warm grass. As I sat soaking up sun, drying, and munching some lunch, I wondered how many different plants I could find within arm's reach. By the time I had finished lunch I had counted twenty-two. This is really what makes the prairies in the Loess Hills such grand places. There is so much life and beauty packed into them. I sat back, squinted into the sun, and gazed out over the labyrinth of sinuous ridges, rounded hills, and hidden valleys. Slowly the trees began to melt away. And

slowly waves of billowing grass took their place. In some areas, where bur oaks were thinly scattered, the silvery green under-surfaces of their leaves flashed in the wind. In other places, the rippling green was peppered with patches of purple, yellow, and orange. On a distant hillside the dark shapes of bison gradually crept over a ridge, and in the valley below a herd of elk waded through deep grass. A northern harrier, bobbing in the tireless wind like a wild kite, skimmed the lower slope below me, and somewhere far below, out in the wet blue-and-green maze of the floodplain, the sharp "kerloo, kerloo, kerloo" of a whooping crane echoed through the surrounding valleys. Close by, a sphinx moth zipped up to a clump of yellow Indian paintbrush, braking momentarily to a hover to grab a quick sip of nectar. And on the heaped tailings of a badger excavation, delicately preserved in the flourlike loess, the silent track of a prairie wolf stared back at me. I have some pretty high hopes for these Hills.

REFERENCES CITED

Bell, J. 1820. *Journal.* Reprinted in H. M. Fuller and L. R. Hafen, 1957. *The Journal of Captain John R. Bell, Official Journalist for the Stephen H. Long Expedition to the Rocky Mountains, 1820.* Arthur H. Clark Co., Glendale, Calif.

Brackenridge, H. 1816. *Journal of a Voyage up the River Missouri.* Coale and Maxwell, Baltimore. Reprinted in R. G. Thwaites, 1904. *Early Western Travels 1748–1846*, vol. 6. Arthur H. Clark Co., Cleveland.

Bradbury, J. 1819. *Travels in the Interior of America in the Years 1809, 1810, and 1811.* Sherwood, Neely, and Jones, London. Reprinted in R. G. Thwaites, 1904. *Early Western Travels 1748–1846*, vol. 5. Arthur H. Clark Co., Cleveland.

History of Harrison County, Iowa. 1891. National Publishing Co., Chicago.

Maximilian. 1833. *Journal.* Reprinted in R. G. Thwaites, 1906. *Early Western Travels 1748–1846*, vol. 22. Arthur H. Clark Co., Cleveland.

Apology for the Prairies

CORNELIA F. MUTEL

As I peer over the gently arching blades of little bluestem and needle-domed crests of yucca, down the nearly vertical bluff to the base of the Loess Hills 300 feet below, the border between the human-dominated croplands and nature-dominated Hills appears as a razor-sharp line that forbids crossing. From the base of the bluffs, straight-lined agricultural fields stretch westward across the pancake-flat Missouri River floodplain and reach for the horizon. Diked ditches drain water from parallel rows of corn, tended by farmers driving on measured ribbons of tidy asphalt, bordered by simple communities of plants brought here by early settlers from Europe and the Asian steppes. Everything below me—hybrid corn, asphalt, dikes, trucks, ditches, grasses in the roadside ditches, the farming tradition itself—has been superimposed on the broad, threatening floodplain of the Missouri River in the last 150 years, has tamed that meandering flow, calmed its violent floods, and created orderly fields for production of calories. I understand the value of the fields. They provide me with my most basic needs and support the economy that supports me. But despite the luxury of their vibrant green, the Iowa of agricultural lands has never truly felt like home to me.

On top of the prairie-covered bluff, I float above the hot haze of fields on the other side of that imagined boundary. The winds that shaped the Hills cascade about me and caress my hair. Around me in profusion bloom predictable clusters of flower-borne scent and color: puccoon, locoweed, prairie ragwort, large-flowered beardtongue. Dried remnants of last year's coneflowers protrude randomly from silvery green fresh growth. And everywhere dance the rounded shapes typical of nature: irregular clumps of scattered bunchgrasses, ballooning crowns of bur oaks on distant north-facing hillsides, and the sharply etched water-carved crests and intricate, ever-dividing tentacles of the Loess Hills themselves. I know that the ancient prairies and groves of impudent trees and shrubs that aggressively finger their way up the slopes quietly support life in far more subtle and complex ways than the croplands below. Unlike human-dependent croplands, the prairies have been shaped for thousands of years until their myriad species, ideally suited to life together in this peculiar environment, formed an interdependent unit, self-sustaining, finely tuned by site and climate. Both prairies and cornfields are grasslands, and both prairies and cornfields are necessary elements of our human-dominated earth.

Nestled into the ridgetop prairie, I contemplate my position in the natural world. I know that as a species, I belong to the five billion–plus of the earth's most powerful animals. The species whose brains and technologies have transformed much of the earth's surface to simplified assemblages of domesticated plants and animals. The species, as many think, that nature was created to serve. The species which, I am often told, brings nature to fulfillment, which necessarily guides evolution and expression, and without which the natural world becomes a meaningless void. But in spirit, I feel more at one with the di-

versity of wild plants and animals surrounding me, growing in seemingly useless profusion, not because of humans but in spite of them. Here, amid the purple pealike blossoms of leadplant, avoiding the sharp pricks of yucca leaves, sensing the peace and rootedness of the prairie, I feel at home.

The most intensely passionate moments of my life have risen from natural areas such as these—writing about them, teaching or speaking about them, defending their existence in one way or another, wandering through them. In these areas, and because of them, I have lived most fully. Preservation of such areas has become my vision for the Hills: a vision of defense of the natural features that have made this region famous, the plants and animals and shapes that have dominated here for at least the past 9,000 years; a vision of better understanding their ancient past and the diverse, highly complex present for the future, whatever pressures that future may bring. And this is not my vision alone, but that of hundreds of others concerned with preserving inviolate these largest remnants of Iowa's once-vast prairies and with preventing this unique, rugged landform from washing through abuse to flatness.

It's not always an easy vision to explain. Why shouldn't these prairies be grazed to oblivion? Who cares if the numerous skippers—uncommon prairie-dependent butterflies whose presence has summoned an entourage of experts from across the United States here to study and collect them—pass on as have the bison and elk and cougar which once roamed these lands? What's the difference if the orangey yellow cups of hoary puccoon blooming at my feet continue to rise each spring to greet the sun, as they have for millennia? Why shouldn't the Hills join the farmlands below and be converted to a manicured garden of ordered shapes, textures, odors? What can the prairie provide that the garden and field cannot?

Nowadays, practical answers are the first given to these questions. Profit-driven societies demand profit-oriented rationales, such as the economic value of recreational use. "Ecotourism," for example. Local towns and families struggling to survive are discovering that the Loess Hills boost the economy by attracting outsiders (and their wallets) by the busload to observe, hike, botanize, camp, or otherwise enjoy the Hills' natural features.

Along the same vein, ecologists talk of the "biological capital" held within the genes of the earth's plants and animals, the vast majority of which live in nature-dominated areas such as the Loess Hills prairies. Of the thirty-million–plus species that inhabit the earth, fewer than a tenth have been identified and named. Only a minuscule portion have been studied for their human benefits. Within this undescribed genetic warehouse of biodiversity lies the promise of products for industries and illnesses yet to be defined: new foods, fuels, organic chemicals, fibers, medicines. We can now insert new genetic material into pea plant nuclei and cross sheep with goats, but we cannot create from scratch the genes that wax the beardtongue's leaves so they lose less moisture or that fire the ottoe skipper to defend its territory fiercely and instinctively. Here, on the Loess Hills prairies, such genetic raw materials—evolved and tested through the centuries—are being stored and propagated for us, effortlessly and free of charge.

Sitting on my prairie-covered ridgetop, I cannot argue with the practicality of this approach. Who can say that the white-blossomed New Jersey tea blooming near my feet won't someday provide a treatment for the liver cancer that killed my mother? Native Americans ascribed strong powers to the species, calling it spotted snake spirit and claiming it remedied bowel troubles, among other ailments. And stranger stories have been told. The Pacific yew—a scrubby evergreen inhabitant of Pacific Northwest old-growth forests—was burned as waste for years by loggers cutting those forests before bark extracts were found to provide a powerful treatment for ovarian cancer. Today, over 40 percent of all prescriptions dispensed by United States pharmacies are organism-derived, over half of these from plants. More than 700 species of vascular plants alone inhabit the Loess Hills—and many of these are rare in Iowa, limited in both range and number. Compare that number to the handful of plant species that proliferate on cultivated lands on either side of the Hills. If natural habitats such as these prairies are destroyed, the plants, too, will pass, along with the adaptive traits and capabilities inscribed in their genes.

But sitting here, watching rivulets of wind finger through the bunchgrasses, smelling fragrances that attract me as well as insect pollinators, I sense another justification for preservation. The earth's prairies and their counterparts, left to independent function and health, constantly provide innumerable "free services." I assume the benefits of their biological recycling processes, the air and water and soil cleansed of toxins and wastes, their countless other life-maintaining gifts such as oxygen, wood, and watershed protection, all created without human energy or economic input. In most cases, we haven't the foggiest idea how to substitute for these ecosystem services. What would I do, I wonder, if suddenly I had to devise technologies for holding these Hills back from the waters of the Missouri and simultaneously manufacture oxygen for my own lungs? The forty-foot roots of the yucca and the silvery green leaves of the leadplant are far better suited for such purposes.

Beyond these concrete functions of natural areas lie those which we sense but cannot quantify, in some cases cannot even define. These stem from the interdependencies that natural ecosystems have evolved over millennia, from the complex checks

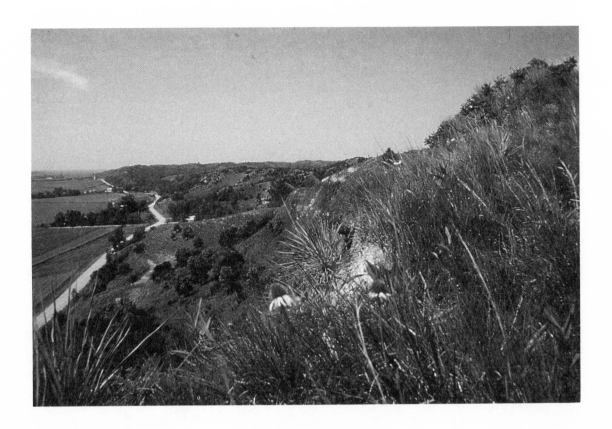

and balances that confer their long-term stability and resilience. The ridgeline prairies, the creekside woodlands have maintained their health for eons with no help from my species. This is not to say that these communities have been static. Life, by definition, is dynamic, and the line between prairie and forest has always been defined by tension, the prairie claiming forested land during drought and the forest nudging upslope during wet periods. But their basic structures have remained self-sustaining, in marked contrast to our croplands and gardens which couldn't survive from one season to the next without human energy and effort. In some sense we realize that the

continuity and order of all life on earth, as well as the quality of life for humans, depend on the healthy functioning of these self-perpetuating wholes and on the little-understood balances natural areas maintain.

Natural areas also tantalize the intellect and tickle the imagination. They feed both the professional's and the amateur's inquisitive mind and stimulate questions that resolutely defy complete answer. Such areas serve as teaching and research laboratories for scientists determined to study predictable natural systems too complex for presumption. And they become "living museums" of the lands we humans roamed before being

separated from them by technology and cities. Prairies have become an important part of our heritage, sites where the lives of Native Americans and Euro-American settlers can be relived in children's minds, where children can gaze upon prairie turnips and imagine earlier inhabitants digging and drying the egg-sized tubers, crushing them into meal to assuage winter's hunger. Without such natural areas to gaze upon, and time to let the mind wander, how will children develop the fascination and love for the natural world that will lead them to try to solve the environmental problems of the future?

The prairies tie me to an even more distant past and future, circling me back to dimly remembered origins and pulling me into dreamworlds of life patterns still to come. Sitting in the Hills, I can imagine beginnings and endings on a massive scale and simultaneously sense the constancy and permanence of a world much larger and more powerful than that of my own day-to-day life. In our world of constant change, these prairies are for me the ancient ones; they have survived longer than any human-concocted civilization or structure. My mind travels back to the time of this prairie's emergence about 9,000 years ago: species then started migrating here from drier lands to the west, nudged eastward during the hypsithermal—a period of extended drought—and they stuck around because they found an environment conducive to their needs. Enveloped in these prairies, I also ponder the future, contemplating environmental problems that we might be creating and how they might be redressed. Global warming, for example. During the hypsithermal, the tallgrass prairie stretched eastward into present-day Ohio, while insufficient moisture shoved the eastern deciduous forest toward the Atlantic coastline. If the climate again warms and dries, the seed heads of drought-resistant Loess Hills prairie plants stand ready to blow forth and inhabit deserted soils, healing the scars of our mistakes.

These prairies nurture my spiritual life as well as stimulate my intellect. Through them I connect to the natural world at large. As I hiked up this ridge, I rose over a knob and chanced upon a meadow of purple, white, and yellow flowers as dense as the mountainsides of blossoms I studied in the Rocky Mountains years ago as a graduate student. Examination of the prairie hillside's flora brought me even closer to those mountainside friends. Various but different yellow sunflowers bloom at both places, as do different species of the tiny starlike flowers of blue-eyed grass. Here the white-flowered downy paintbrush replaces the scarlet paintbrush of the mountains. And the five-petaled leaves of prairie turnip fool me into thinking that I'm gazing over mountainsides of blue-spiked common lupine. Acres of blossoms evolved from the same ancestors, here fitted to lowland drought and there to the rigors of high altitude.

The prairies exemplify many of the traits to which human societies aspire and thus spur me to consider greater possibilities. Cooperation, for example, and a sense of community: look at the yucca, which migrated eastward along the Missouri to the Loess Hills, bearing on its leaves western fungi and bringing along a small white moth whose larvae can mature only by feeding within yucca seed pods; the yucca depends on this moth to pollinate its flowers.

And toughness, and survival amid hardship. Life is not easy in this land of wind, sun, and drought. The plains spadefoot remains underground for much of its life, emerging for only a few weeks each year when heavy, warm spring rains call thousands of these toads to the ground surface to mate and lay eggs, then shrinking back into slumber under three feet of soil until the following breeding season.

And long-tempered adaptation to one's environment: examine the pink-flowered skeleton weed, a relative of the sunflower which flourishes on the driest bluffs. With its leaves reduced to

slivers, with roots that reach twenty times deeper than its foot-tall stems, the skeleton weed is ideally suited to flourish here amid parching sunlight and winds. Or consider the plains pocket mouse, an endangered species in Iowa's Loess Hills, whose relatives inhabit the southwestern United States. Like its desert-dwelling cousins, the plains pocket mouse leaves its sealed burrow only at night or on overcast days and manufactures all the water it needs from the solid foods it eats.

And deep-seated, predictable rhythms that assure us of order, constancy, and permanence within a too rapidly changing world. Long before humans were here to observe the pasqueflower's downy lavender blossoms, it thrust its head above winter's crinkled brown leavings to announce spring's annual return. The rich mellowing of the bluestem into fall's russet colors will continue as long as the species survives; these are no passing fads. And as I grow older and find the earth's endless passages ever more reflected in my own changing body, I increasingly cherish the youth and freshness cradled in the ageless cycles of the natural world: the springtime return of grasshopper sparrows, the blooming of the prairie clovers, late summer's seeding out of native grasses, the prairie's countless other signs of continual rebirth.

I also cherish hopes for the future. People needing proof of nature's resilience need look no further than the burst of native flowers springing from degraded prairies rejuvenated by a spring burn. Or they might consider that, in the early 1980s, three animals thought to have been wiped from the slate of Loess Hills inhabitants—two small rodents (the plains pocket mouse and southern bog lemming) and the ornate box turtle—were rediscovered here, rare but definitely present.

Many who contemplate complexities and interdependencies such as these glimpse through them the workings of a universal spirit. Some call it God. I know one nine-year-old girl who defends the prairies near her Loess Hills home in deeply religious terms, mourning their demise as if it signified the loss of all the earth's goodness. For her, as for many, the prairies are constructing the underpinnings of her spiritual as well as mental and physical health.

These, then, are some physical, intellectual, and spiritual arguments for preserving natural areas such as the prairie in which I sit—for keeping them intact, unused, as close to their original condition as is physically possible. Collectively, these reasons convince me that the transformation of nature to the garden is not simply a question of preference or aesthetics, for, as entomologist, author, and champion of biodiversity Edward O. Wilson writes:

> The surviving [natural] biosphere remains the great unknown of Earth in many respects. On the practical side, it is hard even to imagine what other species have to offer in the way of new pharmaceuticals, crops, fibers, petroleum substitutes and other products. We have only a poor grasp of the ecosystem services by which other organisms cleanse the water, turn soil into a fertile living cover and manufacture the very air we breathe. We sense but do not fully understand what the highly diverse natural world means to our esthetic pleasure and mental well-being. . . . The world is too complicated to be turned into a garden. There is no biological homeostat that can be worked by humanity; to believe otherwise is to risk reducing a large part of Earth to wasteland.

As I look down at the Missouri River floodplain from my ridgetop perch, the human-created croplands, roads, and cities below me and the nature-dominated prairie in which I sit appear to be separated by an abrupt and uncrossable line. But of course that image is false. For I am human, and I delight in roaming the prairies and studying here and defending the lives

I have come to love. And there, on the flatlands below, seeds of wild blue lettuce occasionally stray to sprout and bloom along the highways, and Hills-bred swallows soar and dip above. I suppose that even as I watch, prairie-dusted turtles and frogs trudge laboriously through the cropland toward the drainage ditches to lay their eggs.

All species transform the world through their existence. In this way, we are no different from the badgers who dug their squat burrow on the slope facing me. It's just that we humans are so powerful, and there are so many of us. Our dominance is so prevalent, and our influence so pervasive, that other life-forms falter and fail as we thrive. More people now live on this planet than the total number that ever lived before our time. Today's collective human biomass is greater than that of any species that has ever existed. Lands and resources previously termed wastelands—those parcels that had been left wild for use by other species—are increasingly coming under human domination. Our masses have claimed the vast majority of the earth's surface, designating a scant 4.5 percent for conservation—and even these "conserved" lands increasingly are invaded by the earth's human poor scratching out a subsistence. Twenty to 40 percent of the sun's energy converted into organic matter by land plants now is shunted into supporting the human species. And as our population mushrooms from today's five billion-plus to an estimated ten billion by 2050, how much will be left for the upland sandpiper, the ten-petal blazing star, and other rare species in the Loess Hills and elsewhere?

When I contemplate these figures, I am tempted to throw out all other rationales for preserving these prairies and argue simply for fairness. Iowa's prairies were once one of the most complex and diverse grasslands of the world; they are now one of our rarest ecosystems. Their deep roots and lush growth created the rich soils that have made Iowa the heart of the nation's farmland and fed the nation's growth. But we seem bent on terminating a 9,000-year tradition in a few short centuries. Less than 0.1 percent of Iowa's original thirty million prairie acres has survived the plow. The majority of the state's prairies that remain, and the largest remnants, lie within the Loess Hills, where the rugged landscape has spurned uses intensive enough to demolish prairies directly. And try as we may to leave the scant remnants untouched, close to their original condition, we cannot help but leave our mark on the prairie world for, as the broad and prophetic scholar and one of the founders of the American conservation movement George Perkins Marsh wrote over a century ago, when already warning that human transformation of the earth might lead to human extinction:

> . . . man is everywhere a disturbing agent. Wherever he plants his foot, the harmonies of nature are turned to discords. The proportions and accommodations which insured the stability of existing arrangements are overthrown. . . . The face of the earth is either laid bare or covered with a new and reluctant growth of vegetable forms and with alien tribes of animal life.

Witness the upward creep of sumac and dogwood shrubs closely followed by forests everywhere on Loess Hills prairies. The tenuous balance between invading woodlands and fire-adapted prairies tipped in the last century when (among other factors) the early Euro-American settlers, fearful of fire and set on protecting their hard-earned homesteads, routinely eradicated the prairie blazes that killed invading trees. Don't those few prairies that remain deserve our dedication not only to their survival intact but also to whatever maintenance they require?

But today the wind nudges me and the tickling grasses pull me away from discouragement. I won't throw out the rationales. In hopes of working to preserve what I love, I will continue to teach them, and write about them, and spout them to any-

one who will listen. I will continue to say yes to people trying to preserve and manage prairies and yes to schemes that integrate gentle use with prairie conservation. Yes to haying a prairie rather than planting brome or alfalfa in its place. Yes to cutting invading forests, even poisoning the tree stumps, rather than allowing the trees to continue their upslope creep, but no to their outright destruction or intensive use. I want the prairies' mystery, their wildness to continue. I want to tramp here twenty years hence and find a child discovering prairie turnips or a graduate student keying out land snails. And if the prairies thrive, and if I live long enough to watch my skin age and wrinkle until it becomes a miniature of the corrugated bluffs surrounding me, I hope to travel back here and stand on a prairie-cloaked blufftop overlooking the Missouri and—like the Native Americans of centuries past—ask the rays of the setting sun to carry my spirit from that ancient, intact, sacred spot, up over the agricultural bottomlands, to the timeless hereafter.

REFERENCES CITED

Marsh, George P. 1874. *The Earth as Modified by Human Action.* Charles Scribner's Sons, New York.
Wilson, Edward O. 1993. "Is Humanity Suicidal?" *New York Times Magazine*, May 30, 1993.

About the Artists

LYNETTE L. POHLMAN

KEITH ACHEPOHL
[*born 1934, Chicago, Illinois*]
After receiving his MFA from the University of Iowa, Achepohl lived in Florence, Italy. An accomplished printmaker, he has taught at the collegiate level since 1964 and is currently professor of art at the University of Iowa. He has been active as a visiting artist and lecturer throughout the United States and Europe. His prints and paintings are included in over fifty nationally acclaimed public and museum collections, including the Metropolitan Museum of Art and the National Museum of Art. As a curator he has presented exhibitions featuring Turkish textiles at several midwestern museums. Achepohl has been the recipient of many significant grants and fellowships, including a Louis Comfort Tiffany Foundation Grant for Printmaking and Senior Fulbright Lectureships to Turkey and Egypt.

As a world traveler and explorer Keith has captured landscapes in Egypt, Italy, and Turkey as well as the Midwest. In all his art the essence and spirit of the place are preserved. After seeing the raw power of his Turkish landscapes and the secret passages of his Egyptian architecture and sky, I wanted to have him join *Land of the Fragile Giants* to express the soul of the Loess Hills.

WILLIAM C. BARNES
[*born 1958, Minneapolis, Minnesota*]
Barnes began his academic career studying pre-law in California. He then moved to Iowa and studied art history at the University of Iowa. Predominantly a self-taught painter, he has exhibited his intimate pictures primarily in Iowa and Minnesota over the last ten years. His art is collected by corporations and museums, including the Principal Financial Group, National Bank of Waterloo, University of Iowa, and U.S. West Communications. He currently resides and maintains his studio in Des Moines.

In his art Bill often presents a sense of absence or of someone just having passed through the picture. While his art depicts our time and place, it has a quality of timelessness and in that sense is related to the eternal qualities of the Loess Hills.

RANDY BECKER
[*born 1953, LeMars, Iowa*]
Becker studied art at the University of South Dakota and received his MFA in printmaking in 1985 from Southern Illinois University. He was a fellow at the Yaddo Art Colony and has been a visiting printmaker at the Oxbow Summer Art School Program and other printmaking workshops. Since 1986 he has held the positions of assistant professor, art program director, University Art Gallery director, and director of Integrative Studies at Teikyo Westmar University. In the last decade he has actively participated in regional and national exhibitions in Iowa, Minnesota, Nebraska, South Dakota, Texas, and Illinois. His prints are in the collections of the Sioux City Art Center, University Art Galleries at the University of South Dakota, and Southern Illinois University School of Law, among others.

A native of Plymouth County in the northern Loess Hills, Randy is familiar with the landscape, and this exhibition was an opportunity for him to explore more fully the area of his birth. Randy's prints often incorporate the written word in combination with a visual image. With or without words, his images tell intriguing stories.

GARY BOWLING
[*born 1948, Lamar, Missouri*]

Bowling was raised in southwest Missouri. He received a BS in art education from Missouri Southern State College in 1970 and earned an MFA from the University of Arkansas in 1974. He was chair of the art department at Westmar College in LeMars, Iowa, for nine years. After a painting fellowship at the Yaddo Art Colony, he left academia to focus his energy on painting. He has had major midwestern exhibitions, and his paintings appear in public and private collections including those of the Sioux City Art Center, Sheldon Memorial Art Gallery, and Brunnier Art Museum. Since 1985 he has maintained his studio and residence in Lamar, Missouri.

Having lived for nearly ten years in the northern Loess Hills and traveled many miles around the Midwest, Gary has often been in and out of, next to, and through the Hills, thus making him well acquainted with the area. In 1990 my husband, John, and I privately commissioned him to create a painting of the Loess Hills. Once again he traveled deep into the Hills. It was this early commission that inspired the exhibition *Land of the Fragile Giants*.

ANNE BURKHOLDER
[*born 1940, North Platte, Nebraska*]

Burkholder received a BA in liberal arts and a BFA with distinction in painting from the University of Nebraska at Lincoln. She has since maintained an active midwestern exhibition schedule, including juried shows at the Joslyn Art Museum, Nelson-Atkins Museum of Art, Spiva Art Center, and Sheldon Memorial Art Gallery. Her art is in many public, private, and corporate collections in the United States and Europe, including Hallmark Cards, Inc., of Kansas City, Nebraska Wesleyan University, and IBM in St. Louis. She was the developer, designer, and general contractor of the Burkholder Project, a complex of twenty-six art studios and four commercial gallery spaces in Lincoln, Nebraska, where she maintains her home and studio.

I first became aware of Anne's landscapes at the Museum of Nebraska Art in Kearney. *Land of the Fragile Giants* was an opportunity I wanted to afford her to depict the Loess Hills as sensitively as she had painted the Nebraska Sandhills.

JAMES D. BUTLER
[*born 1945, Fort Dodge, Iowa*]

Educated at the University of Nebraska at Lincoln, Butler currently maintains his home and studio in Bloomington, Indiana. An artist with a very active exhibition record, Butler has exhibited at the Minnesota Museum of Art and the Kohler Art Center. His exhibition *Born in Iowa: The Homecoming* traveled throughout the state of Iowa. Butler is an artist of national stature and is represented in numerous collections, including the Metropolitan Museum of Art, Smithsonian Institution, Art Institute of Chicago, and Des Moines Art Center. He has also received awards and grants from the National Endowment for the Arts, the Illinois Arts Council F. W. Vreeland Award, and the University of Nebraska. He has created public art projects and recently completed a commission for the U.S. Post Office in Oklahoma City.

Having seen the panoramic vistas of Jim's paintings, I wanted to see how he would capture the grandeur of the Loess Hills.

His majestic landscapes and skyscapes reminded me of Catlin's romantic notions of the hills and rivers.

RICHARD COLBURN
[*born 1946, Minneapolis, Minnesota*]

Associate professor of art at the University of Northern Iowa since 1981, Colburn recently participated as an exchange lecturer in photography at the Newcastle College School of Art and Design in the United Kingdom. He received a BA in studio art from Western Washington University and an MFA in photography and sculpture from the University of Minnesota. Colburn has exhibited his color photography widely in the United States, including the Kohler Art Center, University Museum of Art in Eugene, Oregon, and University of Oklahoma Museum of Art. As a visiting artist and lecturer, he has presented at the Paris Photographic Institute, Memphis College of Art, and Radford University. His photography appears in selected collections at Murray State University, Oberlin College's Allen Art Museum, and the Minnesota Museum of Art.

The people of the Loess Hills are like people everywhere, some are the heart and soul of the community and others are not. Rural communities are special places, and some are growing while others are dying out. I invited Richard to the exhibition to capture contemporary faces and the character of some of the Loess Hills residents and to merge rural myth with the reality of its peoples.

GINA CRANDELL
[*born 1949, Lansing, Michigan*]

Crandell received her BA from Michigan State University, her MA from Western Michigan University, and a Masters of Landscape Architecture from North Carolina State University in 1978. Associate professor in the department of landscape architecture at Iowa State University since 1979, she has written numerous articles for *Landscape Architecture*. Her 1993 book, *Nature Pictorialized: "The View" in Landscape History*, describes the process of pictorializing nature through the conventions of painting. Crandell has presented papers on art and landscape, public art, and nature to the Council of Educators in Landscape Architecture, the New York Botanical Garden, Cornell University, and Radcliffe College. In 1991 and 1992 she won national and regional competitions for the Arts-in-Transit Program in St. Louis and "The Once and Future Park" sponsored by the Walker Art Center in Minneapolis. Her work has been exhibited at the Minneapolis College of Art and Design and the Brunnier Art Museum. Her public art project *Interior Garden* was completed in 1992 for the Linear Accelerator Facility Addition at Iowa State University.

I have come to know Gina through her scholarship, teaching, and public art projects. Her conceptual approach and analysis of art, landscape, and people are always thoughtful. Her public art project, for the Loess Hills State Forest and Preparation Canyon State Park, will provide viewers visual stimulation coupled with historical references and futuristic directions.

BEN DARLING
[*born 1953, Manhattan, Kansas*]

Currently maintaining his home and studio in Lincoln, Nebraska, Darling graduated from the University of Nebraska at Lincoln in 1975 and later received his teaching certificate from Nebraska Wesleyan University. An arts instructor and artist-in-the-schools since 1985, he has taught in many rural communities at the elementary, secondary, and collegiate levels. As a

painter and relief printmaker, Darling has been included in juried, invitational, and solo exhibitions in the Midwest, including the Joslyn Biennial, Museum of Nebraska Art, Spiva Art Center, Sheldon Memorial Art Gallery, and *Eight Rivers and the Land*, a Nebraska Arts Council Touring exhibition. In 1989 he was named Nebraska Young Artist of the Year and in 1986 received the Robert J. Dining Landscape Award at the Joslyn Biennial.

Ben is as down to earth as his paintings. He especially enjoys the explorer aspects of painting the landscape. While *Land of the Fragile Giants* is more about land than air, I have always appreciated Ben's skyscapes equally as well as his landscapes.

DENNIS DYKEMA
[*born 1940, Worthington, Minnesota*]

Dykema studied art at Morningside College, the University of Iowa, and the University of Northern Iowa, where he earned an MA in painting in 1970. He has pursued additional studies at Notre Dame University and the Aspen Institute in Oxford, England. Appointed to the art faculty at Buena Vista College in Storm Lake, Iowa, in 1970, he has taught there since. Dykema's works of art have been exhibited extensively in Iowa and the Midwest, including the Sioux City Art Center, Octagon Center for the Arts, University of South Dakota, and Charles H. MacNider Museum. Internationally, he has shown in the Central Bureau of Artists Exhibition in Warsaw, Poland. His paintings are included in public, corporate, and private collections, among them the National Bank of Waterloo, Sioux City Art Center, and Principal Financial Group.

I have admired Dennis's paintings for many years. I first became aware of his art through his students. The Brunnier Art Museum hosts the annual Iowa College Salon, a juried competition for Iowa's collegiate artists. Year after year Buena Vista art students showed inspiration, and it soon became apparent that the art faculty was also inspired. Dennis's painterly impressionism with all his mosaic patterns had to be explored for *Land of the Fragile Giants*.

DOUGLAS A. ECKHEART
[*born 1943, Fargo, North Dakota*]

Eckheart received his MFA from Bowling Green University in 1968. Additional study and studio work were undertaken at Instituto Allende in San Miguel de Allende, Mexico, and the Art Students League of New York City, among others. Since 1968 he has been associated with Luther College in Decorah, Iowa, serving twice as head of the art department and as professor since 1985. He has traveled extensively in Europe, Central America, Mexico, and the United States, where he has served as lecturer, artist-in-residence, juror for national and regional competitive exhibitions, and consultant. He has served as gallery director and curator and organized the *Gerhard Marcks Centenary Exhibition*. His art has been exhibited in over seventy national and midwestern shows, including the Charles H. MacNider Museum, Des Moines Art Center, Oscar Howe Cultural Center, and Butler Institute of American Art. His watercolors and drawings are in public and private collections, including the National Bank of Waterloo, Concordia College Collection, and Waldorf College Collection.

For thirty years Doug's art has often taken its inspiration from his local landscape, which is known for its extraordinary natural beauty and lovely vistas along the Mississippi River. His solo exhibition of paintings and drawings, *Seasonal Sonnets*, captures the landscape moods of northeast Iowa and is regionally traveling through 1995. I invited Doug, who has long been dedicated to Iowa landscapes, to participate in this exhibition so he

could uncover the land and people along the Missouri River just as he has been committed to exploring nature's mysterious cycles and moods along the Mississippi River.

STEVEN HERRNSTADT
[*born 1953, Washington, D.C.*]

Combining art and science in his academic studies, Herrnstadt received his MFA in 1980, preceded by an MA in art and art history and a BS degree in experimental animal behavior from the University of Iowa. Since 1982 he has taught at Iowa State University's College of Design and since 1988 has been an associate professor in the department of art and design. In the area of scientific visualization, photography, and computers, he has been a lecturer and presenter at regional and national conferences and institutions, including the Penland School, North Carolina, and the National Computer Graphics Association. Herrnstadt has participated in national and internationally juried and curated exhibitions, including the Virginia Intermont College Photography Gallery, Catskill Center for Photography, Yeiser Art Center, and SIGGRAPH touring exhibitions in Moscow, Adelaide, and Barcelona. His art is in private collections and in the collections of the Des Moines Art Center, Catskill Center for Photography, Olympic National Park, and U.S. Department of the Interior.

Steve is a close observer of nature and weaves humanity's responsibility to it into his photography. His art can be beautiful and seductive and is always thoughtful. Since he is a faculty member at Iowa State University, I have long known and admired his art. His solo exhibition in 1993 at Olson-Larsen Galleries allowed me to see his landscape photography, and his interest in the *Land of the Fragile Giants* led to his participation in this show.

DRAKE HOKANSON
[*born 1951, Cherokee, Iowa*]

Born in Iowa, raised in California and Colorado, and having returned to northwest Clay County for his last two years of high school, Hokanson knows the rural Loess Hills landscape very well. In 1988 he received his MA degree in American studies from the University of Iowa, with an emphasis on photographic history, vernacular landscape studies, and writing. He soon became a world traveler, writing journals and photographing people and places. He has been a lecturer and taught photography, writing, and mass communication at the University of Iowa from 1982 to 1988. Since 1991 he has been assistant professor at Lakeland College. Combining his interest in literary and visual arts, Hokanson has created a series of theme exhibitions, including *Photographs of a Small Place* (1992) and *The Lincoln Highway: Main Street across America* (1989–1990). His exhibitions have been presented extensively in Iowa and the Midwest. Hokanson's books are *The Lincoln Highway: Main Street across America* and *Reflecting a Prairie Town: A Year in Peterson*; his writings and photography have appeared in many publications, including the *Iowan*, *Smithsonian*, and *Chronicle of Higher Education*. His photographs are part of over one hundred private and corporate collections.

I read somewhere that Drake, while sitting in a hotel in India, realized that the ideal observer of a place and people has an insider's access but an outsider's perspective. He returned to Iowa and began exploring, through his lens and writing, the small town of Peterson, Iowa. That philosophy is common throughout *Land of the Fragile Giants*; from artist to scientist to humanist, many of the contributors have returned home to the Loess Hills or adopted this place as important to themselves, and all desire to share their scholarship and passion for the place. From very early in this project, I knew I wanted Drake to

be part of it. In some ways, it would not be complete without his artistry and honest emotions of Iowa's vernacular landscape and people.

DAN F. HOWARD
[born 1931, Iowa City, Iowa]

Art and academia have been Howard's vocation since graduating with a BA and MFA with a painting concentration from the University of Iowa. On the collegiate level, he has taught art at Arkansas State University and Kansas State University. Since 1974 he has been professor of art at the University of Nebraska at Lincoln and was head of the department from 1974 to 1983. He has a distinguished exhibition career, with over fifty solo exhibitions in thirty-five years, including major retrospectives at the Sioux City Art Center, Blanden Memorial Art Gallery, and Sheldon Memorial Art Gallery. He has also been included in many national, regional, and statewide competitive juried exhibitions. His paintings are represented in more than 350 public, private, and corporate collections in thirty states, including the Lowe Art Museum, Nebraska State Art Collection, Arkansas Art Center, and Kansas State University.

Dan and his paintings are nearly legendary in the Midwest. I hoped this honored and respected painter would take the *Land of the Fragile Giants* as an opportunity to explore his literal and nonliteral ideas as applied to the Hills just to the north of Lincoln. His images are definable and have a seductive allure which draws the viewer into their explorations and interpretations. He is not particularly known as a landscape painter; in fact, after completing two paintings of the Loess Hills, he said he had painted only perhaps a dozen landscape canvases in his entire career.

KEITH JACOBSHAGEN
[born 1941, Wichita, Kansas]

Jacobshagen received his BFA from the Kansas City Art Institute and his MFA from the University of Kansas. He is currently professor of drawing and painting at the University of Nebraska at Lincoln. In his professional career, Jacobshagen has also been an illustrator/designer for Hallmark Cards, Inc. He is a nationally recognized artist who has participated in many solo and group exhibitions, including exhibits at the Minneapolis Institute of Art, Tucson Museum of Art, San Francisco Museum of Modern Art, and Joslyn Art Museum. His works are contained in numerous public and corporate collections, including the Philbrook Museum of Art, Nelson-Atkins Museum of Art, Spencer Museum of Art at the University of Kansas, and the Achenbach Foundation, the California Palace of the Legion of Honor in San Francisco.

Keith is widely known and regarded for his paintings depicting the agrarian landscapes near his home in Lincoln. He mixes well the land, weather, and specifics of the place and transforms them into inspirational and memorable images. I invited Keith to join *Land of the Fragile Giants* to provide us with universally memorable images of similar places and seasons that we all experience in the Hills.

RICHARD E. LEET
[born 1936, Waterloo, Iowa]

Raised in eastern Iowa, Leet received his undergraduate and master's degrees from the University of Northern Iowa and did graduate study at the University of Iowa. He taught at Oelwein Community Schools and in 1965 became the founding director of the Charles H. MacNider Museum in Mason City, a position he still holds, making him the museum director with the long-

est tenure in Iowa. In his career he has been a painter, teacher, arts administrator, lecturer, cartoonist, illustrator, writer, and designer. While developing a distinguished museum, he has also been an active artist with numerous competitive group and invitational exhibitions and over fifty-five solo exhibitions since 1965, including exhibitions at the University of Minnesota at Duluth's Tweed Museum of Art, Sioux City Art Center, and Bergstrom-Mahler Museum. His paintings are in many national and midwestern permanent collections, including the Des Moines Art Center, Blanden Memorial Art Museum, and Waterloo Museum of Art.

Dick is equally respected and admired as a consummate museum director and artist. His watercolors of the midwestern landscape have thrilled many and helped them explore their local landscapes as well as the forces of nature that create our global landscapes. It was important to have Dick participate in *Land of the Fragile Giants* and continue his landscape tradition and exploration in the Loess Hills.

ROBERT H. McKIBBIN
[*born 1951, Philadelphia, Pennsylvania*]
McKibbin received his BFA and MFA in printmaking from Miami University. He has taught in the department of art at Grinnell College since 1976. In 1991 he received the rank of professor; he has served two terms as chair of the department. He has maintained an active regional and national exhibition record, showing his pastels and prints at the Charles H. MacNider Museum, Des Moines Art Center, and Central College. His art is in many public, private, and corporate collections, including the National Museum of American Art, Des Moines Art Center, Hallmark Cards, Inc., Meredith Corporation, Principal Finan-

cial Group, and Brunnier Art Museum. He is a frequent lecturer, guest artist, and juror.

Looking at Robert's pastel landscapes is like experiencing sheer joy. The colors and compositions delight the eye, and, to me, the pastel colors unite the transitory aspects of nature. Asking Robert to participate in *Land of the Fragile Giants* was inviting exuberance and beauty.

ELIZABETH S. MILLER
[*born 1929, Lincoln, Nebraska*]
Associated with Iowa State University since 1969, Miller is a Distinguished Professor in the department of art and design. Her earlier career included teaching at Drake University and the Des Moines Art Center and also serving as gallery director and coordinator of art programs in Waterloo, Iowa. She received her BFA from the University of Nebraska at Lincoln in 1951 and completed her MFA at Drake University in 1967. In the last two decades alone she has participated in over seventy-five competitive and invitational exhibitions of regional and national status. Her paintings are in many public, private, and corporate collections, including the Des Moines Art Center, Sioux City Art Center, Luther College, and Principal Financial Group.

I have known Betty and her paintings since 1972; it was a pleasure to invite her to participate in this exhibition. Her love of the landscape, her exploration of the natural areas of Iowa as subject matter for her paintings, and my love of the Loess Hills led me in 1982 to encourage her to seek out the landscape around Preparation Canyon State Park. She did, and she returned to the Loess Hills again in 1991 when another research project allowed her to follow the Lewis and Clark Trail from St. Louis to Astoria, Oregon, to study the landscape.

CONCETTA MORALES
[born 1960, Long Island, New York]

Morales received her BS from Skidmore College and her MFA from the School of the Art Institute of Chicago. She has taught at the Des Moines Art Center, Iowa State University, in the Iowa Arts Council artist-in-the-schools program, and in the Chicago Public Art Group. She currently maintains her home and studio in Des Moines. She has exhibited her art at the Laumeier Sculpture Park and Museum in St. Louis, Blanden Memorial Art Museum, Sioux City Art Center, and San Diego Art Institute. She is an active lecturer at regional and state arts conferences and has juried for the National Endowment for the Arts and the Iowa Arts Council. Her art is presented in the National Bank of Waterloo, Skidmore College, and Principal Financial Group collections.

A vivid color palette and a personal style that abstracts familiar subject matter characterize Concetta's work. She is an urbanite, and I am very intrigued by her interpretations of a rural landscape.

JO MYERS-WALKER
[born 1944, Holland, Michigan]

For two decades Myers-Walker has been an independent artist maintaining her home and studio in Ames, Iowa. She received her BA and MS degrees in art education at Iowa State University. Combining painting and sculpture, she has created a wide-ranging and ever-evolving body of work. She maintains an active commercial, national exhibition schedule, including the American Craft Council exhibitions, as well as exhibiting in midwestern museums and cultural centers such as those in Madison, Grand Rapids, Iowa State University's College of De-

sign, and Cedar Falls. Myers-Walker has long been involved in the Iowa Watercolor Society, serving as president in 1988. She has done artist-in-residency programs independently and for the Iowa Arts Council in many Iowa communities and in 1989 was popularly voted Favorite Iowa Visual Artist by the Iowa Arts Council. Her paintings and sculpture are in personal and corporate collections, including Casey's Corporate Headquarters, Meredith Corporation, and National Bank of Waterloo.

Jo has a tremendously upbeat personality that is reflected in her own work and also influences the work of others. I invited Jo because of her artistry, whimsy, and goodwill. For years Jo has molded, collaged, embossed, and wrapped carefully selected papers into paintings and sculptures. Playful, delightful, refreshing, and colorful all describe Jo and her art.

JOHN PAGE
[born 1923, Ann Arbor, Michigan]

Raised in Detroit, Binghamton, New York, and Muskegon, Michigan, Page became interested in art in high school. He attended the Minneapolis School of Art, the Art Students League of New York City, and, following military service, graduated with a BA degree from the University of Michigan. He received his MFA in 1950 from the University of Iowa. During his thirty-seven-year college teaching career, he has taught at Mankato State College, New Mexico Highlands University, the University of Omaha, and for thirty-two years at the University of Northern Iowa. In 1987 he fully retired from the University of Northern Iowa and resumed his earlier travels in Europe, Asia, Australia, China, and the United States. Page has exhibited widely in competitive and invitational shows throughout the United States and has had many solo exhibitions in the Mid-

west. In 1992 the University of Northern Iowa and the communities of Cedar Falls and Waterloo honored him by organizing *John Page: A Retrospective in Three Parts*. He has received numerous awards, including a National Endowment for the Arts Printmakers Grant in 1974. His prints and paintings are in the Walker Art Center, Seattle Art Museum, Joslyn Art Museum, and Des Moines Art Center. Page now resides in Green Valley, Arizona.

Combining his acquired European landscape tradition, romanticism, and impressionism with the vistas of northeastern Iowa, John has created many prints and paintings depicting Iowa scenes over his fifty-year career. With a worldly yet local focus that characterizes the intent of this exhibition, John was a perfect artist to participate. Though I had known his work for years, I had not met him and his wife, Mary Lou, until after they had been to the Loess Hills in preparation for *Land of the Fragile Giants*. I am not sure which I enjoy more, his art or John and Mary Lou, and that, too, is what is important about this exhibition, each of us discovering art, a place, and people.

GENIE HUDSON PATRICK
[born 1938, Fayetteville, Arkansas]
Patrick received her BFA from the University of Georgia in 1960 and her MA from the University of Colorado in 1962. She also studied at the University of Illinois, Colorado Fine Arts Center, and Mississippi State College for Women. From 1979 to 1990 she was adjunct associate professor in the School of Art and Art History Extension Program at the University of Iowa and taught at the Cedar Rapids Art Center, Radford College, University of Virginia Extension Program at the Roanoke Art Center, and Northeast Mississippi Junior College. Her paintings have been exhibited nationally and extensively in midwestern solo, invi-

tational, and competitive shows, including shows at the Blanden Memorial Art Museum, Walker Art Center, Des Moines Art Center, and the University of Iowa Museum of Art. Patrick's art is represented in the permanent collections of the Laura Musser Museum, Pillsbury Company Collection, Minneapolis, and Art on Campus Collection, Iowa State University. She currently maintains her home and studio in Iowa City.

Genie's paintings of Iowa landscapes are as breathtaking as her landscapes and skyscapes of Mexico, where she often travels. In 1986 Iowa State University acquired her painting *Autumn Signs* for its public art collection, and since then I have actively sought out her art for further exploration. Her sensitivity to capturing the unique qualities of each landscape and atmosphere is again reflected in her painting for *Land of the Fragile Giants*.

JOHN PRESTON
[born 1953, Pensacola, Florida]
Preston received his BFA from Maharishi International University in 1984. Among other shows, he has had solo exhibitions at Olson-Larsen Galleries in West Des Moines and the Institute for Creative Arts in Fairfield, Iowa. He has shown in juried and curated shows at the Des Moines Art Center, Butler Institute of American Art, and other midwestern sites. He has completed many commissions, and his art appears in corporate, private, and public collections, including Hallmark Cards, Inc., National Bank of Waterloo, and Pioneer Hi-Bred, Inc. Preston maintains his home and studio in rural Fairfield.

I do not remember the year, but with great clarity I remember the instant I first saw John's paintings and pastels. To me the qualities of his art were inspired from Dutch landscapes of several centuries earlier. The horizon was low, the land thin strips dotted with minuscule points of light reflecting the silos and

white farmstead buildings, and the enormous skyscapes filled with atmospheric vapors. In the Loess Hills I knew he would capture the weather, land, and humanity.

JOHN SPENCE
[born 1943, Abilene, Texas]

Spence graduated with bachelor and master's degrees in photography from the University of Nebraska at Lincoln and has had an extensive and accomplished career in photography. Working for Nebraska Educational Television as a photographer, cinematographer, and editor, he collaborated on over fifteen major projects, including *The Hired Hand*, a documentary dealing with farm-oriented hired hands, and *Reunion*, about a fifteen-year high school reunion. Spence has taught photography at the University of Nebraska at Lincoln, University of Connecticut, and SummerVail Workshop in Vail, Colorado. Since 1977 he has been an independent filmmaker, with his home and studio in Lincoln. His independent productions include *Corn and Culture* and *Robert Henri and the Art Spirit*. He has exhibited nationally and regionally at the Sheldon Memorial Art Gallery, Kansas City Art Institute, University of South Florida at Tampa, and Ford Gallery at Eastern Michigan University. His commissioned art is in the Nebraska State Capitol and the Minnesota Department of Transportation in Brainerd, and his photographs are widely seen in national and regional presses.

Museum directors often talk to one another about the latest exhibit or an exciting artist. John and his work were recommended to me by George Neubert, director of the Sheldon Memorial Art Gallery at the University of Nebraska at Lincoln. George was exuberant about John's photography, and I, too, was captivated by his images. John's representational realistic images are personalized with precision, character, and moods.

TOM STANCLIFFE
[born 1955, Elmhurst, Illinois]

Stancliffe graduated in 1982 with an MFA in sculpture from Northern Illinois University, having previously received his BS from Illinois State University with an emphasis in sculpture and printmaking. Since 1988 he has served as assistant professor in the University of Northern Iowa art department. He has exhibited extensively in Illinois and Iowa at such institutions as the State of Illinois Center Gallery, Des Moines Art Center, and Sioux City Art Center. Public collections and commissions include an art-in-architecture sculpture project for the North Point Marina in Zion, Illinois, the Amcore Bank Collection in Rockford, Illinois, and Mount Mercy College, in Cedar Rapids, Iowa. He maintains his home and studio in New Hartford, Iowa.

In 1992 Tom's wall sculpture *Sod Buster* was juried into the Des Moines Art Center's annual Iowa Artist exhibition. To me the power of that sculpture spoke of historical and mythological qualities of the rural landscape. In spite of the landscape's permanence, Tom's art often explores the transitory nature of the landscape as it is shaped and reshaped by humanity and nature.

DAVID WEST
[born 1933, Chicago, Illinois]

West was raised with art and artists. He graduated with a BFA from the School of the Art Institute of Chicago in 1960. He was a practicing artist and teacher at art centers in Minnesota until he became director of the Sioux City Art Center in 1965. He has been associated with Morningside College since 1983 and is currently an assistant professor there. Throughout his teaching and arts administrative career he has maintained his private studio. He has exhibited in the Gosling Museum of Art, Walker Art

Center, and Sioux City Art Center, with many other solo and group exhibitions.

David has been painting the Loess Hills for decades and regards the landscape for its beauty and form, not necessarily because of its unique geological formation. Having attended Morningside College, I periodically receive college publications, upon which one of David's landscapes was reproduced. This led me to his studio. His paintings' constantly changing effects of light and atmospheric conditions bring together reality and abstraction.

DONALD J. WISHART
[born 1940, Melrose, Iowa]
Wishart received his BS degree in animal science and his MS degree in journalism and mass communication from Iowa State University. He has been associated with Iowa State University Extension for three decades and has been a communication specialist since 1981. He has extensively collaborated with university staff in writing, photographing, editing, and producing films, videos, and photography programs shown throughout the state. Some of these projects have been distributed nationally and internationally, such as *Walking the Journey: Sustainable Agriculture That Works*, completed in 1992. He has also served as a visual arts juror and consultant to 4-H groups, college students, and Extension personnel.

It is always a delight to find an artist outside the usual artistic institutions. When she heard of the concept of *Land of the Fragile Giants*, mutual friend and artist JaneAnn Stout insisted I call Don. Through their years of collaboration on Iowa State University Extension projects, JaneAnn knew his artistic eye and sensitive style. I did call, and he humbly shared with me his video production *Early*, about a small community's values. It is stunning, and I was pleased to invite Don to participate in the show. When he traveled to the Loess Hills he was reunited with college friends now living in the Hills, who helped him explore the area. His excitement and dedication to this project have been a personal joy for me.

Photographic Credits

All artworks in the album were photographed by Charles Greiner, Front Porch Studio, except the following, which were photographed as credited below:

Crows over the Catsteps: Bruce Meyer
Dakota View from the Loess Hills: JMC Productions
Ides of March (cut brush fires near Missouri Valley): Roger Bruhn
kissitgoodbye: Steven Herrnstadt
Neola, Pottawattamie County, Iowa, March 14, 1992: John Spence

All photographs in the essays were taken by Don Poggensee, except the following:

Page 23: Tom Rosburg
Page 25: Tom Rosburg
Page 32: Art Bettis
Page 71: Don Farrar
Page 76: Don Farrar
Page 83: George Knaphus